The Illuminated Theat

CW00741176

What sort of thing is a theatre image? How is it produced and consumed? Who is responsible for the images? Why do the images stay with us when the performance is over? How do we learn to speak of what we see and imagine? And how do we relate what we experience in the theatre to what we share with each other of the world?

The Illuminated Theatre is a book about theatricality and spectatorship in the early twenty-first century. In a wide-ranging analysis that draws upon theatrical, visual and philosophical approaches, it asks how spectators and audiences negotiate the complexities and challenges of contemporary experimental performance arts.

It is also a book about how European practitioners working across a range of forms, from theatre and performance to dance, opera, film and visual arts, use images to address the complexities of the times in which their work takes place. Through detailed and impassioned accounts of works by artists such as Dickie Beau, Wendy Houstoun, Alvis Hermanis and Romeo Castellucci, along with close readings of experimental theoretical and art writing from Gillian Rose to T.J. Clark and Marie-José Mondzain, the book outlines the historical, aesthetic and political dimensions of a contemporary 'suffering of images.'

Joe Kelleher is Professor of Theatre and Performance at Roehampton University, UK. His previous publications include *The Theatre of Sociétas Raffaello Sanzio* (Routledge, 2007) and *Contemporary Theatres in Europe: a Critical Companion* (2006), co-edited with Nicholas Ridout.

The Illuminated Theatre
Studies on the Suffering of Images

Joe Kelleher

Routledge
Taylor & Francis Group

LONDON AND NEW YORK

First published 2015
by Routledge
2 Park Square, Milton Park, Abingdon, Oxon OX14 4RN

and by Routledge
711 Third Avenue, New York, NY 10017

Routledge is an imprint of the Taylor & Francis Group, an informa business

British Library Cataloguing in Publication Data
A catalogue record for this book is available from the British Library

Library of Congress Cataloging in Publication Data
Kelleher, Joe.
The illuminated theatre : studies on the suffering of images / Joe Kelleher.
pages cm
Includes bibliographical references and index.
1. Theater audiences--Psychology. 2. Theater--Production and direction--Europe. I. Title.
PN1590.A9K44 2015
792.01--dc23
2014043680

ISBN: 978-0-415-74826-1 (hbk)
ISBN: 978-0-415-74827-8 (pbk)
ISBN: 978-1-315-70789-1 (ebk)

Typeset in Sabon
by Taylor & Francis Books

Contents

List of illustrations

Acknowledgements

I had been promising this book, to myself and others, for some time. If I have been able to keep my promise I have others to thank for that. At the first and at the last, Ben Piggott, my commissioning editor at Routledge, has been on the case in every respect from even before the get-go. Throughout the process fellow performers in the scene of learning, scholars and pedagogues, artists and practitioners of all sorts, curators and programmers and fellow students have supported the project by inviting me to rehearse the materials and to share thoughts and conversation in a range of contexts. I have enjoyed every moment and benefited enormously. Others, colleagues, collaborators, interlocutors on panels and pages and various stages, correspondents, critical friends and encouraging strangers have opened worlds for me. Some of them, the anonymous readers of the book proposal in particular, I am unable to credit personally (each one gave invaluable advice). Others, though, I can name. The following have all contributed in one way or another: Gigi Argyropoulou, Konstantina Georgelou, Efrosini Protopapa, Danae Theodoridou, Manolis Tsipos and others in Athens and Nafpaktos and Syros, Joel Anderson, Ioli Andreadi, Lis Austin, Sophie Berrebi along with Hendrik Folkerts at the Stedelijk, Marin Blažević and Lada Čale Feldman in Rijeka, Maaike Bleeker, Silvia Bottiroli at Santarcangelo and elsewhere, Andrea Božić and her colleagues at *We Live Here*, Claudia Castellucci, Karen Christopher, Bojana Cvejić, Piersandra Di Matteo, Karoline Gritzner, Georgina Guy, Adrian Heathfield and all at *Performance Matters*, Lin Hixson and Matthew Goulish, Emke Idema, Janez Janša and *Maska*, Adrian Kear, Zane Kreicberga and the New Theatre Institute Latvia, Bojana Kunst, Carl Lavery, Boyan Manchev, Bojana Mladenović at Het Veem, Maria O'Connor, Terry O'Connor, Niki Orfanou, Louise Owen, Flora Pitrolo, Goran Sergej Pristaš and BADCo, Marco Pustianaz, Eleftheria Rapti, Alan Read, Kati Röttger, Annalisa Sacchi, P.A. Skantze and Matthew Fink, Zoe Svendsen, Kasia Tórz and

Dorota Semenowicz at Malta Festival, Barbara Van Lindt and all at DasArts, Maurya Wickstrom and Julia Willms. I am indebted to them all. I also owe considerable thanks to colleagues in the Department of Drama, Theatre and Performance at the University of Roehampton who remind me, daily, that thinking about theatre is *interesting*, which means that work is too. I have learned much from Josh Abrams, Simon Bayly, Laure Fernandez, Ernst Fischer, Ewan Forster, Sarah Gorman, Susanne Greenhalgh, Chris Heighes, Emily Orley, Susan Painter, Jen Parker-Starbuck, Ioana Szeman, Graham White, Lee White, Fiona Wilkie and others named already. To my undergraduate students at Roehampton who took the plunge on a new course called 'The Theatre Image' and who may have thought I had the answers, but were fine making up their own answers when they found out that I didn't – thanks. And thanks also to administrative and support staff at Roehampton who held it all together (they always do) when the head of the department was in a particularly hard-to-get-hold-of phase of 'finishing his book.' This is a book about spectating, not really a book that fishes for 'inside knowledge.' I have tried to say what I think about what I have seen and heard. I am grateful to the artists who have facilitated the endeavour, listened to me talk about what they do, and talked back in turn: Dickie Beau, Romeo Castellucci and all at the Socìetas, Forced Entertainment, Alvis Hermanis, Kinkaleri, Stephen Rea, Lois Weaver. Simon Vincenzi (who will now see what I have to say about his work) has been particularly supportive. Other individuals too went above and beyond. Snejanka Mihaylova was amongst the first to talk with me about what the images might be doing in the theatre of thought. Rebecca Schneider gave critical advice at a critical moment. Eirini Kartsaki sustains the pleasures of repetition and the joys of collaboration. Kasia Tórz has kept me in touch with reports from the theatrical front line. Aoife Monks commented on early chapter drafts and helped me to see the possibilities. Nicholas Ridout has said more than once he's been looking forward to reading this book, and that in itself has been reason enough to write it. Giulia Palladini, more than anyone, at a time when it really mattered, read the work and talked to me about it, helped me hear what it might be by listening to her. Zohreh Moghimi, no ordinary 'general reader,' has helped (me and the book) beyond measure.

An earlier version of a section of Chapter 5 appears as 'On Misattention' in Marin Blaževic and Lada Čale Feldman, eds., *MISperformance: essays in changing perspectives* (Ljubljana: Maska, 2014).

Introduction

Rosemary Lee, *Melt Down* (2011); Sam Shepard and Field Day Theatre Company, *A Particle of Dread (Oedipus Variations)* (2013)

Show and tell (the suffering of images)

For example, *Melt Down*, a piece by choreographer Rosemary Lee, which I saw under the chill sun of a late October afternoon in 2012 in Granary Square, a large, open and – on that occasion – rather quietly populated space between the Regent's Canal and the converted industrial facade of Central Saint Martin's college in King's Cross, north London.[1] *Melt Down* is about twenty minutes long and is performed by twenty or so men: men of various ages and appearances, men dressed as men, in their shirts, their jackets, their scarves and their hats, walking out towards us silently and deliberately from behind the college building, going straight to the spot where the performance has to happen, spacing themselves out from one another, each assuming their place and then standing still. They raise their arms above their heads: a posture that acknowledges the occasion they are part of, although not a gesture of address, I take it, towards any of us, the spectators. We are scattered around, some of us quite close to the action, others watching from the canal bridge, or from across the road, approaching the performance not by coming across, but merely by looking over. There is a large bell, a proper old foundry bell in a standing frame, which another man strikes to mark the passing minutes, although the chimes sound irregular and the minutes seem to dilate immeasurably as, with the striking of the bell, the men fall. They fall imperceptibly. That is, our vision is not slow enough to follow them. At least, *my* vision is not slow enough: I only know for sure they are falling because at each chime of the bell they have all fallen a little further. I will have seen by the end what has taken place, without altogether having seen it happen: like watching something melt. Something – the something that is themselves, these men – is being pressured into collapse. But also not pressured, not altogether: they choose to fall, they are here to show us what falling is like, or what falling is like for

them; although at a certain point it will not have been possible not to fall, all the way down.[2] They lie on the ground for a while, still and silent. And then they get up and leave.

It is, I suppose, a pretty minimal sort of theatre (and Rosemary Lee may not even think of it as theatre at all), involving just the spectators, the actors, the action that is to be performed, the place and occasion of the performance and then everything else that might be going on beyond that. I mean the comings and goings here and around Granary Square (some of which are noticeable during the performance); or the shows that some of us will see later this same evening (at the festival for which the *Melt Down* showings serve as a kind of prelude); but then, yes, everything else, from the private concerns of those of us gathered there and reaching out to the wider city beyond us, out to 'the world' at large. That is where we – actors and spectators all – have come from of course, although our ways of getting here will have been different. Most immediately, some of us will have made appointments to attend this performance; others, I imagine, are here by chance, passersby or local residents, caught up in the spectacle to different degrees, according to the different levels of attention we bring. As for the men, I take it they have been trained to perform this action, to fall slowly like this so that they touch the ground in that moment, as best they can: to make an image, as we might say. And, as they fall, to be falling from the image, so that the image, even as it dissolves in the air on the chimes of the bell, sticks: sticks and dissolves in us instead, distributed between us, fading and waxing, multiplying as it may, mutating in transmission. I think of the men as citizens of the image, that gesture at the start of raising their arms – an announcement, a claim upon that citizenship, which somehow or other the rest of us are called upon to honour. Which we do by leaving them to it and instead asking about the image itself. What makes them melt? Or, what had frozen them, so that they melt now in our regard? Was it something they had seen, or that they know about, or have heard tell of? Something to do with *themselves* being seen, is that what collapses them? But they also, as we have said, collapse of themselves; their performance is poised somewhere between an action that is carried out (something that people *do*) and something that has happened – is happening – to people. It is happening now to those people: individuated as they are, male as they happen to be. And they are here; they *were* here, patently, they shared the same temperature as ourselves, the same cloudy light (which is already changing). But it is also like they belong to – or have come from – somewhere else, from other places, with news of what is going on in those other places. News of a great, terrible catastrophe – a melting or a freezing over, the message is not

specific – of global ecological crisis most likely; of everyday fragilities for sure. A voiceless chorus with something to tell. Of how it is for them, inhabitants of the image, whom the image cannot hold, although there is nowhere else they can go, nowhere else they can fall to. Of how it is for others in the world. And how it is for the rest of us, holders of the image now, for whom suffering the image – receiving its transmission, bearing amongst us its infinitesimal weight and motion – will have something to do with recognizing that the image itself has nothing to tell. Images don't do that. As one author has put it, speaking of images in visual art, in figurative painting especially, images 'distinguish' themselves, as it were from whatever catastrophe they may be images of. But if the image does not tell – or if it tells (mutely) only of itself, to say 'I am this thing'[3] – what then of those collapsing men, those actors, those figures in the image who, no less mute than the image, are, to all appearances, minute by minute, *dying* to tell? What shall we have to say of *their* 'suffering'? It is a delicate business. There was, for instance, something in how they walked back to where they came from after the performance, removing themselves from the scene, delicately and without demonstration – a sort of unspoken flourish to their mute appearing just a moment ago – that meant when I left too, I was smiling. Something for sure has stuck.

Perhaps I can start there, simply by saying this is a book about trying to make sense of particular performances that have stuck with me, through one spectator's experience of attending theatre in the first decade or so of the twenty-first century. (And not just theatre but also dance, performance art, visual arts and screen arts – although mainly theatre.) And not just 'stuck' with me either, but bothered me. I am thinking about performances, particular moments of performance, gestures, texts and images that have worked their way into my thinking – how I think about theatre and also how I think about life, the 'wider world' – and stayed with me as unfinished business. Unfinished because I find myself as often as not – lacking the poise and accomplishment of the performers in Rosemary Lee's piece – barely able to 'tell' anything of what I have experienced, until I ask a question or two of the images. As if, after all is done, all that I have are the images – which of course begs a question or two as to what might be meant by 'the images.' We will get back to that shortly. Where we will also get to as this book proceeds, although as spectators, as theatre makers and performers, as scholars and students of the contemporary theatre it is likely we were there already, is the simple fact of the diversity and unpredictability of the range of theatrical experiences available. And not just across the landscape of a city like London where I and my students

see much of our theatre, but in any of the singular, immediate situations (performances, rehearsals, posters, reviews) where we encounter the theatre's invitation and promise to its participants. And it is a mixed sort of promise, given that what counts as the 'contemporary' these days – the *theatrical* contemporary anyway – includes a considerable variety of historical forms and expressions, a whole shake-up of what Raymond Williams some time ago referred to as historically discrete 'structures of feeling,'[4] any of which can be put to work these days to speak to the times, these times of ours. What that means, some of the time, is that the ones on stage, the actors, the figures, even the 'characters' if you will, seem aware of the sort of situations this historical déjà vu imposes on them. We will be coming back to this, in the early chapters particularly. What it also means is that there may be a range of what Maaike Bleeker, in her book *Visuality in the Theatre*, calls 'positions of subject vision' working alongside each other. That is to say, ways of seeing and attending – particular relations to the seen, implied in how the artwork is structured – with which the actual seer herself might not coincide. And which, as Bleeker goes on to remark, can lead to disorientation in the spectator just as readily as it can appear to confirm a sense that one is seeing 'how it is.'[5] This, I would add, may require the spectator, emancipated or disorientated as he or she may feel themselves to be,[6] to work things out retrospectively, to replay the performance after the event; or (to put it in slightly different terms) to return to the scene of the crime as if it were an act of mind. When we do so we may find ourselves understanding something of what Caroline Wake means when she writes that 'we are spectators in the moment but witnesses in and through time. [...] The affect itself does not arrive during the performance but afterwards.'[7] And recognizing too something of what P.A. Skantze recalls for us of the itinerant theatre spectator's special kind of attention 'that comes from a mix of care and dreaming,' with a care for 'what has been going on onstage, in performance all over the place all over these years.'[8]

If, however, this book is about dissecting, untangling and drawing out certain experiences of spectatorship – which it is – it is also a book that seeks to attend, above all, to the works, the performances that have provoked and sustained those experiences. Performances which – for all that is disparate between them – appear to be niggling at certain shared concerns. Concerns about actors and spectators and what circulates between them. About the insidiousness, the seduction, the beauty and the waste of images; about the spectators who generate images upon the bodies of the actors and then suffer the images to haunt them, to bother them; and about the actors, the figures in the images, who bear up the

images, who suffer the images to exist, but who might – you sometimes feel – disengage if they could. To put all of that another way, I have had an increasing sense over the last few years, as what remains for me of the various works I will talk about in the chapters to come has shuffled between my memories and perceptions, that what has got 'stuck' in the sensibility for *them* – these shows, dances, plays, actions, films, pictures and performances: including theatrical but also literary, critical and philosophical performances – is 'theatre' itself. Theatre as an opening, for sure, an insistent promise of possibility (of imagination, of resistance and communication, and of meaningful pleasure just for starters: the several forms that the promise might take will be explored in the rest of this book). But also theatre as an obstruction, as an anachronism even, a particular historical technology of representation, of time and motion management, that infects contemporary sensibilities just as much as it informs them. This book is also about that: about the idea of theatre and some of the expressions that idea takes, in a range of theatrical and performance forms as they speak to the times in the early twenty-first century.

In these lights, 'image' no less than 'theatre' becomes a rather fluid thing, and maybe not even a thing at all but a term that we use to speak about something that, as Hans Belting remarks, defies our attempts at reification, 'even to the extent that it often straddles the boundary between physical and mental existence.' As Belting goes on to say: 'It may live in a work of art, but the image does not necessarily coincide with the work of art.'[9] Nor does it necessarily belong to visuality, although it does depend (Belting again) on 'its being invested, by the beholder, with a symbolic meaning and a kind of mental "frame".'[10] When I use the term in this book, then, I do not consider theatre images as the fixed contents of a stage picture – if such contents could ever be considered fixed, or indeed 'contents' – but as a sort of impression (it may already be fading or in flight, while still smarting from the blow) taken from what the spectator sees and hears on stage. The image then, once fabricated and perceived,[11] can seem to function as a sort of operator of relations, or a kind of pre-verbal – or post-verbal – currency circulating between the stage and the auditorium, between spectators and others beyond the show, and also circulating for oneself, between the sensed and the imagined, the felt and the understood, mutating as it passes in transmission from body to body, between the on and the off, the all gone and the still to come.[12]

At the same time, however, there can be something immutable about the images we take from the theatre. And this, more than any transformation in our impressions, can produce its own sort of ambivalence. I

am not thinking now so much of what stays fixed or stilled in a picture or a photograph, but what remains to reappear as itself, in the performance of a play: even in a play that has been performed many times over. Samuel Beckett captured this pretty definitively in his 1972 play *Not I*, where the unnamed gabbling figure, of whom all we see is her mouth in a spot of light surrounded by darkness, is tumbled into the interminable life of the image by the unconscionable memory of the actor (i.e. her ability to remember and repeat all those words) who lends her body and speaks the lines; by the inexhaustible fascination of the audience who just won't let go; and by the shining of the theatre lantern that suspends memory and forgetting in its single unwithering beam. No wonder the hooded figure at the edge of the stage in Beckett's drama makes its gesture of 'helpless compassion.'[13]

We can find expressions of comparable ambivalence or aporia – although again the range of application is diverse – running as a thread through what we might call late modernist critical thought. With the Francophile Beckett having turned our attention in that direction, I pick out a few French examples, from the mid twentieth century to the turn of the twenty-first. We have already alluded to Jean-Luc Nancy's 1999 essay in which he defines the art image – for all its force, its intensity, its violence – as something set aside, removed, cut off. 'The image is a thing that is not the thing,' he writes, 'it distinguishes itself from it, essentially.'[14] For Nancy we relate to the image as to a profoundly 'dissimilar' entity, intimate but at a distance. Maurice Blanchot meanwhile in the early 1950s, in a discussion of literary images (although his attention is turned also to the visual, for example the corpse of the recently deceased who, for the mourners, begins to 'resemble himself'), writes of the image's alliance with formless materiality, and hence its 'proper passivity,' which for Blanchot, in all obscurity, 'makes us suffer the image even when we ourselves appeal to it, and makes its fugitive transparency stem from the obscurity of fate returned to its essence, which is to be a shade.'[15] Roland Barthes, delightfully although not without pathos, writes in *A Lover's Discourse* of an intimation of the visual discretion of the beloved, who 'as if he sought to resist this fresco in which he was lost as a subject, whenever he was subsequently to appear in my field of vision (walking into the café where I was waiting for him, for example) did so with every precaution, *a minimo*, impregnating his body with discretion and a kind of indifference, delaying his recognition of me, etc.: in short, trying to keep himself out of the picture.'[16] And then we have Georges Didi-Huberman, with more abstraction it may appear than either Blanchot or Barthes, although Didi-Huberman is attending to the materialities of the symptomatic detail in the illogic of the Freudian

dream-work and the all too visual materiality of the un-interpretable mark on the surface of a painting (a portrait or a landscape) that makes a tear or 'rend' in the fabric of representation. As he writes in his book *Confronting Images*, even the hollowed out representation '*calls forth* the figure'. A figure that no longer 'speaks' to us in the conventional sense but makes 'a cry or even a mutism in the supposedly speaking image.'[17] The mutism, we might suggest, of one being performed, theatricalized, by actors and imagining spectators (not that there is any other way for such a one as 'Mouth' in Beckett's play to be).

Or as W.J.T. Mitchell has observed more recently, in a phrase that might serve as a motto for our discussion: 'Historically, then, the attribution of life to images is the occasion for deep ambivalence about value.'[18] That ambivalence has continued to have traction in our own time. For example the editors of a recent volume of essays titled *The Life and Death of Images* write in their introduction of 'how we might understand the image, often but not always the artwork, as a form of life, more specifically a form of damaged or endangered life – life threatened by death.'[19] Amongst the essays that follow, philosopher J.M. Bernstein, speaking of Gilles Deleuze's analyses of the images in Francis Bacon's paintings, writes of 'the suffering body, the body bearing the world, the body etched in the image of all that makes it that it cannot make in turn.' Judith Butler, in her response to Bernstein, evokes the image of a body 'suffering from a deadness that is induced through an array of social and political actions upon the body.' W.J.T. Mitchell (again) in a wide-ranging discussion of 'what images are and what they are becoming in our time' of the 'biodigital picture' and terrorism's 'war of images,' and then focusing on press images of atrocities during the war in Iraq, remarks that 'the mutilation of a corpse is thus the mutilation of an image, an act of iconoclasm that is reproduced as an image in another medium.'[20] And Griselda Pollock recalls Susan Sontag's 1977 *On Photography*, in which Sontag notes that to suffer is one thing, 'another thing is living with the photographed images of suffering, which does not necessarily strengthen conscience and the ability to be compassionate. It can also corrupt them.' Of which Pollock remarks: 'Susan Sontag seems to suggest that images happen to us: marking us by an exposure to a sight. That is, there is a subject who is affected by the encounter with *an image* of the pain of the other.'[21] As indeed there is, although there is also, as Sontag goes on to argue and as Pollock acknowledges, a subject (it may be the same subject) who becomes immured to the image of suffering. Helpless compassion and all that, which according to Beckett's stage direction 'lessens with each recurrence till scarcely perceptible at third.'[22]

There are, though, other ways of being responsive to, or responsible for, the images.[23] I think for instance of video artist Hito Steyerl's double-edged comments on the digital proliferation of images in our world. 'Image spam,' she calls it: 'our contemporary dispatch to the universe,' which may well provoke all sorts of 'withdrawal from representation,' but which also indicates something of a certain readiness of contemporary images, to be made by anyone and put to as yet unforeseen uses, given that 'any image is a shared ground for action and passion, a zone of traffic between things and intensities.'[24] Technologies of image-making and the political-historical circumstances in which these technologies are put to work, are themes of much recent theory. To take another example from photography, Ariella Azoulay, over the course of a couple of books, explores how 'all images issue from an act of erasure. Wherever there is erasure, the image aspires to arise. The erasure doesn't precede its appearance; it inheres in it and is the condition of its possibility. For an image to appear, something else has to be erased.'[25] In her later book, *The Civil Contract of Photography*, which examines photographic images arising from situations of violence and political inequality across the world, and particularly in contemporary Israel and the occupied territories of Palestine, Azoulay addresses the 'civil power of being a spectator.' This is a power which may well be undermined by the sort of definitive identification of an image that would say 'This is X,' but which is also dependent on the spectator's 'prolonged observation' and her 'capacity to report on what she observes.' Azoulay reaches for a theatrical metaphor: 'The act of prolonged observation by the observer as spectator has the power to turn a still photograph into a theatre stage on which what has been frozen in the photograph comes to life.'[26] What comes to life, however – and this stands even for photographs of the dead; indeed, *especially* for photographs of victims of violence and for those whose membership of the civic community has been denied or erased – is a claim upon citizenship, as members of a new 'virtual political community' that 'is not dictated by the ruling power, even when this power attempts to rule and to control photographs.'[27] In this context, the suffering of images would amount to something like a political responsibility, to strangers and fellow citizens alike, although I am sent back to the complexity of such responsibility by pages on the ontology of suffering by philosopher Adi Ophir, a sometime collaborator of Azoulay's and whom Azoulay credits as having contributed to her understanding of catastrophe as a preventable event.[28] In Ophir's account of suffering, what the sufferer bears is the unbearable intensity of something that 'goes on' over an unrelieved duration, something acting upon the subject from which he or she – the sufferer – is unable to

disengage. As suffering continues, something in turn is transmitted by the sufferer: not the suffering itself – nobody can really appropriate another's suffering – but a representation of the fact that the sufferer is bound to their situation. The sufferer becomes 'a living communicative act, whether or not she cries for help.' A transmission of sorts – it may be a verbal appeal, or a wordless cry, or the self-withdrawal of one who suffers in silence – positions someone else as the receiver, the destiny of that appeal, the witness, real or imagined, of a call, a demand, a craving 'to disengage'.[29]

It strikes me that this demand to disengage, this demand made upon the one who receives that call, who witnesses that suffering, is like a demand made upon the spectator to be there in some other way than she is: to be there still, but differently. As Ophir goes on to argue, the sufferer is to be recognized as inhabiting a different temporality, a different sort of time than the one who witnesses the suffering. Or she is until the fabrications of memory take place, the fabrication of 'a common temporal continuum and a homogenous space.'[30] A sort of image space as we might think of it, which can only obstruct the memory of suffering 'because it erases the unbridgeable difference between the temporality of suffering and the temporality of those who remember.' For Ophir, responsibility for the memory of suffering would have to acknowledge 'the untranslatable moment of private suffering' and also 'relinquish in advance a unitary and unified historical time into which suffered time is gathered,' which for Ophir also means the deconstruction of 'any historical metanarrative.'[31] This is the sort of relinquishment of certain narrative and imaging operations, and acknowledgement of fractured temporality, I sometimes think, that the contemporary theatre grasps intuitively, practically, while recognizing what it cannot help but harbour in its own operations: something stuck in the machinery, the mangled reminder of the sufferer herself maybe, whose craving to disengage – while it might provoke ambivalence for ourselves – is definitive, absolute, unconditional.

I finish this section with another example, from the dramatic theatre this time; a forensic intervention, a reflection on what is harboured in theatrical knowing. The example is a version of the Oedipus drama written by the American playwright Sam Shepard and produced by the Field Day Theatre Company in the city of Derry in Northern Ireland towards the end of 2013. The production was something of a return to the theatre for Field Day themselves, a company set up by the actor Stephen Rea and the playwright Brian Friel in 1980 during the period of intense political conflict that became known as 'The Troubles,' although in the years since the peace agreement the company has largely focused

on publishing activities. Shepard's play, titled *A Particle of Dread* and set, in Nancy Meckler's Derry Playhouse production, in a white-tiled space resembling the interior of an abattoir, presents what the playwright has described as a set of 'Oedipus variations.' A kind of dispersal of the tragedy and an extension of its resonances into other, disparate situations. So, while the bare bones of the Oedipus story are played out in this indeterminate wipe-clean place, other scenes happen in contemporary America, where a casino boss is murdered; where an old man and his daughter visit the crime scene and try to put together the clues; and where a police forensics expert – like a figure straight out of a TV crime procedural show – sees immediately everything that happened on this spot, demystifying every clue. In this way awareness and remembering start to become porous, as if the characters across these different worlds were infected by the knowledge of the actors who are doubling between them. This infection is something of a predicament. As Shepard writes in the programme, 'Can we become completely ourselves even while wishing we were something else? The denial or refusal of this predicament seems to me what might be called tragedy.'[32] It is also a predicament of history, as the integral Sophoclean drama is broken into pieces: scenes, images, stories, particles of intimation – clues, in other words – that take place at different times, in different places around the world, and that speak to each other, pretending to a kind of kinship or mutual belonging. On the basis of which something leaks between them, and leaks also into Derry Playhouse in December 2013, where the Oedipus drama is being played again in a city that holds in living memory its own history of violence. At the end of the play the actor Rea, in the character of Oedipus, bloody and blinded and limping as he has to be, is being led off by Oedipus' daughter Antigone. My origins, he tells us, are rotten, my everyday is rotten. He speaks of himself as one who must be driven out of the city if the city is to be cured, as one who knows too much, who knows too much of himself. Out of sight and out of mind. Some words then are said by a chorus figure about a city where things happened, terrible things we take it, but which has since returned to normal, although a normality that is still haunted by its 'particle of dread.' The images, it would appear, are incorrigible.

A theatre without images (the illuminated theatre)

There is, though, perhaps, a cure for that. And it is an illuminated theatre. It is time to say something of how this book is structured and what sorts of things it contains, but I want to get there again by way of another story, another spectator's account. This account, on the face of

it, is quite minimal so it may not keep us long. It comes from a philosopher who one evening in 1901 was at the Palace Theatre in Berlin. We know this much because he makes a note of it shortly afterwards, which is put to use in a lecture series that he will deliver in 1905. However, we cannot know for sure whether he actually goes to see a show at the theatre or merely passes the theatre building in the street, lit up in the glare of gas-lamps and (as we might imagine it) the glitter and bustle of the assembling crowd. That is because all that the philosopher says is the following: 'I remember the illuminated theatre.'[33] The philosopher is Edmund Husserl, the first major figure in the philosophical movement known as phenomenology, which the *Stanford Encyclopedia of Philosophy* defines concisely as 'the study of structures of experience, or consciousness. Literally, phenomenology is the study of "phenomena": appearances of things, or things as they appear in our experience, or the ways we experience things, thus the meanings things have in our experience.'[34] The phenomena that Husserl is concerned with in his lectures have little to do with the theatre, as it happens, but rather the workings of memory and the consciousness of 'internal time': how, for instance, we experience the recollection of something that comes to mind as if it were happening now: the illuminated theatre that I saw yesterday, for example. As Husserl goes on to argue it is not his perception, his act of seeing the theatre that he remembers, but the appearing theatre itself. 'The theatre then hovers before me as something present,' he writes, 'as if it were now'; even though he knows it to be something past, something 'having been.'[35] What this means is that 'the illuminated theatre is the same: Berlin's Palace itself now hovers before me.' The theatre itself, he insists in the earlier note, 'not a mere image.'[36]

There are various aspects of Husserl's account that have resonated with me during the writing of this book. Not least the movement that is traced from something that happened for someone in a public space – the theatre – which has been turned over in private thought and then returned to a rather different sort of public space, the lecture, the essay, the study, as an example of the 'not now' recollected in the now. To this extent, the philosopher's example is, well, exemplary, and it describes the basic gesture of the chapters that follow here as concisely as I could hope. I would also say, though – and this in spite of the first two words of the present introduction – that when I encountered the works that I discuss in the pages ahead, I did not really experience them as 'examples' of anything. It was always more a case, as I was setting out earlier, of asking of a particular performance – or a particular experience – how it was that it had stuck with me, and why it was that it continued to 'hover before me,' and what it was that the work, the experience, the

occasion was provoking me to say. What the philosopher's example provokes me to say is that the illuminated theatre seems oddly unpopulated. It is a theatre without images, in fact a theatre without much of anything really except the intending consciousness of the spectator and the returning image – although no 'mere image,' we are told – of the theatre itself.

This book departs from there. What I aim to do is recover the detail, and in doing so dissect both the spectator's acts of perception, and the theatre's intentionality towards the circumstances, historical and otherwise, in which its own acts are performed. In the following chapters I describe and analyze a number of early twenty-first-century theatres, texts and performances extensively: turning a light, I hope, on the sort of detail that will give a good account of the particularity of a range of contemporary practices and spectator experiences. In going about this, I have tended to follow the dramaturgy of the works, in the very simple sense of starting with the beginning and following through to the end, telling what goes on. There is an altogether practical aspect to this procedure, in that I am aware that many of the performances I discuss will be unknown and (documentation aside, which I have drawn attention to where it exists) unavailable for the reader. I am aware too of the limits of such a dramaturgical endeavour, aware that the question of what can be brought to mind for others of one's own experience will remain contestable. I have at least aimed to offer enough material to open my own analyses to contestation, for others who will be inclined to see things differently (I hope indeed that they do). A dramaturgy, though, in the limited sense that I am using the term here, is not just the action but also the associations the action provokes. This concerns the second aspect of my procedure, which involves following an association, a thread or impression that I take from a performance, so as to put one thing beside another. Often that other 'thing' will be a theoretical text or another performance (sometimes from an earlier historical period). Where it happens to be a text, I have endeavoured to have the thought that is at work there 'speak,' like a character in a drama, with opportunity for the authors to be properly introduced, and for readers who are unfamiliar with the texts to make a first acquaintance. The sort of short-form quotation I indulge in above will have been an exception: think of that as the words in the brochure for a curriculum (curriculum: a course of study; *not* a canon of accepted works); or a sort of virtual theatre festival, which includes amongst the performances talks and demonstrations, and spaces for reflection and refreshment.

However, we are not quite done with the example of Husserl, who has after all leant me the title for this book. Along with the analyses of

particular contemporary and historical *theatres*, what I have also aimed to do is take account of that dubiously abstract and universalizing entity *the theatre itself*, both as it continues to hover in the imagination of this spectator and as I find it re-illuminated and worked through – which is to say, embraced, contested, dismembered, reconceived and returned to and variously cast into the dark – in the performances I consider. I approach this by elaborating, across the chapters, a thematic anatomy of ways in which the illuminated theatre brings the 'suffering of images,' as discussed above, to light. These ways, or so I have intended in assembling the chapters, grow out of each other, or in response to each other, again like a course of learning – and I hope enjoyment – that starts where it must and then goes wherever it can. However, to set up at this stage some sign-posts towards the directions we will be taking, these ways include: the happenstance and contingency of image-making gestures (Chapter 1); the ambivalence of returning, for both actors and spectators, to the theatre as a place of enjoyment (Chapter 2); the ruptures and returns of recognition, in theatre particularly, but not just in theatre (Chapter 3); the complicities of theatrical rhetoric with the machinery of production and consumption (Chapter 4); the historicity of theatrical imagination (Chapter 5); theatre's sociality and the vicissitudes of forgetting and affectionate attachment (Chapter 6); and, at last, the encounter of the latecomer spectator, the well-rehearsed actor (as rehearsed as they can ever be for what comes next) and the punctual, all too punctual figure in the theatre image who will have been there, ahead of them both (Chapter 7). A festival, then, or a curriculum which seeks to share with its participants a set of motivating questions: What is an image in the theatre? How is it produced and consumed? How does it remain? Who is responsible for the images? And what does this responsibility cost? The wager – my wager – is that contemporary theatres have something significant to say to these questions. *The Illuminated Theatre* aims to articulate with its reader what that might be.

Notes

1 *Melt Down* was made for the 2011 Dance Umbrella festival and first performed outdoors under an ancient and over-spreading tree in a grassy square in central London, amongst mid-day strollers and passersby. I saw the piece this autumn at the 2012 festival.

2 See also the rich collection of materials in Ric Allsopp and Emilyn Claid, eds., *On Falling*, *Performance Research*, 18.4 (2013).

3 Jean-Luc Nancy, *The Ground of the Image*, trans. Jeff Fort (New York: Fordham University Press, 2005): 9.

4 See Raymond Williams, *Drama from Ibsen to Brecht* (Harmondsworth: Penguin, 1973).

5 Maaike Bleeker, *Visuality in the Theatre* (London: Palgrave Macmillan, 2008): 10, 33.

6 I have in mind here Jacques Rancière's much-cited title essay to *The Emancipated Spectator*, trans. Gregory Elliott (London and New York: Verso, 2011): 1–24. I'm also, though, reminded of the exit from the cave in Plato's even more famous allegory in Book VII of *The Republic*.

7 Caroline Wake, 'The Accident and the Account: Towards a Taxonomy of Spectatorial Witness in Theatre and Performance Studies,' in Bryoni Trezise and Caroline Wake, eds., *Visions and Revisions: Performance, Memory, Trauma* (Copenhagen: Museum Tusculanum Press, 2013): 33–56; 38.

8 P.A. Skantze, *Itinerant Spectator/Itinerant Spectacle* (Brooklyn: Punctum Books, 2013): 9–10.

9 Hans Belting, *An Anthropology of Images: Picture, Medium, Body*, trans. Thomas Dunlap (Princeton and Oxford: Princeton University Press, 2011): 2.

10 Ibid., 9.

11 Ibid., 3.

12 It will be transparent to readers of Rebecca Schneider's recent work that I am touching here on territory she has mapped out extensively. I shall be returning to Schneider's thought. Rebecca Schneider, *Performing Remains: Art and War in Times of Theatrical Reenactment* (London and New York: Routledge, 2011).

13 Samuel Beckett, *Not I*, in *Collected Shorter Plays of Samuel Beckett* (London: Faber, 1984): 213–23.

14 Nancy, *The Ground of the Image*, 2.

15 Maurice Blanchot, *The Space of Literature*, trans. Ann Smock (Lincoln, Nebraska and London: University of Nebraska Press, 1982): 254. For a critique and development of this thought see Amanda Beech and Robin Mackay's 'Body Count,' *Parallax* 16.2 (2010), 119–29. This 'dossier' forms part of a valuable collection of essays on image practices and theory.

16 Roland Barthes, *A Lover's Discourse: Fragments*, trans. Richard Howard (London: Vintage, 2002): 192.

17 Georges Didi-Huberman, *Confronting Images: Questioning the Ends of a Certain History of Art*, trans. John Goodman (Pennsylvania: University of Pennsylvania Press, 2005): 155, 210.

18 W.J.T. Mitchell, *What Do Pictures Want? The Lifes and Loves of Images* (Chicago and London: University of Chicago Press, 2005): 93.

19 Diarmuid Costello and Dominic Willsdon, eds., *The Life and Death of Images: Ethics and Aesthetics* (London: Tate, 2008): 16.

20 For an important investigation of contemporary performance practices in this light, across a range of contexts, see Jenny Hughes, *Performance in a Time of Terror: Critical Mimesis and the Age of Uncertainty* (Manchester: Manchester University Press, 2011).

21 J.M. Bernstein, 'In Praise of Pure Violence (Matisses's War)': 37–55, 44; Judith Butler, 'Response to J.M. Bernstein': 56–62, 62; W.J.T. Mitchell, 'Cloning Terror: The War of Images 2001–4': 179–207, 185, 195; Griselda Pollock, 'Dying, Seeing, Feeling: Transforming the Ethical Space of Feminist Aesthetics': 213–35, 224, in Costello and Willsdon, op. cit. See also Susan Sontag, *On Photography* (London: Penguin, 1977): 20, and for Sontag's return to and later revision of the theme her *Regarding the Pain of Others* (New York: Picador, 2004).

22 Beckett, *Collected Shorter Plays*, 215.

23 See also Hans-Thies Lehmann's discussion of 'response-ability' to 'an ethics of perception' in *Post Dramatic Theatre*, trans. Karen Jürs-Munby (London: Routledge, 2006): 184–85.

24 Hito Steyerl, *The Wretched of the Screen* (Berlin: Sternberg Press, 2012): 161, 172.

25 Ariella Azoulay, *Death's Showcase: The Power of Image in Contemporary Democracy* (Cambridge Mass. and London: MIT Press, 2001): 93.

26 Ariella Azoulay, *The Civil Contract of Photography* (New York: Zone Books, 2008): 167–68.

27 Ibid., 22–23.

28 Ibid., 30. For an engagement from a theatre studies perspective which alerted me to Ophir see Alan Read's *Theatre, Intimacy & Engagement: The Last Human Venue* (London: Palgrave Macmillan, 2008): passim.

29 Adi Ophir, *The Order of Evils: Towards an Ontology of Morals*, trans. Rela Mazali and Havi Carel (New York: Zone Books, 2005): 259–61.

30 Ibid., 276.

31 Ibid., 276–77.

32 Sam Shepard, programme note, *A Particle of Dread*, Field Day Theatre Company, December 2013.

33 Edmund Husserl, *On the Phenomenology of the Consciousness of Internal Time (1893–1917)*, tr. John Barnett Brough (Dordrecht, Boston, London: Kluwer Academic Publishers, 1991). See §§ 27–28 for the passage in question: 60f. The 'Berlin Palace' is identified in a 1901 sketch for Husserl's 1905 lecture series, collected in the same volume.

34 *Stanford Encyclopedia of Philsosphy*, 2013, online: http://plato.stanford.edu/entries/phenomenology/#1 (last accessed 22 August 2014).

35 Husserl, *On the Phenomenology of the Consciousness of Internal Time*, 60.

36 Ibid., 190. For an extended philosophical reading of the argument see John B. Brough, 'Presence and Absence in Husserl's Phenomenology of Time-Consciousness' in Lenore Langsdorf, Stephen H. Watson and E. Marya Bowe, eds., *Phenomenology, Interpretation, and Community*, Volume 19 (New York: SUNY Press, 1996): 3–15. Pannill Camp is sure that Husserl's memory of an 'illuminated' theatre means that the philosopher is in the auditorium during a show, 'otherwise what could its illumination mean to him?' See 'Theatre Optics: Enlightenment Theatre Architecture and the Architecture of Husserl's Phenomenology', *Theatre Journal* 59.4 (2007), 615–33, p. 627. For an argument that 'the phenomenology of theatre demonstrates that phenomenology, too, is essentially theatre, a theatrum philosophicum,' see Andrew Haas, 'The Theatre of Phenomenology', *Angelaki* 8.3 (2003), 73–84.

1 The interpreters (on the birth of images)

Ernst Bloch, 'Images of déjà vu' (1924); Marie-José Mondzain, *Homo Spectator* (2007); Dickie Beau, *LOST in TRANS* (2013)

In a spot

Scene one. We open on a conversation between two friends, two writers from Germany, Ernst Bloch and Walter Benjamin. The conversation took place in 1924 in a bar on the Italian island of Capri and lasted, Bloch recalls, 'a September night, until the return of the fishing boats from the sea at dawn.'[1] Benjamin would note later of his stay on Capri, which ended the following month: 'I am convinced that to have lived for a long time on Capri gives you a claim on distant journeys, so strong is the belief of anyone who has long lived there that he has all the threads in his hand and that in the fullness of time everything he needs will come to him.'[2] The particular thread that I want to draw out here is a slender one, and doubtless a fragile thing compared with the sort of tapestries that both Bloch and Benjamin will put together in later life. I trust, though, there is a virtue at the start of things in working in close-up like this. There will be journeys to come, distant enough I hope. The topic of the friends' discussion this September night: a sort of literary folk tale that is familiar to them both called 'Blond Eckbert,' written over a hundred years earlier by the eighteenth-century author Ludwig Tieck. Bloch takes up the narrative in a postscript to his essay 'Images of déjà vu':

> Here Berta, the wife of Eckbert, may be found narrating her own strange story about the old woman for whom she used to tend animals as a child. There was a little dog, as well as a songbird that each day laid an egg containing a pearl. The story does not proceed in a very moral fashion. Berta yearned to see the wider world, and so decided to run away. Weeping, she departed: she patted the dog and tied it inside the hut, then took the bird and a jarful of its pearls

with her to the city. There she lived splendidly for a time, yet was compelled finally to strangle the bird, for its singing tormented her with feelings of remorse. She met Eckbert the knight, who became her husband; in his castle she lived happily and peacefully, though occasionally she was oppressed by thoughts of the abandoned hut and the old woman's fate. She told all this to Walter, a knight who was her husband's friend, one Autumn evening in Eckbert's castle. What is extraordinary in Tieck's fairy tale is Walter's response to Berta's confession. 'Many thanks, noble lady,' he says. 'I can well imagine you beside your singing bird, and how you fed poor little *Strohmian*.' Now Berta, in telling her story, had never mentioned the little dog's name; yet Walter speaks the name quite casually and matter-of-factly, as if he had seen the dog with his own eyes. That night Berta told her husband, 'I was seized with great horror that a stranger should help me to remember the memory of my secrets.' And the story continues in the same meandering style. It goes forward even while standing still and always comes back again to the interrupted situation, even in its final sentence: 'Faint and bewildered, Eckbert heard the old woman speaking, the dog barking, and the bird repeating its song.'[3]

As Peter Krapp notes in his study of the history of the topic since Freud, déjà vu – the not uncommon experience we have when we recognize, or feel that we recognize in what is happening in the present, something of what has already happened, in the past – 'exemplified for Bloch the popular "metaphysics" of his contemporaries.' But for Bloch that was not, Krapp remarks, its most interesting aspect.[4] In fact, Bloch proposes Berta's situation as a special case; an example of what he calls 'déjà vu of the other,' although he will go on to insist that it is not because of a stranger that Berta has unlocked the memory of her secrets. The forgotten secret is all her own – except, of course, to the extent it is exposed here to the rest of us, passerby readers and lookers in, whoever might come upon Berta's tale and make something of it, to interpret as it were.

For Bloch, what is interesting about déjà vu, or false recognition as it is sometimes called, is what it allows us to glimpse of unfulfilled potential. It is not the 'content' of an earlier experience that is recognized, but rather an 'act of will,' an 'intention' that has not been realized, an 'orientational' or '*wishful*' act with respect to a situation that the subject at one time might have hoped to experience.' The experience of déjà vu, Bloch writes, is 'tantamount to awakening with a shock to all the past disruptions of this kind, all the aborted beginnings of our life in

general.'[5] I should say already that in evoking the *act* as such – in particular, the potential act awoken in the image – I am looking ahead already to a theme that will be brought into fuller focus by the final chapter of this book. But we will get there in time. For now, everything else apart from the unlooked for recurrence of this 'pure experiential potential' is so much mental scene-painting. Or so it is for Berta. As Bloch and Benjamin develop the theme in the conversation that Bloch records, Berta has only 'apparently' left the old woman's hut, 'while her conscious forgetting, her neglect of duty have remained behind with the dog. Walter's voice, therefore,' Bloch's account continues, 'is like a face appearing in the hut's window at night to announce where she is: Berta occupies the scene of her own story, and her happy marriage is just a rainbow in oily water, there in the animals' stable.'[6] It is as if for Berta, her life – her own distant journey from there where she started to here where she finds herself looking back on it all – has not even begun. In this light, 'as if illuminated from above,' as Bloch puts it, Berta 'does not cast the least shadow into which she might flee.'[7] She is, we might say, in something of a spot: a violent spot as it happens, subject to a pervasive moralism that not only punishes her, it kills her. The same night as Walter's revelation of the dog's name, Berta takes to her bed and she dies shortly after (this is only the first catastrophe of several to follow, in a rather fantastically fruity story that will climax with revelations of sibling incest).

Although it is not entirely clear where the offence is supposed to lie, it appears that Berta (Berta first of all) is guilty of something. As Bloch – or Bloch and Benjamin – interpret it, 'Berta's true offence is that she abandoned the dog, which comes to represent all that she has left behind.' Bloch goes on: 'Her true guilt lies in the omission of an action, leaving something behind in a place that has been abandoned forever.'[8] And Berta is still there 'where she is,' fixed like an image by the face and comment of a passerby, a latecomer stranger. However, to be there still – in the image – is also to be there in all her potential, guilt-ridden or hopeful as the case may be, but anyway to have that potential in readiness: a potential to desire, to decide and to do. This is what Bloch comes around to, or hints at anyway: 'There is another, brighter shock that comes not from forgetting,' he writes, 'but from anticipation; it is manifested bodily as a shiver.' It may be we know no more than this: that something is happening for no good reason we can discern, or that nothing at all is happening – although that is something we can shiver at too. Bloch again: 'In any case, we cannot see the exact instant as it is being lived: neither the self that lives it, nor the immediate content that it presents. But this obscurity is also the place of a continual "forgetting"

of I-know-not-what; animals that frighten or repel us dwell visibly there and a single barking dog can bring us back to it.'[9] So it is that we return to the spot, or somewhere like it. And so it is too that we find ourselves, 'as if illuminated from above,' like figures in a theatrical scene, self-interrupted, or interrupted by a face at the window.[10] A stage situation where so much has already been done and decided – scripted and enacted indeed – but where the actor herself is still to make her first move. So it is, facing the stage – or else facing out from it like the actors do – one attempts to grasp where one is right now. As if we might grasp the present *historically*, glimpsing something of ourselves (the barking dog must be alerting us to *something*) amongst the animals and all of the other creatures in range, actors and objects we can never read well enough (ourselves included), but to whom we make our attachments – fools that we are – even so.

Bloch's essay, I should say, came, as many of these things do, as an accidental gift, wrapped up as a reference in another text that had been recommended to me. The source was a parenthesis in contemporary philosopher Paolo Virno's reading of Henri Bergson's thoughts on déjà vu from the 1850s, which we shall come to in another context in a later chapter. Virno, I must admit, is not impressed: he refers briefly to Bloch's text as 'not without interest, but too generic and rhapsodic.'[11] Anyway, I became attached to the material: to Tieck's strange story (which concludes, by the way, after much further wandering, with Eckbert encountering the old woman from the hut and finding out that he and Berta were in fact brother and sister, at which point everything just collapses); and attached also to the thought of a scene (Berta in the hut, Bloch and Benjamin in the bay) bitten into by a sound: in this case the sound of a barking dog. I can imagine a dog barking that summer night of 1924 in the Capri marina, infecting the talk of the two German intellectuals. There was, as it happens, a dog barking outside most mornings, somewhere out of sight if not out of hearing, where I was staying at a friend's house for a week to begin work for this book, and where I was thinking as I did so that this is how it had felt much of the time following theatre, mainly in the UK and continental Europe, in the early twenty-first century. There would often be some sort of unaccountable sound leaking in from outside the stage picture there too, an immediate and invasive pressure of sorts on the one who had to be there: an actor, like Berta, who was dealing with the problem of what is happening and what happens next. A problem – or so it seemed to me – that had something to do with images, the allowance of images, the putting on and abandoning of images, the suffering of images as I came to think of it. That of course begged the question what sort of thing an 'image'

might be. Something conjured, something promised from what falls into view? Something to be reckoned with that isn't really there, not yet, not quite? Some sort of 'nothing' after all?

Time for some theory. Time, for instance, to consider what image theorist Lambert Wiesing calls 'artificial presence.' For Wiesing, a fundamental effect of images as such is what he calls an 'artificially produced presentness.'[12] Wiesing, a contemporary thinker working in the phenomenological tradition established by the early twentieth-century philosopher Edmund Husserl, distinguishes between the 'image carrier' that 'exists as a piece of the world' – for instance a two-dimensional picture or a three-dimensional representational sculpture, or indeed at one point in his argument a two- or three-dimensional stage set – and the 'image object,' something that the picture or sculpture or stage set makes visible, or we might say acknowledgeable, but which is itself 'a nothing, not part of the world but an object for a consciousness.'[13] The way Wiesing explains it, the image carrier – picture, sculpture, stage set and so on – is subject to the laws of physics, and potentially at least available to all of the senses of someone who encounters it, whereas the image object, the thing depicted, displayed, presented – and by extension acknowledged and interpreted – 'cannot be heard, smelled, touched, or tasted': it is never 'quite present' but rather 'merely artificially present, that is, reduced to visibility.'[14] In one of Wiesing's more catching phrases: 'Things in images are exclusively visible and never collect dust.'[15] A kind of visual echo of what *is* collecting dust already. A sort of remaining potential for sense and significance, of what crumbles under the weight of speech, of what we have already let go, back into privacy and fading, back to whatever it may have meant or intended before we came to the scene.

And we keep coming to the scene, to enjoy those echoes, to recoup that potential, or to corroborate it at least. Later in his book, as he considers more contemporary image media – abstract photography, virtual reality and the like – Wiesing modifies what might be taken for 'visibility' in these contexts. He introduces the term 'validity' to discuss how it is that the medium of language enables human beings to share understandings with each other, more precisely how it is possible to 'think and mean not only something equivalent but also the very same thing' in different places and times; or in different parts of the same place at the same time, as we might in the cinema or theatre.[16] Validity, which Wiesing defines as the 'artificial self-sameness' of the novel that you and I read in our different times and places, or the image that we see, or even 'the very same judgement' that each of us makes, occupies a similar place to that of the visibility of image-objects in the earlier formulations,

except that now the potential exposure to all is a given. Wiesing: 'it can no longer be said that what, thanks to media, comes about as validity is a private affair. Medial validity exists only in communal form: "The number five is not my own."'[17] The number five, indeed, is a shared 'inter-subjective' matter, shared between you and I along with everyone else who counts. For Wiesing there is liberatory potential here, for humans anyway. 'Humans are part of the world – but precisely not just that, since by means of media they participate in realities that do not behave like the world of physical things.' The image-making media that enable us to generate and validate such non-physical realities, according to Wiesing, 'are the only means humans have to disempower physics. That is why without media no human existence that is more than the presence of stuff can emerge.' 'Media,' Wiesing concludes, 'liberate humans from the ubiquitously present dictates of the physical world.'[18] For Berta, this is what it was all about: liberation indeed, from some *sort* of reality. To emerge from the hut so to speak, and not just 'so to speak.' Except Berta – Berta in the story, Berta in the image – is still in something of a spot; and nor is it just the dictates of the physical world that constrain her.

Berta is exposed – and to that extent embarrassed, as it turns out catastrophically so. She is exposed in her relations to others, to the animals in the hut and the old woman her guardian, to her husband and his friend, exposed also to herself. As I have been suggesting, the image of Berta in the hut – interrupted, revealed and captured 'as if illuminated from above' – is not unlike the typical appearance of a figure (an actor, a character, a *someone* anyway) on a theatrical stage, at least as regards many of the stages that this spectator has attended to over the past couple of decades or so. Certain qualifications may follow. For one, the theatre is not like the cinema, in the sense that from our different seats in the auditorium we don't necessarily hear and see – or in Wiseing's terms validate – the exact same things as each other.[19] That has to do with the fact that in the theatre the medium, the image-carrier, is to a large part the actors, the interpreters, whose bodies and labour are very much part of the world of physical things, although in rather peculiar ways.

A couple of instances come immediately to mind. For example, that the figure so deliberately and elaborately composed and presented on the stage might, at some moment, look up into the overhead illumination and face us all with something we were not ready to deal with, a look or a movement that wasn't in the script, even briefly to silence the applause.[20] Or that the figure would remain there on the spot, regardless of the applause and seemingly unaware of the catastrophe to come, exposed and at the same time removed altogether from whatever that

figure's appearance gives us, the audience, to understand of what is happening there, of what went on back then: the weight of history on the scene, the movement of politics in the image.[21] Berta, I would say, carries a bit of both, abandoning her situation and abandoned to it, all the more so as we bring her image to mind. As said, there are no shadows into which she can flee.

From hand to mouth

We should be ready now to set out the structure of this first chapter, as follows: a progress towards the theatre through three stages, three scenes (we have just had the first one) in each of which a person – an actor, say – is caught in the light and found to be up to something. As simple as that, if only that were simple, because at this point the questions begin, the all night discussions as to what was seen or heard tell of and what it might mean, what it might be worth, what there is to do with it. Of course, there is also the thought that keeps its own council – and there will be more to say about that in later chapters – but there is no way around the talking out loud, the conversing and the telling of tales across a variety of worlds. And not just theatre worlds, although all of the worlds we shall visit are sites of image-making. We have already listened in on a discussion between friends in an all-night bar on an island off the coast of Naples, followed a fantastic sort of 'modern' fairy tale from a couple of centuries ago, and started to acquaint ourselves with other writings of the same sort as the one you are reading now, academic essays, texts of literary and visual and performance analysis, where the image-making takes place amongst theoretical and rhetorical speculation. In the pages ahead, before our first three scenes are concluded, we will also encounter ancient tales of people and gods and half-gods and monsters, of violence and transformation, fixed into images and then picked apart again with each re-telling and turning over. And within the tales and conversations there will be further tales, voices to be heard from within the picture: the sharing of life stories, along with moments of revelation and confession, of forgiveness and appeal and accusation. Which is to say also that all of it – however fantastic the story or form – is underwritten ultimately by something like an ongoing report from the ordinary, from the fervid ground of everyday life. We shall speak more of that when we get to the theatre. We are already on our way.

To arrive there, however, as in any good fairy tale, we shall have to do more than listen to what is said. We shall, for instance, have to negotiate a variety of objects, without which none of our stories and

texts and speeches, our reflections and conversations can be built. Already, a stranger's chance remark. A barking dog. A literary text that two people happen to share. To follow shortly: a stain on a wall, shaped like a human hand. Later: an audio tape found on a suburban train. An email someone receives fifty years later telling them about that recording. Crocuses in the yard. An absent lover. Things that befall us from outside, that fall into the picture. Call them contingent objects: they happen to us, their value or significance, if they have any, still to be decided. Meanwhile they get noticed, chosen, attached to, attended to by others, and in that attending something like a conjuring takes place, a figuration, the conjuring of a someone – a figure or character or whatever we want to call them: a *person* anyway – who is revealed upon the scene, with something to do now, something to show or say, some responsibility to uphold. Let us look again at what there is.

'The spectator is a work of our hands.'[22] That phrase appears in *Homo Spectator*, a book by philosopher Marie-José Mondzain that I picked up from the display table at the Avignon festival bookshop in summer 2008. The title was already enough for me and was supplemented by the photograph on the book's cover of what looked like the shape of a human hand with fingers spread, outlined by a blood-sore splash of colour upon a pale stone surface. The opening chapter of *Homo Spectator*, which speculates upon that image, kept me occupied on the train ride home through Paris to London, and beyond.[23] These stencilled outlines – images of a hand, we presume, made 'by hand' – were created in the Chauvet-Pont-d'Arc cave in what is now the Ardèche region of France around thirty thousand years ago, although only discovered for modern times in the mid-1990s.[24] Mondzain constructs what she calls a *fantasia* upon these recent findings, figuring the image-making gesture as a sort of drama, a small drama for a solo performer. This is our second scene. In this scene a creature not unlike ourselves, 'fragile and courageous' and with good reason to be afraid of the dark (as Werner Herzog's more recent documentary film on the Chauvet cave reminds us, there were at various times other animals in the cave too[25]) descends into a hole in the earth. There they extend an arm as far as the stone surface in front of them. This is now all there is of distance. In their other hand they hold a burning torch, casting a light on their extended arm and animating the shadows – and, it may be, some of the hundreds of animal paintings that also eventually filled the cave walls. The outline of that extended hand is made with the aid of the mouth, in Mondzain's account by blowing a gob-full of pigment upon the hand that is pressed against the stone. The resulting mark, then, is what remains of the 'third act' of the little drama – the first act the extending of the hand, the

second act the blowing of the pigment – as the hand is withdrawn from the wall to leave behind an outline of what is there no longer, although there only a moment ago. In this instant, the image gives birth to the spectator. Mondzain: 'The man of the cave does not offer an object to his vision. He stages the composing of his first look, he brings himself into the world as a spectator in a scenography where his hands become the figure of the first show.'[26]

Given the theatricality of the conception we won't be surprised if its insights are not set in stone, whatever the Chauvet walls appear to show us. The situation here is more diaphanous than that. The quality of the diaphanous is that it is translucent (it allows the passage of light) but not transparent (it does offer some resistance to sight).[27] It is the see-through, say, when it is seen as such. For Mondzain, drawing on Aristotle, diaphaneity (*le diaphane*) is what enables colour to be seen, the colour of life as it were (even if it is not life itself).[28] Which we see as soon as light is brought to the matter, a torch in the hand for instance, or an opening to sunlight, or if needs must a lantern turned on from above. As soon as light is brought in there is scope – those flickering animal drawings, the glimmer of a rainbow in oily water – for someone to see for themselves. And also to see something of what the others might be seeing. There is scope for curiosity and distraction. There is scope also for discrimination.

We can remind ourselves for a start that Mondzain's *fantasia* reconstructs an action that may never have happened in the way she describes it. However, in being shared amongst readers – and re-staged in my telling here – it enables the drama to be played again, to be conjured up for as many of us as care to reproduce a version of the scene for ourselves. It is a drama, we say, about a creature like ourselves, who shares with us this peculiar capacity to make images, which is also the capacity to imagine absence – one's own absence first of all. As it is, this image-making capacity is achieved in the same moment as a limitation is realized, an absolute limitation, which has to do with the impossibility of seeing one's own face, at least without some sort of displacement or mediation. We depend on others to present us to ourselves; we are in their hands; they appear to be signaling to us that this is so. They are also, however, long ago beyond all that. So, while this is a drama about someone going into the dark – going *back* into the dark, if we take Mondzain's cue about 'a re-descent into [...] an uninhabited place that is not fit for habitation'[29] – to leave a trace of themselves amongst the shadows, it is also a story of this creature's emergence from the shadows, through the signs, into the light of the world. This is an emergence onto the stage of history, where humanity will continue to emerge – fragile, courageous, irrefusable – in the mostly anonymous

forms of history's singular subjects. Our solitudes are realized with and amongst others, and our vision – by way of our image-making capabilities – is realized through a capacity to speak. As Mondzain puts it in a later text: 'I would even go so far as to say that this imaging subject opens the field of words for the subject who, from now on, can say: "I see."'[30]

All of which, of course, are conditions familiar to the theatre, where our more or less solitary communion with what appears to appear on stage and which demands that we conceive of it as image, happens in the company of other image-makers, producers, actors, spectators and readers, all of whom no doubt are capable of saying something *else* of what they see. Which is the last twist, in that all of this talking and telling is not a redemption of vision so much as an abandoning of the stage, of images, actors, spectators, all; leaving behind the place of vision for other places, of action and talk. Or, simply, the abandoning of one stage for another elsewhere. Mondzain: 'The imaging operation is a place of departure, man sets off, he will speak and not turn back.'[31] And 'he' will speak, doubtless of many things to many people while leaving behind, well, *her* for one. As Mondzain will go on to argue, the first hand-made image is also the instituting of sexual difference. (If the illuminated cave as a place for the theatricalization of gender is our topic, I am reminded of Luce Irigaray's reading of Plato's famous allegory of the cave as a place for the perpetual reproduction of 'man' as long as the material circumstances of this reproduction are overlooked. As Elin Diamond puts it, deliciously, 'philosophic man discovers that, horrifically, mother is a theatre.'[32]) Then again, as Alan Read remarks: 'Marie-José Mondzain's imagined spectator working solo against the wall is not the origin of anything,' let alone the community of the human, but rather 'the retreating remains of a collective who once watched together. The artist followed their audience in this respect.'[33] Followed them into 'politics' for instance. We need to take a step back to get a better view.

In her earlier work on the eighth- and ninth-century Byzantine iconoclast controversy, Mondzain studies the development of a theological construct called 'economy,' according to which image and vision – or in this case invisible authority and perceptible earthly powers – were brought into a determined relation with each other.[34] More the stuff of doctrine than diaphaneity, the result was a structure that was no less violent than it was redemptive (to the extent it was a figuring out of the meaning of Christ's incarnation, a pre-figured violence was anyway always on the horizon, with mercy mopping up in advance). At stake was a political conflict between church and state, involving an emperor's attempt to challenge and appropriate the persuasive and powerful force

of painted religious icons, their communicative speed, their emotional effectiveness. The charge against visual images – on all sides of the conflict – was that of idolatry, the sacrilegious production and use of false, temporal representations of divine things. The response of the theologians was to develop the concept of 'economy,' the practice of domestic household management that had been extended by the apostle Paul into a way of understanding the mystery of Christ's incarnation, and which was elaborated now by Byzantine church intellectuals into a sort of divine praxis, 'God's art for the convincing and saving of mankind.'[35] One of the ways in which this convincing and saving – which was also a form of subjugation – was supposed to work involved conceiving the visible painted icon as an 'artificial image' in relation to the true living image of the divine which remained, essentially, invisible. Mondzain: 'The image is invisible, the icon is visible. The economy was the concept of their living linkage. The image is a mystery. The icon is an enigma. The economy was the concept of their *relation* and their *intimacy.*'[36] So it goes for ninth-century theology, with the remainder (and the remains can still be seen[37]) being the condemnation of idolatry, of all 'illusionist and immanentist fictions' and the unruly passions they provoke.[38]

It was a condemnation to be enforced, again, by violence. At one point later in her book Mondzain writes briefly about the Russian film director Andrei Tarkovsky and his eponymous 1966 film about the medieval icon painter Andrei Rublev. The film is an epic of iconoclast and iconophile violence, written across a vast landscape, which involves the painter Rublev withdrawing into silence in the face of the horrors he has seen – a withdrawal he maintains until the final moments of the film. (At which point, the narrative ends and the film concludes with a sequence of still images of Rublev's paintings; as if the narrative of suffering – of passion – triggered a diaphaneity in the film itself, and a switch from black and white to colour, from fictional reconstruction to art itself as the historical 'time that remains.'[39]) With respect to Tarkovsky's film Mondzain reflects on passion, on the 'moving fragility of that flesh that is discovered in the experience of passion: all the passions'[40] and considers the vocation of the icon painter, whose work is not possible 'within passion' but would be no less impossible – as the film shows – without the 'infernal crossing of the universe of temptation, despair, and death.' In the film, she suggests, as we follow the journey of the icon painters across the face of fifteenth-century Russia, we might imagine the twentieth-century artist, Tarkovsky himself, finding 'his own cinematographic vocation at the heart of this infernal, redemptive pilgrimage.' She adds: 'It could also be said that the issue he deals with concerns the

passage from passion to compassion, that is, to that imaginal affection that takes us back to similitude with those whom we do not resemble.'

In these lights, it only remains to remark that what the three-act drama performed at Chauvet brings to the economy of violence and redemption is an element of contingency.[41] This is, on the one hand, the contingency of survival of particular marks that were made on the world's interior surface and which happened to have remained, not indelibly so, but protected for millennia by a rock fall, a controlled climate, and then a chance discovery and a more deliberate conservation. It is also the contingency of a spectator's – any spectator's – attachment to these images, whether that attachment is experienced as compassion, or any other mode of fellow-feeling or imaginal affection. Or we should say rather, attachment to these image-making gestures. For Mondzain, ultimately it seems, an image is less an object placed before our eyes or an identifiable thing (even an artificial or imaginary thing) than a sort of operator of relations, generating and drawing attention to relations between our gaze and the visible world, between speech and vision, and also relations between living subjects as such. And what remains of such operations? Smudges, surface infringements, breaches between a moment, an action, a gesture that took place in that present, and the future that arrives as if from outside, though it was already harboured within. That future is ourselves. Or it would be ourselves if we were not always arriving just a little too early, a little too late, and just a little too eager to give up our own abandonment, our own exposure to and complicity with whatever happens. But then the show opens anyway, another diaphanous occasion for the compassions to converge on signs of life that are both fleeting *and* remaining, signs of others who were there and who almost *seem* to be there still, but who have left us to our own courage and fragility, whatever we can muster now.

LOST *in* TRANS

For example, I click and a link opens. An mp3 audio file. The digitization of a cassette copy of a 3 inch tape reel found on the floor of a North American commuter train sometime in the 1960s. A woman is speaking. The file has, apparently, been around the internet for a while. Linked to. Liked. Re-named. Commented under. In a comments stream below the present link, where the file is named 'nubbin,' listeners debate when and where in the 1960s the recording was likely to have been made.[42] An Expo is mentioned. And Whistler Mountain. Most likely the Montreal Expo in 1967. Whistler Mountain is in British Columbia. Canada, then. The woman is speaking to a man who isn't there. An audio letter. An

intimate address, no less so even now. Maybe it was the recipient who left the tape on the train. She sounds a little nervous. There is a crack in her voice, an evidence of time. The voice of someone who is not as young as she was. She addresses him as 'darling.' She thanks him for the two phone calls over the weekend, which must have been expensive. She talks about the weather, the snow, the extreme cold where he is, she imagines his journey in to the office. She tells of Trudy and Mabel's ill-health. Trudy is in hospital after an operation for a genital urinary condition. Mabel is old and ill and her care has been making demands on the whole family. She tells him about some recent purchases she has made, some Indian baskets which she found at an auction; she tells him she has been busy at work; tells him about the bright beautiful weather this morning and imagines a day they might have spent together. She imagines them having sex, and she describes what she imagines in detail. The tape lasts fifteen minutes and the sex takes up most of it, as if she were imagining what they were doing in real time. The description is vivid, it becomes a scene, an episode, the only episode there is. Her breathing intensifies. And then the episode ends. She daydreams about a drive they might have made this afternoon, to Whistler Mountain. She can see in the yard the crocuses are out. She dreams of a vacation journey she would like to make although it would have to be much later in the year, September at best, to see the Expo and then go down the St Lawrence river into the United States. 'A sort of circle tour,' she says. Maybe they would be able to see each other, however briefly. But she's not counting on it, and she doesn't think that he is either.

Fifty years later performer Dickie Beau is on stage at London's Southbank Centre in his 2013 show *LOST in TRANS*, a project developed with Julia Bardsley as dramaturg. Drag fabulist. Gender disillusionist. Video-interactive performer. The epithets that Dickie Beau ('given name' Richard Boyce) brings with him promise something special, something to fascinate, something transformative. They also look back, to allegiances, to contexts and identities, and to departures. That is already one of the things that drag does, registering at once its own spectacular – or semi-spectacular – transformations, and at the same time echoing performance cultures, sub-cultures and traditions, worlds and ways of being and doing and becoming, that have nurtured its practice: stand-up cabaret, gender impersonation, entertainment as such, entertainment as hospitality, hospitality as radical disturbance and critique, and all manner of complexities of stage-audience complicity and criticality, of identification and dis-identification in between.[43] Not to mention the performances that happened back before, the early ones, the private and try-out ones, the making up and putting on. Not that Dickie

Beau quite comes across as a full-time drag performer, although he does dress up and tell stories – after a fashion – and much of the material that eventually went to make up the full-length shows that he has done so far was tried out in night clubs and cabarets.[44] There's so much else mixed up in what he does, spectral twists upon mime and clowning, solo autobiographical performance art as well as something not entirely removed from regular dramatic acting, along with experiments in the more recent traditions of new medial cultures – of chat-rooms, of home edit video mash-up. His main *schtick*, however – to borrow the old-school stage speak he takes on from one of his stage characters – is indeed derived from drag cabaret. That is the technique of 'playback,' of lip-synching to recorded voices, although in Dickie Beau's case this involves mainly the presenting of historical spoken material, re-animated with extreme actorly precision, the performer's body a kind of archive of ghosts, his face a sort of athletically affective screen of articulations, his mouth stopped with other people's voices.

The other element of Dickie Beau's *schtick*, aside from the lip-synching, in the two theatre pieces to date anyway, is the use of a semi-transparent gauze, a diaphanous screen across the front of the stage onto which texts and images – captions, archive photographs, prepared videos, seeming amplified live relay – are projected. The screen is there for *LOST in TRANS*, and also for *BLACKOUTS: Twilight of the Idols*, an earlier performance that was based largely on Boyce's own recorded conversations with the former *Life Magazine* journalist Richard Meryman, by then in his 80s, the last person to interview Marilyn Monroe, days before her death in 1962. In *BLACKOUTS* Dickie Beau 'plays' Meryman – the impersonations are not just to do with crossing gender, they also often involve crossing age[45] – as if Meryman were Boyce's older self, fifty years from now. Meryman remembers his own *schtick*, how the *Life* interviews were put together – like Boyce's 'digitally scripted' pieces for the stage – by 'slightly manipulating,' as Meryman says, what his subjects said and putting that in his articles, as if it were them speaking directly on the page.[46] Now that they are speaking directly on Beau's stage there's a tone to the recorded voices, an odd sense of keen but crumbling availability.[47] So it goes for Monroe in the tapes of her final interview, reflecting both on acting – her intentions for what she still wants to be and do as an actor – and the sometimes rather disappointing strangeness of other human beings. Something of the same goes for the third main 'character' in *BLACKOUTS*, Judy Garland, again near the end of her life, in Chelsea in London, attempting to dictate her autobiography into a tape recorder, barely able to cope with the functions of the machine, but somehow defiantly challenging down the moment just as she is

challenged by the technology. Dickie Beau plays Garland in a costume that is old and young, all colour and darkness, all livid red and black, Judy and Dorothy at once,[48] but it is the recorded and played-back talkers, the voices of the idols themselves – Monroe, Garland, Meryman too – who are their own image-carriers. And they carry Dickie Beau/ Richard Boyce along with them, in all their fragility. Mondzain writes of the relation between images and idols: 'The idol invokes presence, the image revokes it, the idol belongs to the field of dominions, the image to the uncertain domain of fragilities.' She also has something to say about ghosts: 'If one knows how to listen to ghosts, one hears them speaking to us of the shared life of images and not of the terrifying return of the dead.'[49] That seems just about right here, where something of the Hollywood idols, something of their substance, leaches through the diaphanous stage screen from where Dickie Beau is 'placed' with such decided precision between the sound cues, the lighting plan, the projected videos, the bobbing syllables and the dragging pull of those out-of-the-picture American voices. As it were, right there in the web of it all. As for the idols, it's like they have been overcome by an operation they can feel working on them and which their own words speak of, but which is more fugitive and dispersed now than it was and rather painful to self-re-assemble. Like re-assembling an image of the un-illusioned human being, remaindered from the species, dazed and confused in Chelsea, fumbling with the switches and appendages of the new-fangled technical apparatus, attempting to tell her tale.

We switch focus again. A spider crosses its web. There was, presumably, a spider there already, in the old woman's hut where Berta labours and decides; or in a cave in that part of the world that will come to be called France where someone goes in with a torch and finds a treasure of pre-historic pictures. The spider was there but her web was diaphanous. It only becomes visible when the sun catches it, revealing its structure, which is to say when the sun gets caught in the web, 'participating in its energy,' 'the diaphanous incarnation of a force.' The last phrases are from an essay by philosopher Boyan Manchev on the politics of technique – as Manchev puts it the technique of the body, 'where technique will be understood as an immanent quality of life itself.'[50] In particular here a spider's life, although the application extends. Manchev looks to the *Metamorphoses* of the Latin poet Ovid, itself a vast interconnected web of storytelling based on myths and legends of earlier antiquity, and which includes amongst its tales of transformation the story of Arachne, a woman famous across the Greek world for her remarkable, surpassing technique in image-making. Arachne's particular skill is in the weaving of tapestries, transforming died sheeps' wool into

legible pictures, in which she is able to fix – i.e. give limit and form to – the monstrous, inconsistent and unaccountable actions of the shape-changing gods, not least their assaults on mortal women. This she performs unrepentantly in a competition with the goddess Pallas Athena, depicting scenes of terror and violence with infallible verisimilitude. 'You would have thought that the bull was a live one, and that the waves were real waves.'[51] In so doing she exposes the gods' transgressions, at the same time – Manchev proposes – rendering the divinities' own marvelous transformative powers as just so much impressive technique, 'reduc[ing] the unlimited monstrosity of the gods to a series of miraculous *technai* [...] placing their form within limits and, therefore, limiting their desires.' A *Verfremdungseffekt* or alienation device by which all others are to be measured, made by hand, out of the picture, there on the loom. Athena, jealous and enraged, strikes Arachne. Arachne would rather hang herself than submit to the god. The god Athena rescues the human – punishes her, suspends her by the same cord she was about to hang herself with – and transforms her into the spider. However, Arachne still has her *techne*, her craft, her *schtick*, her ability to change things, to transform them. And she also still has her defiance. Her virtuosity now, in Manchev's reading of the tale, is her very metabolism, her capacity to transform – through her own body – whatever 'victims' fall into her web from outside, the fruits of contingency as it were, into the substance of the web itself. The web, then, is a sort of sheer diaphaneity, its weaving an operation that combines craft and skill with felt, sensible experience – and which offers no sacrifice to the gods, no left-overs, no remainder. The gods themselves are done away with. We might say also – rehearsing our terms from earlier – it surrenders no image, as if the web were a sort of imageless image-carrier, except for the embodied image of the spider herself. So it is, then, Manchev argues, that Arachne's transformations serve (while serving no-one) as a figure of resistance – a resistance not least to the commodification of forms of life.[52] Arachne does what she does, generating 'unseen life forms' out of the body's own 'disorganization,' what it disorganizes of others, and of itself.

Dickie Beau's *LOST in TRANS* also looks to Ovid's *Metamorphoses*, although he picks on a different story from the collection, that of Echo and Narcissus. Richard Boyce writes in a programme note, a 'postscript' to the performance:

Echo was the nymph who fell in love with Narcissus. Most people know who Narcissus was: the guy who fell in love with his own reflection and turned into the narcissus flower (aka the daffodil).

> People forget about Echo. Echo had followed Narcissus into the
> forest and longed to declare her love to him but, under a curse, she
> was only able to repeat words she had already heard, so she couldn't
> tell him her feelings. When she tried to embrace him, he pushed her
> away. Heartbroken, she retreated to a cave where she wasted away,
> until all that was left of her was the sound of her voice ... [53]

The performance begins with a video prologue projected onto the front
stage screen, itself a density and tumble of images and stories and affects,
of organized disorganization. All is monochrome, black, white and grey.
Captions evoke the mythical Greek figure Tiresias, dual-sexed, blind, but
able to see into the future; but then they spin the name immediately into
assonance and association, cross-media, mixed-historical, I Tiresisas, I.
T., I, tree. Literature, technology, inhabited nature. Dickie Beau – a head
spins in the darkness – has a persona of his own but it's a blank sort of
persona, blank and discerning, white faced, hairless, sharp black lipstick,
eyes shaded or else oddly mechanized, but then the eyes are replaced for
a moment by flexing vocal cords. A sort of surgeon of the visible, self-
operated upon by speech. A hyena (is it a hyena?) turns on itself, caught
on a night-vision camera, apparently sucking at what drips from its own
wounded belly. A cyclopean eye fills the screen. A planet spins in outer
space, as planets are given to do, and the location technology zooms in.
Anywhere can be somewhere that something is happening. A spot on the
surface of the world. Richards Street, Vancouver, British Columbia.

This is how it is with Ovid's book too. It is not a matter of ancient
literature, something old dredged into the present. The stories are to
hand as we happen to receive and remember them, even as they draw
back to where they have been residing, a human-haunted landscape
where flowers and animals and birds and trees and rocks and clouds and
waterfalls – even the intangible sound that the air bounces between one
place and another – retain the evidence, the mark, the name by which
they can be recalled, of passions, of transformations, of dispersed integ-
rities. We might see something analogous in our own time where
'nature' takes the form of processes we no longer consider divine but
which mess with us anyway, dynamics of production and consumption,
of waste and employment, of being and identity, where our integrities
are dispersed amongst the username and password combo, account
numbers, credit and other records, whatever is known of us, whatever
we accrue of ourselves and each other to value or disvalue, to use and
exchange and to tell.

But then, that's what the old stories do, they offer ways of seeing that
tempt us to re-tell, that seduce us with the possibility that we might be

interpreters. Maurice Blanchot puts it nicely, speaking of Ovid's text, when he remarks that the Greek myths themselves do not say anything, 'they are seductive because of a concealed, oracular wisdom which elicits the infinite process of divining.' Whatever lessons we derive, we bring them ourselves, after the fact. 'What we call meaning, or indeed sign,' Blanchot writes in a book called *The Writing of the Disaster*, 'is foreign to them [the myths]: they signal without signifying; they show, or they hide, but they are always clear, for they always speak the transparent mystery, the mystery of transparence.'[54] It is a matter again of diaphaneity. As for Echo and Narcissus, for Blanchot this is 'yes, a fragile myth, a myth of fragility.' It is a myth of one who dies (Blanchot adds, 'if he dies') in the face of the incorruptibility of his image, the immortal part of him which is not his to know, hence his dying, hence his transformation into a flower, 'a funereal flower or flower of rhetoric.'[55]

It is, we say for ourselves, like any of the tales in our collection a story of remaining of sorts, of out-living oneself in a sort of perpetual fading and disclosure that writing, and the performance of writing, honours, even as it ushers that fading towards its end, re-immersing names and faces – along with the virtues and passions that accompanied them – into the landscapes that the rest of us inhabit, where they remain, stubbornly so. Of the disclosures of Narcissus in Dickie Beau's *LOST in TRANS* I remember from the show old home movie footage, late twentieth-century English, suburban back garden, a couple of children playing. I remember also stories being told in the several voices that are channeled through the show, including taped testimonies of the painter Francis Bacon, the pop star David Bowie, and of drag subculture superstar Dorian Corey amongst others.[56] Stories of a boy child's dedication-cum-compulsion to perform, to be seen performing by others and to see himself performing as an other, as Dickie Beau, a way of being and doing that became a way of life, so that 'even my family have stopped referring to me as Richard, my given name, and begun to call me Dickie Beau … I am the phantoms – the personae – I perform.'[57] But then, what of Echo? Where is she? What of her?

We might say she is caught in the web. A friend of Dickie Beau's 'on the other side of the world' sends him an email, drawing his attention to an online file called 'nubbin.' Not being a particularly attentive reader of programme notes, I did not know about this at the moment in the show when Dickie Beau again comes onto a stage that is almost entirely darkened apart from a spot on a microphone stand. I had no idea what was going to happen next, or how long 'next' would last. Dickie Beau stands sideways to us, illuminated from above (I think of Berta in *her* 'spot'), white-faced, dark-clothed, a removed kind of presence now, isolated like

a singer, reaching his face up into the microphone, his throat extended for the voice to pass, his lips moving when the voice comes, a voice that is not his own, a voice that fills the auditorium, that of a middle-aged woman with a Canadian accent, slightly self-conscious in her delivery, who speaks on a bright late Winter morning, before going to get her hair done, of sex to someone we don't know. The whole thing is extraordinary, and for this spectator the episode rather overwhelms everything else in the show. I am aware of myself watching and listening. I am aware of others in the auditorium doing the same. I have no idea what any of us are seeing or hearing. There is a moment part way through her letter when the episode is at its most intense when the speaker's breath – the sound of her breathing – overcomes her speech. I thought at the time – I couldn't tell for sure – that the breathing I could hear was that of the performer at the microphone, his breath for her breath, or his breath besides her speech, there on behalf of another's vanished passion, a fragment in the vastness of all desiring. A sort of audible diaphaneity, something sounding through, something other than the sound itself: an imaginal affection on the part of someone here for somebody else, someone other than oneself, who isn't. As if the actor, winder and unwinder of threads, interpreter of fragilities, might become an interpreter of worlds. As if every passion that has ever been might be attended to, somehow, in time.

Which may, after all, be what we came here for. For someone at once who is there, is imagined to be there, or is given the task of standing in there, holding up the image with whatever strain or insouciance they can muster. Or else leaving the image suspended for the rest of us to manage: there where the mark was made on the wall (it must have been made by *someone*), there where the loose remark was uttered and overheard, there where the absent lover is being thought of and spoken to, now, even still. And there where the interpreters are; although even they (ourselves included) may have departed by the time we come to write and talk about them.

Notes

1 Ernst Bloch, 'Images of déjà vu,' *Literary Essays*, trans. Andrew Joron and others (Stanford: Stanford University Press, 1998): 200–208; 207.
2 Walter Benjamin, *Selected Writings*, II (Harvard: Harvard University Press, 2005): 471. Cited in Howard Eiland and Michael W. Jennings, *Walter Benjamin: A Critical Life* (Harvard: Belknap Press, 2013): 214.
3 Bloch, 'Images of déjà vu,' 205–6.
4 Peter Krapp, *Déjà Vu: Aberrations of Cultural Memory* (Minneapolis: University of Minnesota Press, 2004): 42.

5 Bloch, 'Images of déjà vu,' 202.

6 Ibid., 207.

7 Ibid., 208.

8 Ibid., 208.

9 Ibid., 208–9.

10 Not unlike, we may add, the essential shock of the Brechtian stage situation that Benjamin, drawing on the threads, will evoke in an essay a decade later: 'the truly important thing is to discover the conditions of life [...]. This discovery (alienation) of conditions takes place through the interruption of happenings.' Walter Benjamin, *Illuminations*, trans. Harry Zohn (Glasgow: Fontana/Collins, 1977): 152.

11 Paolo Virno, *Il ricordo del presente* (Turin: Bollati Boringhieri, 1999): 15. My translation.

12 Lambert Wiesing, *Artificial Presence: Philosophical Studies in Image Theory*, trans. Nils F. Schott (Stanford: Stanford University Press, 2010): 113.

13 Ibid., 36. For Wiesing's discussion of sculpture and stage sets in relation to Plato's ideas on mimesis, see 112–16.

14 Ibid., 51.

15 Ibid., 20. For a concise critique of the anti-historical tendency in phenomenology, see Eagleton: 'Phenomenology sought to solve the nightmare of modern history by withdrawing into a speculative sphere where eternal certainty lay in wait; as such, it became a symptom, in its solitary, alienated brooding, of the very crisis it offered to overcome.' Terry Eagleton, *Literary Theory: An Introduction* (Oxford: Blackwell, 1992): 61.

16 Wiesing, *Artificial Presence*, 129.

17 Ibid., 130.

18 Ibid., 133.

19 Wiesing notes the same, *Artificial Presence*, 129.

20 The allusion is to Samuel Beckett's 1982 play *Catastrophe*. See Samuel Beckett, *Collected Shorter Plays* (London: Faber, 1984): 295–301. Another raised face will appear at the end of the final chapter of the current book.

21 The particular example that comes back to mind for this sort of image is from an early twenty-first-century London revival of a 1969 play by David Storey, *In Celebration* (Harmondsworth: Penguin, 1971). Act two, scene one: 84–5.

22 'Le spectateur est l'oeuvre de nos mains.' Marie-José Mondzain, *Homo Spectator* (Paris: Bayard, 2007): 30. All translations from this book are my own.

23 'Les images qui nous font naître,' Mondzain, *Homo Spectator*, 21–58. Patrick ffrench translated a large part of the chapter for circulation at a seminar with Mondzain at King's College London, which Alan Read convened. Mondzain's reading of the Chauvet images is also rehearsed in her essay 'What Is: Seeing an Image?' Bernd Huppauf and Christoph Wulf, eds., *Dynamics and Performativity of Imagination: The Image between the Visible and the Invisible* (London and New York: Routledge, 2009): 81–92.

24 The Chauvet discoveries followed those at Lascaux in the 1940s.

25 Werner Herzog, *Cave of Forgotten Dreams*, 2010.

26 Mondzain, *Homo Spectator*, 30.

27 Mondzain, 'What Is: Seeing an Image?,' 86ff. Mondzain acknowledges the work of Anca Vasiliu. See Vasiliu's *Du Diaphane: Image, milieu, lumière*

dans la pensée antique et médiéval (Vrin: Études de philosophie médiévale, 1997). Mondzain's primary source for reflections on diaphaneity is a passage in Aristotle's *On the Soul*, II, 418a–b.

28 Mondzain, 'What Is: Seeing an Image?,' 91.

29 Mondzain, *Homo Spectator*, 26.

30 Mondzain, 'What Is: Seeing an Image?,' 81.

31 Mondzain, *Homo Spectator*, 37.

32 Luce Irigaray, *Speculum of the Other Woman*, trans. Gillian C. Gill (Ithaca, New York: Cornell University Press, 1974). Elin Diamond, *Unmaking Mimesis: Essays on Feminism and Theatre* (London and New York: Routledge, 1997): xi.

33 Alan Read, *Theatre in the Expanded Field: Seven Approaches to Performance* (London: Bloomsbury, 2013): 13.

34 Marie-José Mondzain, *Image, Icon, Economy: The Byzantine Origins of the Contemporary Imaginary*, trans. Rico Franses (Stanford: Stanford University Press, 2005).

35 Mondzain, *Image, Icon, Economy*, 13.

36 Ibid., 3.

37 For example, Tate Britain's 2013 exhibition *Art under Attack: Histories of British Iconoclasm*.

38 Mondzain, *Image, Icon, Economy*, 176.

39 The phrase is also the title of Giorgio Agamben's reading of the Pauline concept of the 'remaining time' (also in relation to Walter Benjamin's 'Theses on the Philosophy of History') in Agamben, *The Time that Remains: A Commentary on the Letter to the Romans*, trans. Patricia Dailey (Stanford: Stanford University Press, 2005).

40 Mondzain, *Image, Icon, Economy*, 181.

41 For a very useful and compact account of current thinking around contingency, see Robin Mackay, ed., *The Medium of Contingency* (London: Urbanomic and Ridinghouse, 2011).

42 The file can be found on the blog of New Jersey freeform radio station WFMU. http://blog.wfmu.org/freeform/2007/04/365_days_116_nu.html (last accessed 17 August 2014).

43 José Esteban Muñoz writes on the great diversity within drag performance – from mainstream commercial entertainment that presents 'a sanitized and desexualised queer subject for mass consumption,' through 'gay drag,' to more radical forms that create 'an uneasiness in desire, which works to confound and subvert the social fabric.' Muñoz, *Disidentifications: Queers of Color and the Performance of Politics* (Minneapolis: University of Minnesota Press, 1999), 100. For a fascinating recent case study of drag as a 'setting to work of visual images' in the 1960s New York underground scene see Giulia Palladini's 'Queer Kinship in the New York Underground: On the "Life and Legend" of Jackie Curtis,' *Contemporary Theatre Review* 21.2 (2011): 126–53.

44 See Gavin Butt and Ben Walters' documentary film *This Is Not a Dream* (London: Performance Matters 2014), on the use of video and moving images by queer and alternative artists since the 1970s.

45 For a reading of cross-dressing performances that are not about gender see Aoife Monks, *The Actor in Costume* (Houndmills: Palgrave Macmillan, 2010), especially 78–98.

46 See the website www.dickiebeau.com (last accessed 17 August 2014).

47 A sense too of Samuel Beckett's drama *Krapp's Last Tape*.

48 'The Judy Garland costume by Nicholas Immaculate is an amazing manifestation of character through clothing. Half-child, half-hag, it references Dorothy but in dark red taffeta with a heavy red wig; the striped stockings recall the wicked witch in the ruby slippers they both wore. Like Bette Davis in *Baby Jane*, it suggests something innocent and wonderful becomes poisoned and dangerous.' Peter Jacobs, *The Public Reviews*, http://www.thepublicreviews.com/blackouts-twilight-of-the-idols-contact-theatre-manchester (last accessed 17 August 2014).

49 Mondzain, *Homo Spectator*, 38, 34.

50 Boyan Manchev, 'The New Arachne: Biopolitics of Myth and Techniques of Life.' Versions of Manchev's essay appear in his Italian-language book *Miracolo* (Milan: Lanfranchi, 2011) and in the Swedish-language journal *Divan*, 1–2, 2013. I am working from an English version kindly sent me by the author. For a lecture version in English currently online see *Weaving Politics*, http://www.weavingpolitics.se/video-day-two (last accessed 17 August 2014).

51 Ovid, *The Metamorphoses of Ovid*, trans. Mary M. Innes (London: Penguin Books, 1955): 137.

52 Manchev alludes to Foucault's words: 'So resistance comes first, and resistance remains superior to the forces of process.' Michel Foucault, 'Sex, Power, and the Politics of Identity,' in Paul Rabinow, ed., *Essential Works of Foucault 1954–1984*, vol. 1, *Ethics, Subjectivity and Truth* (New York: New Press, 1997): 167.

53 Richard Boyce, 'Postscript,' *Dickie Beau: LOST in TRANS*, Purcell Room at Queen Elizabeth Hall, July 2013, part of the short season Queering Voices, curated by Dickie Beau.

54 Maurice Blanchot, *The Writing of the Disaster*, trans. Ann Smock (Lincoln and London: University of Nebraska Press, 1992): 127.

55 Ibid., 128.

56 Some of the material, including the 'nubbin' recording had been worked with in an earlier cabaret piece, *Retroflection*. See the Dickie Beau website.

57 Boyce, 'Postscript.'

2 The borders of the marvellous (on reconstruction and returns)

Desperate Optimists, *Helen* (2009);
Søren Kierkegaard, *Repetition* (1843)

Trailer

I start this second chapter with an example of what are still called 'theatrical trailers,' those strange sort of allegorical micro-dramas which are shown in cinemas before the main event. These tasters of forthcoming attractions can seem bent on undermining anything the theatrical promise holds forth, compressing into their 60 seconds length everything of note that is going to happen in the film you haven't even decided to watch yet. But let us look at this one, you can follow me online and see what remains.[1] There is one main indoor shot that is returned to throughout the sequence, a large room, a school hall or such, with cutaways to various outdoors scenes. A red-painted wall flat across the back of the hall stretches from one side of the screen to the other. A teenage boy leans against the wall in the background, to the side. But he is not significant, and will soon be forgotten as the camera closes in on what is. Central to the shot and in front of the wall a young woman – another teenager – in black t-shirt and jeans, is flanked on either side by two uniformed police women, one of whom hands her a yellow leather jacket. 'We'd like you to try this jacket on.' There is a cutaway shot. The camera pans over the same jacket on the ground, outdoors, on a pile of dried leaves. In the school hall the girl puts on the jacket. The police woman speaks again: 'If you could just look to your right.' She does. 'If you could just walk slowly to the wall, and slowly turn back again.' The girl does so, wearing the jacket. Cutaways. A park. A shot at distance. A line of police amongst the trees, searching. Mid-shot. Three police are working around a small area of the park that is circled with yellow markers. One picks up the yellow jacket to place in a transparent plastic bag. Back in the hall, as the camera closes in on the face of the girl: 'Can I ask you to confirm your name?' Girl: 'Helen. Helen Townsend.' 'Ok, can you confirm your address for me?' 'It's room 8, Summerfield House.'

'That's the care home on the west side?' 'Yeh.' 'Helen, can you confirm
that you will be able to work with us between now and the reconstruc-
tion?' 'Sure.' Cutaway. Helen, or we assume it is Helen, wearing the
jacket, is seen from behind, walking away from us through the park, a
bag over her shoulder. 'It's a great thing you're doing, Helen, and don't
worry, we'll be there to help you do your best.' The last shot is a close-
up on Helen's face, back in the hall, looking straight out, although it
doesn't look as if she is looking at us. She is looking into a camera.
There is a difference.

The film is *Helen*, the first full-length feature made in 2009 by the
directorial team Christine Molloy and Joe Lawlor, who were known in
the 1990s for live performance work that they made under the creative
partnership Desperate Optimists (the name still appears in their film
credits) and who, since 2003, had been working on a series of beauti-
fully – but also often disturbingly – textured short community-based
films involving amateur actors.[2] Something of that texture is brought
into *Helen*. The lush green park where we see schoolchildren playing at
the start of the film becomes the spot where a teenage girl, Joy, has dis-
appeared, leaving behind a few possessions, including the yellow leather
jacket. We first meet Helen properly in the scene that the trailer is based
on, when she is asked to step forward from a line-up where Joy's
schoolmates are being auditioned for a television reconstruction of the
missing girl's last walk. Helen, a young woman who is given to appear,
from the little she says, as if she has lived her life to this point un-
noticed by others and without accumulating any notable experiences of
her own, is presented with an opportunity and she takes it. As does the
actor Annie Townsend in the role of Helen, who is lucid with reserved
articulacy as the implications of Helen's task are followed through
shudder by shudder. As the preparation for the reconstruction proceeds
Helen becomes, for others, an impossible but indispensable stand-in for
the missing girl. Meanwhile, she herself becomes attached to occupying
the spaces left vacant by the other girl's life: she eats with Joy's parents,
meets with her boyfriend, adopts the other girl's look (she wears the
yellow jacket wherever she goes), while also starting to learn something
of her own history. Helen, an orphan, has approached the age when she is
legally entitled to see the files about her life. That is, she is entitled to decide
if she wants to see the files, to decide how much she wishes to know.

There are two things I want to draw attention to. First, the cinema-
tography in *Helen* (by Ole Birkeland) is remarkable, giving the film a
very particular quality of colour and light. I spoke in the previous chap-
ter of diaphaneity, of colour as an effect of light being brought to
translucent materials. Here, the effect is almost phosphorescent, as if

shining with the light of the things that make up this world, rather than the light they reflect. The places in which this light shines forth, however, are thick with a strange sort of pretending – not of deception or illusion, but to do perhaps with that same voluntary 'standing in' that Helen takes on. For example, the schoolchildren playing football in the park in the long slow-motion take that makes up the film's opening shot – an effect that very much holds over from Molloy and Lawlor's earlier community film commissions – *look* as if they know they are being recorded for a film. Meanwhile the cities where the film was shot and where its non-professional actors presumably are based – Birmingham, Newcastle, Dublin – stand in for a composite city that is each of them and none, so we are never even sure whether this story is taking place in England or Ireland (my sense is England *probably*). Similarly unsettling, although again it is an effect that is kept so to speak at the surface of things, the adults in the film talk as if they were working from a script – which of course they are – but as if this script had been written with the purpose of acquainting young people with uncomfortable truths about the world, while keeping those truths at the same time distant and in plain sight.

This relates to the second thing I want to say, which is that what Helen does in this film above all else is she thinks, and her thinking takes place in proximity to authority – or 'the authorities.' We see this in the trailer: she is called forward by the police women, who speak to her as

Figure 2.1 Annie Townsend in *Helen*, 2009, dir. Christine Molloy and Joe Lawlor.

she stands between them, and as they speak she thinks. The role of the authorities is to take responsibility for knowledge, and to impart knowledge where appropriate to others, not least younger people. They include the school authorities, the foster and care authorities who advise Helen, the police who are conducting an investigation into Joy's disappearance, and Joy's parents who befriend Helen and start to teach her things, even as they fear to find out what has happened to their own daughter. All of these authority figures are depicted in the film as benevolent, caring, humane individuals. They are also depicted as participants in a sort of knowledge-churning operation, and an operation that has interests and concerns of its own.

Helen also has her interests. She is learning to be a part of this larger operation, but her part is ambivalent. And the film itself, at the level at which it follows through on the premises it sets up and what it chooses to show and tell, shares that ambivalence. For example, the film's own drive to knowledge is not fulfilled, or not in the most likely ways. A story that follows a police investigation into a young woman's disappearance might be supposed to end up discovering what happened, if in fact anything happened or was done. But this does not take place. In this sense the film enacts a sort of suspension of authority, of narrative authority anyway, although there are still things that Helen wants to know. Or we imagine that she does. Basic things, about the experience of living. She sits on the bed in the hotel where she works although she is not supposed to. She spends time with Joy's boyfriend Danny. It is as if she wants to know what it is like to do these things, to have a life. And she wants to know what it is like to be involved in social relations. It is as if she has not had a life yet and has never really been involved in social relations, at least not so she has experienced them as such. (Helen to Danny: 'Will you tell me that you love me? It's just … I've never been told that before. And … I'd like to know what it feels like.') Around her people appear stunned to various degrees, or we imagine they might be. There is bewilderment, with interruptions of grief and impatience, but also careful gestures of patience too and consideration. Amongst these people Helen attempts to take back a life that she has not really had, and to do so through acts of repetition – of repetition and return – that involve her performing an image on other people's behalf. She rehearses for the reconstruction. She takes on a kind of theatrical responsibility.

Theatre marks the spot

We will be coming back to *Helen* after a detour through a very different sort of work, as it happens a piece of mid-nineteenth-century literary

philosophy. Both pieces, I should say, are works that have haunted and taunted me for some years, not least for the ways in which they both rehearse a mode of theatrical returning. They return us I shall argue to what Samuel Weber has called 'theatricality as medium,' but also involve straightforward returns to specific, historical theatrical experiences: the rehearsal of a school production of the stage musical *Brigadoon* in the case of Lawlor and Molloy's film; a full-blown night out at the illuminated theatre in the work we will consider shortly. What also strikes me, however, in both the twenty-first-century feature film and the nineteenth-century text, is the way that the theatre is figured as a place to depart from, and in a particular sense. Call that a sense that belongs to the young, or to those whose youth is already being experienced as an accelerated maturing, a reaching forward for life that just happens to perform this reaching from somewhere that resembles a theatrical stage. Or so it may appear, to eyes grown accustomed to seeing in particular ways.

Søren Kierkegaard's 1843 book *Repetition: An Essay in Experimental Psychology* is a sort of philosophical novel. That is basically how it works, it has characters and speeches and incidents, and the reader engages by following the narrative and participating in the various reflections. We need to say, though, that it also is and it is not Kierkegaard's book. By that I mean it is written under a pseudonym. The supposed author is a middle-class man of means and of letters (he has at least written this particular book) called Constantine Constantius, which may sound like a name for someone ripe for a fall, a pratfall perhaps. For a philosophical book, however, *Repetition* is also practical-minded, opening with a very practical demonstration indeed of its theme, as a story is told about the ancient philosopher Diogenes putting an end to a theoretical dispute about the impossibility of motion by standing up and simply walking backwards and forwards. The point being that if recollection involves a projection backwards to recover what has happened before, repetition involves a movement forwards in time.[3] It is a movement that makes a claim not on theory but on life – I already want to say that it makes a claim on something newly lived, something different which life is still to give, but perhaps we have not got there yet. It is Samuel Weber who draws attention to resonances in the book's Danish title *Gjentagelsen*, a word that implies a 'taking again' of everything that has been given.[4] In the way, perhaps, that Helen 'takes again' the opportunity she is given when she is asked to step forward by the authorities. In short, it is about a taking back of happiness, an idea that is elaborated in the opening pages where we are told that whereas recollection is a melancholy affair 'the love of repetition is the only happy love.' It is, Constantine asserts, 'a decisive expression.'[5] However,

as Weber will also point out, and as Kierkegaard's writing has established from the off, for all of the reflection on life, love and happiness going on, we are also in the region of a certain theatricality, and a popular burlesque theatricality at that.[6] There may be bumps in the way. Someone could trip up.

There are two sorts of repetition that run alongside each other in Kierkegaard's book, two ways of taking back life and happiness. One of those has to do with love and social relations (and in this book the privileged social relation is marriage). The other way is through the individual enjoyment of social *distance*, and that happens in spectatorship. Hence the two interweaving plots of *Repetition*, which concern respectively a love affair and a visit to the theatre: versions of 'taking again' that reveal it to be a complex business, not only of reclaimed self-possession but also of renewed self-abandon – in love *or* at the theatre.

Let's start with the love affair, and the *dramatis personae*. There are three main characters in the book: the 'author' Constantine Constantius; second, an un-named young man whose confidant he is; and third an un-named young woman who barely features in the book, who never appears or speaks, and who only comes into the story through reports from off-stage. Of the two men, we might say that both are a sort of practitioner-theoretician type where life is concerned, and in this mode Constantine will devise a scenario for the young man to act out, a sort of anti-seduction aimed at the nameless young woman. There is a context for all this. Constantine recounts how he was visited by a young man of his acquaintance who tells him of a problem, which is briefly as follows, although there is much elaboration and agitation in its setting out. The young man has fallen in love and he is engaged to be married, but already – mere days into the relationship – he finds he enjoys recollecting the object of his affections more than he enjoys actually being engaged to her. He is in the deepest disquiet, suffering terribly he says, although relishing, it would seem, every moment. He is the exemplar of the melancholy lover mentioned above. Effectively the relationship is over, but what is to be done? Constantine devises a plot. The young man must make himself despicable, unlovable – unlovable to her anyway, and this he can do by acting out the role of a deceiver, a seducer, himself a conceiver of plots. Already the mirrors are turning and the elements of the deception are put in place, Constantine arranging the props and appurtenances. The plan, however, comes to nothing. The young man backs out. He fails to turn up to perform his part. His soul lacks the elasticity of irony. Or something. Or he does not believe in repetition. Or he loves the 'young girl' (as Constantine's text keeps referring to her) after all. Whatever. Constantine's plan remains nothing more than an

unperformed scenario. So Constantine packs his bags. He will test if this taking back of life is possible by other means. He will try through a literal repetition. He will go to the theatre, where the repetition is renewed nightly in the illuminated theatres of Berlin.

Specifically, he will attend one of the popular burlesques at Berlin's Königstäter Theatre, where the star is the actor Beckmann, a 'genius' of comic improvisation capable of 'paint[ing] the scenery for himself,' who can 'come walking' onto the stage bringing 'everything with him,' and in whose sketchiest characterizations resides 'the mad demon of laughter.'[7] Constantine has been before and he knows it is good. He is even able to tell us how it is good. He has a connoisseur's authority in this regard, as we might say a complicity with the medium. Put otherwise, Constantine gets on well with what today we might call the images of *kitsch*. 'A modern individual,' he writes, 'sated with the strong meat of reality' might still be 'moved' by the easy sentimentality of cheap genre paintings, which recall the all-purpose generality of the paper cut-outs of men and women that we make as children.[8] One is moved, he writes, by such things precisely because one does not know how to respond to them. The genre painting and the paper cut-out, he tells us, produce 'an indescribable effect for the fact that one does not know whether to laugh or cry, and because the whole effect depends upon the mood of the beholder.' So it is at the Königstäter Theatre where, for Constantine, 'the effect depends in great part upon the spontaneous activity of the spectator,' and 'the single individual asserts himself to an unusual degree.' He continues: 'To view a farce is for a person of culture like playing the lottery, except that one is spared the annoyance of winning money.'[9] Given that the 'reciprocal regard' between actors and audiences 'is here done away with,' so that one cannot know at such an event if one has behaved properly or not and laughed in the right places, one can rely neither on one's neighbours in the theatre of an evening nor the newspapers the next morning 'to know whether one has been entertained or not.' The spectator has, rather, 'to know by himself.'[10]

This, of course, is a spectatorial ethic that depends on social privilege. Constantine, who is not a man for crowds – whether that be the 'exceedingly diversified' audience of the Königstäter or the human mass that tends to crush together in an unpleasant fashion in pursuit of self-improvement ('as if it were a question of their eternal salvation') at the more up-market venues – likes to sit by himself at the theatre.[11] At the Königstäter he takes a private box if he can; and if he can't, he informs us, boxes 5 and 6 on the left have a back corner seat for only one person that will do just as well. There one is on one's own and the theatre appears empty, even if – particularly once Beckmann has come on

stage – it does not *sound* empty. It is, he says, like being Jonah in the belly of the whale, the swell of laughter around him resounding 'like a movement of the monster's viscera.'[12] On previous occasions he has abandoned himself to this storm of laughter, lying back, he tells us, 'in my loge [a box at the theatre], cast aside like the clothing of a bather, flung beside the stream of laughter and merriment and jubilation which foamed past me incessantly.'[13] And he can afford this moment of self-abandon as it only takes an image to restore him – the sight of a young woman, he informs us, for whom he remains invisible, but whose own 'quiet smile of childlike wonder' is, from his vantage in his loge, sufficient to bring him back to himself, and happily so.[14]

Except, we might note, a smile is not necessarily *for* anyone at all; it is given but that does not mean it is in anyone's gift. On this occasion anyway it all goes horribly wrong for Constantine and it does so utterly and immediately. He cannot get his usual place. He is obliged to sit amongst other people who don't seem to know, he tells us, what to feel, whether they should be enjoying themselves or bored. And this bores him. He cannot see the young woman or anyone like her from where he is sitting. Beckmann isn't funny, or doesn't seem funny now, and after half an hour Constantine leaves. He comes back the next evening but things are just as bad. Worse, even. The only thing repeated is the impossibility of repetition. Meanwhile outside the theatre, in the city, everything conspires to irritate him. The furniture in his rented apartment irritates him terribly. The sun blazing through the window of his favourite coffee-house, the quality of the coffee – which may in fact be no better or worse than it was before – and the behaviour of the waiters in his favourite restaurant, all get under his skin. When he goes out into the streets the streets are dusty, 'and every attempt to press in among the people and wash off the dust with a human bath was discouraging in the highest degree.'[15] Pretty soon Constantine Constantius is fed up with repetition and returns to Copenhagen, taking his irritation home with him.

This, I suppose, is Constantine's pratfall. We might have seen it coming. I am not unsympathetic, however. There are, I am sure, only a few occasions when I have really wanted to go back to the theatre. By that I mean repeating the full experience of a particular theatrical event, if that were possible: to follow the same actions and images, to watch the same actors doing the same things, to see them generating the same recognitions and responses that I have enjoyed on a previous occasion. It is a peculiar business. The American philosopher Stanley Cavell had something to say about this in an essay he wrote some decades ago about the experience of returning as a reader or a spectator, not to the burlesque farce it has to be said, but to classic tragic dramas such as

Shakespeare's *King Lear*. What is at stake, Cavell suggests, is 'a parti-
cular sense of exposure' to what was there already from the first, but
which for one reason or another we were unable to see, or unwilling to
acknowledge.[16] For Cavell, this ignorance requires treatment, but it 'is
not to be cured by information (because it is not caused by a lack of
information).' The cure will have to do rather with care, above all a
certain care for the social, for society and our part in it: our political and
familial but also not so familial relations to other people whose worlds
we share and touch upon. This anyway is how Cavell saw it in the mid-
1960s when he was writing his essay: 'Our problem is that society can no
longer hear its own screams. Our problem, in getting back to beginnings,
will not be to find the thing we have always cared about, but to discover
whether we have it in us always to care about something.'[17] As an
example of the sort of thing he means, he reads *King Lear* as a play
about 'the avoidance of love' (a theme that is not so far from Kierke-
gaard's book), where refusals to recognize and acknowledge the singu-
larity of other people and their attachments to us is tied up with a fear
of recognizing or revealing one's own singular frailties. This avoidance
may prove, as it does in the play, catastrophic. So it goes for Lear with
regard to his youngest daughter Cordelia. 'From the beginning, and
through each moment until they are led to prison, he might have saved
her, had he done what every love requires, put himself aside long enough
to see through to her, and be seen through.'[18] On the basis of this read-
ing Cavell writes of the theatre itself that 'the medium is one which
keeps all significance continuously before our senses, so that when it
comes over us that we have missed it, this discovery will reveal our
ignorance to have been willful, complicitous, a refusal to see.'[19] What
this means, amongst other things, is that the pleasure we take in
returning to such situations – and for Cavell it is indeed a pleasure – is a
complex one. Or better, a demanding one, involving as it does the
demands of others, other things, other creatures, other people. Indeed, he
characterizes the experience of returning as one of '*having to remember*,'
as if there were something in the work that appeals to us, calls on us 'as
though it is not finished with us.'[20] Perhaps like the memories and
recordings and marks on the wall we discussed in the previous chapter.

This, as it happens – these spots, these indelible marks and stains – is
where Samuel Weber's more recent consideration of theatricality as
medium departs from. And, in the process, appears to depart – as in turn
and walk away – from the sort of diaphaneity or transparency we were
evoking on the earlier occasion. In the words of Weber's introduction to
his 2004 book *Theatricality as Medium*: 'Theatre marks the spot where
the spot reveals itself to be an ineradicable macula, a stigma or stain that

cannot be cleansed or otherwise rendered transparent, diaphanous.'[21] Weber has just been discussing one of the scenes in the history of philo- sophical literature that commentators and theorists of the theatre return to most often, Plato's allegory of the cave in his book *The Republic*. Weber remarks that there is much in the theatricality of Plato's tale that goes unacknowledged by the ancient philosopher, even as his con- demnation of mimesis, of acting and pretending tends to be extended to all aspects of the theatre. And extended also – this is Weber's particular concern – to the theatre's 'effectiveness,' its capacity to work through and to generate 'effects.' One of those effects, which taxed Plato greatly, is the sense of ungovernable departure as such – departures from 'self- identity' and 'self-presence' – which have a way of leaving something behind, something opaque, something that stays as Cavell would say 'before our senses,' something between an image and a sign. Call it a spot, a stigma, a stain, etc., but illuminated and noticeable. A yellow leather jacket, perhaps. A set of yellow markers around a patch of ground. An example of such a spot, Weber continues, is the stage itself, although immediately this is more than just an example. It is the parti- cular place where something happens and is seen to be happening, where something 'takes place.' And for Weber 'such happenings never take place once and for all but are ongoing.' They repeat, they return and (again) they depart, although they never quite go away. Weber: 'They take place, which means in a particular place, and yet simultaneously also *pass away* – not simply to disappear but to happen somewhere *else*.' Out of such repetitions, Weber argues, pointing us towards the apparent paradox of singularity generated out of repetition, 'emerges nothing more or less than the *singularity of the theatrical event*.' And it is this recurring, 'happening,' 'theatrical' singularity, he concludes, that 'haunts and taunts the Western dream of self-identity.' It does so as tragedy, and then it does so again, if it didn't already, as farce.

Farce, of course, is where we left things in Kierkegaard's text. And not just in the theatre, but also at the level of Constantine's plot. In short, the two men – although supposedly experts in such matters – fail to repeat. It is a farcical business all round. But then it was likely to be. Weber draws attention to the Danish and German word *Posse* used by Kierkegaard to signify the sort of burlesque farce that Constantius goes to see in Berlin, which derives from the French word *bosse* meaning a bump or a dent, like a dent in a car: whatever breaks or interrupts the shape or contour of a form or a figure. For sure, Weber remarks, *Posse* 'involves repetition, but not necessarily repetition of the same, for "the same farce can produce very different impressions."'[22] Audiences, not least, are unpredictable: 'the "mood" or situation of the audience is

never entirely predictable, much less a "necessary" function of the universal.' There is, though, it would appear, possibility here. As Weber puts it, even as Constantine fails in Berlin to 'take back,' through a literal repetition, what he believes he has lost, 'another kind of repetition, of *Gjentagelsen*, will have begun to emerge.' That is to say, 'repetition as the medium of *difference* rather than as the means of *staying the same*. And that medium will reveal itself as irreducibly *theatrical*.'[23] The theatre that Constantine finds himself in – although he thought he was returning to a familiar place – is a theatre 'in which there are no proper places and where nothing stays put for long.'[24] Not that it is not a seductive theatre, repeating its seductions everywhere, and not only in the theatre itself but on the street outside the theatre, in the view from one's apartment window. This, Weber remarks, citing Constantine's own phrases, is 'the magic of theatre,' the 'passion of possibility.' One cannot help but desire to be part of it, 'to descend into the street, onto the stage,' to walk about, to be a shadow on the scene, at least be something other than a spectator watching from a fixed position. At the same time, as Weber points out, it is a desire that knows and accepts 'its own impossibility. It does not go out into the moonlit street or descend onto the stage, but merely watches its "rejuvenated self" doing this in imagination.' 'But this means,' he continues, 'that it returns to the role of spectator, precisely imagining itself as an active participant or protagonist.'[25] Add to that the observation that not the least farcical aspect of the affair is that Constantine and the young man fail also to leave the confines of the book in which their failures are narrated – that is, they fail to get beyond the confines of a certain theatrical philosophizing. They fail – in Kierkegaard's terms – to make 'a movement.' Not that a mere voluntary movement – standing up and stepping forward – would be enough. It would also have to involve belief in the movement itself and what may come about from it, irrespective of belief, 'by virtue of the absurd.' And so they never get further than the 'borders of the marvellous,' the edge of realization – in love *and* at the theatre.[26]

While they are loitering at the border, however, the young woman – or the 'young girl' as Constantine has been referring to her – the one on whose behalf their earlier machinations were constructed, does make a repetition. She makes the only true repetition in the book. She gets married. It happens just towards the end. The young man, who has since decamped to Stockholm, reads about it in the newspaper and tells Constantine the news in one of a series of letters without return address that make up the final section of the book. These letters are a performance in themselves, not just verbally, but in the way they evoke a theatre – all of a sudden a brand new theatre of darkened auditoria,[27] where an actor

appears to a spectator sitting before them in the dark, speaking in the heightened critical-analytical prose of psychological intimacy. It is as if, in 1843, after all that has gone before, the modern bourgeois spectator is being born, and its name – its ridiculous name – is Constantine Constantius:

> [...] you comprehend the finest nuance better than one does oneself. But the next instant I am in despair at the superiority you display in knowing everything and being unacquainted with nothing. [...] You possess a demoniac power which is capable of tempting a man to be willing to venture everything, to want to have strength which ordinarily he does not possess, which ordinarily he does not desire to have, but only so long as you are looking at him [...] when it comes to acting I would not do it at any price in your presence. By one look you would confound everything. Face to face with you I have not the courage to admit my weakness [...]. At this instant I dare not see you, and yet I cannot do without you.[28]

I am reminded of Cavell's remarks from the essay cited earlier, with respect to our relation as spectators to fictional characters on the theatrical stage, that we are not in their presence while they are in ours. Clearly, the reader and the spectator can still be *addressed*, but some sort of distancing, some sort of disequilibrium, is starting to settle in. For Cavell, the ubiquitous darkened indoor auditoria of our modern theatres dramatize this disequilibrium; although 'a theatre whose house lights were left on [...] might dramatize the equally significant fact that we are also inaudible to them, and immovable.'[29] Cavell goes on to remark: 'The plain fact, the only plain fact, is that we do not *go up* to them, even that we cannot.' Not least, perhaps, because of the extent to which it will have been something of ourselves up there – ourselves but strangely different, repeated somehow.

And so it is that the young man speaks from his epistolary stage of what he now understands repetition to be. He speaks of the Old Testament story of Job, the man of faith – the wealthy man of faith – who is put to the test and made to lose everything: his sons, his wealth, even the integrity of his own flesh (Job develops boils and has to scrape his own skin off with shards of pottery). But Job keeps faith and is rewarded with a repetition. Everything – except his sons – is returned to him, and double. The young man anticipates something similar happening for him. He speaks of a thunderstorm. He writes 'I am expecting a thunderstorm ... and repetition.' 'What is this thunderstorm to accomplish? It is to make me capable of being a husband.'[30] And then, a couple of

months later, 'She is married.' He has read so in the newspaper, and while there will be further words and a few more pages of effusions ('The chalice of inebriation is again held out to me, already I enhale its fragrance'[31]), there is no confounding the possibility – it has to remain a possibility – that her marriage has nothing whatsoever to do with the two men whose fortunes and thoughts we have been following throughout the book. At this point Kierkegaard's book breaks off.

The life of an actress, and a thunderstorm

For philosopher Gillian Rose, the young woman's off-stage repetition becomes something of a challenge – and also an opportunity – for the reader of Kierkegaard's book, a book about repetition in which the only true repetition that happens (the young woman's marriage), happens as it were outside the main narrative. But then, the only narratives that *Repetition* is capable of delivering on have to do with the evolving self-consciousness of those such as Constantine and the young man who are unable to repeat and who, it will turn out, only know repetition 'theatrically and philosophically.'[32] For Rose it is as if the reader, herself beloved and abandoned, were finally being abandoned by the book. Unless we say she releases herself from the book, as if this were the movement the text had been rehearsing all along, how to release the reader whose 'philosophical eros has been aroused by the narrative and its accompanying reflections.'[33] Except the book doesn't really want to let her go, it wants her at least to think of it sometimes, just as the two men, 'mournfully,' want to be remembered by the young woman, as Rose says 'to tarnish her repetition with retrospection.' It is the reader's own passion that is at stake, her own capacity to engage in what Rose will come to call 'love's work,'[34] and which here she relates to a question of maturation, in particular maturation in 'the life of an actress.'[35] It is not, though, simply a matter of becoming wiser and older but of being able to return, as one reaches maturity, to the potential of 'an original condition.'[36] The idea for instance (Rose takes it from Kierkegaard) that 'in order to *portray* [Shakespeare's] Juliet it is essential that an actress possess a distance in age from Juliet.' This, however, is something that 'the gallery,' as Kierkegaard himself puts it (presumably those theatre audiences less sophisticated in these matters than the philosopher – there is still something of Constantius *in* Kierkegaard), 'can naturally never get into its head.'[37] It has to do, then, with a turn, a movement, from being beloved by others to loving for oneself. In Rose's language, a repetition that involves a passage 'from knowing oneself loved, "loveable," to finding oneself graced with a plenitude of being-able-to-love, and thus to risk

loving again and again, regardless of any particular outcome – disastrous or successful.'[38]

That is not easy, for an actress or anyone else. In Rose's phraseology it means returning perpetually to the 'anxiety of beginning.' It means living in what she calls the 'broken middle.' It means living and loving and 'acting' in the world (which means acting 'politically' too) in situations where the authoritative starting places crumble with indirection, where the established authorities are readily deflated,[39] or are already being led from the city by their daughters. These are real places too, not just fictional, they are the cities and situations in which we live – the sort of city in which Molloy and Lawlor's Helen lives for sure – where love is not simply acknowledged and let be, taken again and reciprocated, but 'forced and fantasized into the state' (we will keep coming back to echoes of *Lear*) and registered as violence; and where law and ethics are, in Rose's term, 'dirempt': divided, separated by force, torn apart. There is, for Rose, no 'new spectatorship' that will mend that diremption, at least not without acknowledging the oppositions of 'freedom and unfreedom' which 'initiate process and pain,' and deciding for and suffering 'any risk of coming to know.'[40]

We need to draw focus. Helen, whom we left earlier, is neither lover nor beloved in any strong sense perhaps, but there is something of love's worker about her even so. However, she does not shout about it. Unlike the young male hero of Kierkegaard's book, there is very little about her of the histrionic claimant, and very little about her of entitlement. But there may be a thunderstorm in the vicinity for Helen: some sort of repetition – or decisive expression. Thunderstorms have been in the vicinity all along. We have had Job's storm, or at least we have had talk of it. We have also, from our evoking of Cavell's essay on another tale of lost daughters, *King Lear*, had that play's theatrical tempest in mind, or at the edge of a mind slipping away from itself, called back into intensity – the mind and the tempest – for the duration of an actor's set piece speech every time the play is performed, doubtless along with some choice scenic effects. There we will find the king himself shouting against the natural elements ('Blow, winds, and crack your cheeks! Rage! Blow!') at the climactic mid-point of a drama that began with his own failed attempt, as king, to legislate for the future of the state – and for his own future care – with a decisive expression, of sovereignty, of love. Although in fact there were to be multiple decisive expressions of love and all for the same sovereign, repeated down the line, one from each daughter, each more loving than the other supposedly, but then stumbling on the exception, Cordelia. As in the legends and fairy tales, from Antigone in Greek myth through Joseph and his Brothers in the

Bible to Beauty and the Beast and Cinderella, it is so often the younger child who takes this role, here the last and lost daughter, the one who needs to work it all out on her own, the one who loves indeed and stays silent. In Shakespeare's play the father's failure results in a proliferation of plotting, much explicit violence and the loss of just about everything: life, sight, security and for the king an abdication of kingdom and of care and – by the time we meet him in the thunderstorm – any trappings of his former dignity other than what he bears about himself, his face, voice, demeanour, and a habit for giving orders – even to the winds.

In Desperate Optimists' film things are altogether less windy. Decisions are dealt with more delicately, and more securely. And there is no thunderstorm. I thought, though, that there was going to be one. There is, I was suggesting earlier, a peculiar quality to the light in *Helen*, a certain phosphorescence to things, a sort of pretending light, as if things were weighted with illumination, as if light were something they carried with them, from one place to another, like the actor Beckmann in the Berlin burlesque who brings everything on with him (and to gales of laughter). And I was thinking when I saw this film at the cinema four or five years ago that it reminds me of that weather that you get sometimes when a storm is imminent, or has recently passed by. The sort of calm that occurs – and which we recognize, we intuit, from experience – in the vicinity of heavy weather, just out of the picture. The way you feel you know sometimes, when you step out of doors, that there is a change in the air.

Now, though, having returned to watch the film again on video recently, I am not so sure. Maybe I made it up. Maybe like Constantius as he heads to Berlin for what he believes will be a *familiar* experience, I was imagining what I saw and what I felt. Maybe I don't know what I know. This, for the record, is how the film narrative concludes, the last few scenes. Not that the drama isn't still, at some level, meteorological. Perhaps it has to do with a different kind of acting: the kind of acting that happens after the ages of plotting and sovereign decision. The kind of acting that belongs indeed to a time of 'interpretation,' and which is performed – to cite Weber again, although from a different context – on a 'stage […] around and on which anything can happen, even the appeal for a miracle.'[41] Each scene in this final sequence is separated by a second or so of black. Helen phones her care worker, she has decided that she will now look at the files of her life. There is a scene at night in a car with Joy's boyfriend Danny. Helen shows him a photograph – we never see the photo, but we see Helen receive it from the care worker later – the only photo in existence of herself with her parents, her father

holding her as a baby, the parents and the child in a beautiful place, amongst trees, in a park. Danny remarks how young they all look, all three of them, and how loving the parents appear. How it looks as if that was what they wanted someone seeing the photo to understand. Helen asks Danny to say he loves her. 'I've never been told that before, and I'd like to know what it feels like.' He tells her he does. There is a rehearsal for a school play, *Brigadoon*. The teenagers are rehearsing the scene where the 100 years sleepers will awake at the start of their day in the present world. The teacher director speaks to the young people about love before they lie down on the stage. 'Through love,' he tells them, 'we enter into the unknown, and become someone else.' Helen sits between Joy's parents on a sofa. The three of them are watching TV. The yellow leather jacket is hanging in the hall. Helen, wearing the jacket, walks in daylight in the park where Joy disappeared. In a voice-over she speaks to the other girl. She imagines her return. 'You'll come back, when you're good and ready.' Helen lies down on the leaves, like one of the *Brigadoon* sleepers. She sits at a table with her care worker, a mature woman with an Irish accent, who has the file in front of her. 'It's important,' the older woman tells Helen, 'that you feel in control of this process.' Helen is told what little there is to be told about her parents. She is given the photo of the three of them in the park. Helen listens and looks. 'I'd like to stop now,' she says. But she is still there, we can take it as a pause not a stop. There needs to be time for thinking and whatever else. The final shot is a view, someone's view, from a house onto a patio at night-time. The camera pans up into darkness. This is the end of the film. The beginning, though, was in brightness. And as for the thunderstorm that does not happen? Maybe what struck me on that first watching, to which I need to return now in order to see it, is simply that Helen is small in the scheme of things, not in the world of the film, but in the world that the film burrows into. She is exceptional and unexceptional at once. She is also capable of deciding about things, she takes back that capability as it is offered to her. Others are indeed in storms – Joy's parents; years ago Helen's own unhappy parents too we find out – and she is not immune, but maybe for the moment she is small enough to make her way in between. That is how she appears in the film's first long shot, or that is how the girl in the yellow leather jacket appears whom we notice in the background in the city park, hugging and saying farewell to a group of school friends, walking on across the park amongst younger children, her bag over her shoulder, gradually coming to fill the screen as the camera follows her from behind, as she heads up a hill towards the trees. It was obvious from the start. It is, yes, a bright Spring day.

Notes

1 *Helen* (dir. Christine Molloy and Joe Lawlor, Ireland and UK, 2009). Theatrical trailer https://www.youtube.com/watch?v=cbCmhOdLWU4 (last accessed 17 August 2014).

2 The series has been collected under the title CIVIC LIFE. See http://www.des perateoptimists.com/civiclife/index.html (last accessed 17 August 2014).

3 For an important counter-argument against the imperative towards movement, in dance performance particularly but also in modernist thought, see André Lepecki, *Exhausting Dance: Performance and the Politics of Movement* (London and New York: Routledge, 2006): 1–18. Needless to say, Kierkegaard himself does not take the virtues of motion for granted. 'It is within the individual [that repetition] must be found, and hence the young man [the other hero of the tale, who we shall encounter later] [...] keeps perfectly still.' Kierkegaard, *Papirer*, vol. IV, cited Lowrie, in Søren Kierkegaard, *Repetition: An Essay in Experimental Philosophy*, trans. J. Lowrie (London: Oxford University Press, 1942): xx.

4 Samuel Weber, 'Kierkegaard's *Posse*,' in *Theatricality as Medium* (New York: Fordham University Press, 2004): 200–228; 206–7.

5 Kierkegaard, *Repetition*, 4.

6 Weber, 'Kierkegaard's *Posse*,' 218.

7 Kierkegaard, *Repetition*, 58–9.

8 Ibid., 48–9.

9 Ibid., 50–1.

10 Ibid., 52–3.

11 Ibid., 61.

12 Ibid., 62.

13 Ibid., 63–4.

14 Ibid., 65.

15 Ibid., 70–1.

16 Stanley Cavell, 'The Avoidance of Love: A Reading of *King Lear*,' in Stanley Cavell, *Must We Mean What We Say? A Book of Essays* (Cambridge: Cambridge University Press, 2002), p. 314. I was introduced to Cavell's essay by Simon Bayly. See Bayly's *A Pathognomy of Performance* (London: Palgrave Macmillan, 2011): 30–31.

17 Ibid., 350.

18 Ibid., 301.

19 Ibid., 313.

20 Ibid., 314.

21 Weber, *Theatricality as Medium*, 7.

22 Weber, 'Kierkegaard's *Posse*,' 219. For another reading of the farcicality – and theatricality – of Kierkegaard's text, and not just in the central Berlin episode, see Stuart Dalton, 'Kierkegaard's *Repetition* as a Comedy in Two Acts', *Janus Head* 4.2 (2001). http://www.janushead.org/4–2/dalton.cfm (last accessed 24 October 2014).

23 Weber, 'Kierkegaard's *Posse*,' 211. For an extended consideration of this theme in Kierkegaard and others, see Gilles Deleuze, *Difference and Repetition*, trans. Paul Patton (London: Continuum, 2004): 6–12.

24 Weber, 'Kierkegaard's *Posse*,' 215.

25 Ibid., 216–17.

26 Kierkegaard, *Repetition*, 91.

27 Although there had been adjustable gas-lighting in many European theatres since the second decade of the nineteenth century, it would be another thirty years yet until Henry Irving introduced darkened auditoria *during the performance* at the Lyceum in London in the 1870s, even if the idea of darkened auditoria had been in circulation for three centuries. Dennis Kennedy, ed., *The Oxford Encyclopedia of Theatre and Performance* (Oxford: Oxford University Press, 2003): 742–3. The Königstädter Theatre on Berlin's Alexanderplatz was built in 1824 'financed on the basis of a royal licence allowing performances the royal troupe declined to produce.' William Grange, *Historical Dictionary of German Theatre* (Lanham, Maryland, Toronto, Oxford: Scarecrow Press, 2006): 25–6. The theatre was closed down in 1851 and used as a wool warehouse and tenement house.

28 Kierkegaard, *Repetition*, 97–8.

29 Cavell, *Must We Mean What We Say?*, 332.

30 Kierkegaard, *Repetition*, 135.

31 Ibid., 146.

32 Gillian Rose, *The Broken Middle: Out of our Ancient Society* (Oxford: Blackwell, 1992): 19–24.

33 Ibid., 19.

34 The theme is developed in Rose's later autobiographical work *Love's Work* (London: Vintage, 1997).

35 See Søren Kierkegaard, *The Crisis and a Crisis in the Life of an Actress*, in *Kierkegaard's Writings, XVII: Christian Discourses: The Crisis and a Crisis in the Life of an Actress*, ed. and trans. Howard V. Hong and Edna H. Hong (Princeton: Princeton University Press, 2009).

36 Rose, *The Broken Middle*, 21.

37 The words are Kierkegaard's, cited by Rose, *The Broken Middle*, 20.

38 Ibid., 23.

39 See Vincent Lloyd, 'Gillian Rose: Making Kierkegaard Difficult Again,' in Jon Stewart, ed., *Kierkegaard's Influence on Philosophy*, Tome 3 (Farnham: Ashgate, 2012): 203–18. For a penultimate draft of Lloyd's essay see http://vwlloyd.mysite.syr.edu/rose-kierkegaard.pdf (last accessed 17 August 2014).

40 Rose, *The Broken Middle*, xiii.

41 Weber, *Benjamin's -abilities* (Harvard: Harvard University Press, 2010): 194.

3 Darkness and doubles (on theatrical recognition)

Kinkaleri, *Nerone* (2006)

After the cinema, the rigours of live action again. One show of ninety minutes. Four young performers this time. A show very much of its time, addressing the times. We shall speak of nothing else, entertaining the images, pulling on a thread or two to see where they lead. But first, an invocation to the theatre, and the maybe unexpected evocation of an ancient name. The Latin biographer Suetonius gives a detailed account of the sort of pumped-up culture of theatre and public spectacle that prevailed during the reign of the Roman emperor Nero. We read, for instance, of a staged naval engagement in an artificial lake of sea-water with sea-monsters swimming in it, and hear of a ballet of *Daedalus and Icarus* where the actor playing Icarus, dying for real in his failed flight, fell beside the emperor's couch spattering the imperial presence with his blood. At first, Suetonius tells us, Nero would watch the shows through a small window in the closed imperial box. Later, however, he would open the box and preside over the performances, taking part in tragedies and singing contests himself, performing in masks modeled on his own face, holding his listeners literally captive as he sang while other members of the audience 'being so bored with listening and applauding [...] furtively dropped down from the wall at the rear, since the gates were kept barred, or shammed dead and were carried away for burial.'[1] The impression that Suetonius bequeaths us is of a stage-struck emperor who would only appear at public engagements with a voice-trainer standing by, who joined in when fights took place among the pantomime actors by throwing things onto the heads of the crowd, and who in his military preparations 'was mainly concerned with finding enough wagons to carry his stage equipment.'[2] It is an impression of theatrical obsession and also political irresponsibility that becomes inseparable, as the story proceeds, from an image of murderous criminality which leads, as the state falls into ruin, to Nero meeting his end as a fugitive, hiding out in a house near Rome, stabbing himself in the throat as his pursuers close in

and dying 'with eyes glazed and bulging from their sockets, a sight which horrified everybody present.'[3] At his death, we are told, citizens ran through the streets in celebration, although there were also those who would continue to lay spring and summer flowers on his grave for some years after, and Suetonius concludes the biography by recording that 'twenty years later, when I was a young man, a mysterious individual came forward claiming to be Nero; and so magical was the sound of his name in the Parthians' ears that they supported him to the best of their ability, and only handed him over with great reluctance.'[4]

In 2006 the Italian performance collective Kinkaleri made their seventeenth theatrical work, *Nerone*.[5] The title is the Italian version of Nero's name. The show takes place in a black box studio theatre. It is a movement piece for four performers – two young men and two young women – involving, amongst other things, images and traces of action from basketball and volleyball: basketball and young men in the first act, volleyball and young women in the second. The two acts – or 'halves' – are of 45 minutes each with an interval between: the length of a football match, and I am taking that as deliberate on the company's part. None of the performers belong to the six-member Kinkaleri collective and they are, as I say, noticeably young, in their early or mid-twenties. Younger than the Kinkaleri members themselves, who began their work in the mid-1990s. Delegated performers, then, whose actions evoke, dimly, circus games, animal acts, gladiatorial contests and so on, dug out I imagine from memories of school history lessons or sword and sandal dramas at the movies or on TV. But whose memories are these? It is like the ones who are responsible for the allusion – the authors, the devisers, the company themselves – had withdrawn themselves from what we might call the black hole of representation.[6] Or else fallen straight in it. Maybe they are still falling. Because *Nerone*, as we shall see, is a rather black hole indeed.

Not that the company don't have something to say to us, directly. An epigraph to *Nerone*, printed at the head of an extended programme note beneath a photograph of two feral-looking dogs circling each other on a scrap of yard or wasteland, sets the tone. The epigraph is a sentence by the German film-maker Rainer Werner Fassbinder, from one of two short texts written in the late 1970s in which Fassbinder reflects on a 'dream of death' he had one night when he was twenty-six years old some half a dozen years before, while he was in Bremen to direct a play. Fassbinder's sentence is a piece of threshold existentialism, something recalled of the intuitive philosophy of youth. 'In the life of every human being there comes the terrible, wonderful moment that forces its way into the consciousness of some like a lightning bolt and into the

subconscious of others like a sacred pain, the moment when you recognize the finitude of your own existence.'[7] As Fassbinder goes on to say, wiser to things now, the experience is an instance of the 'strange, unnecessary, but apparently useful paralysis that comes over us simultaneously with the longing for a utopia of our own.'[8] An experience which maybe can be put to good purpose. When he writes these texts, Fassbinder is about to go on and direct his first English-language film, *Despair*, an adaptation by Tom Stoppard of Nabokov's 1930s-set early novel of middle-aged angst, with Dirk Bogarde in the lead. An opening into creative capability, then – or despair. For Fassbinder, for now, an opening into enjoyment, released by the negative capability of a recognition. As he says: 'The enjoyment made possible by this recognition of the ultimate meaninglessness and actual fortuitousness of every existence.'

As for how it stands with the Italian artists, their collective position is signaled perhaps by those circling dogs, images of entry-level animality at the threshold of expressive capability, which human self-consciousness still has to measure up to, let alone get beyond. The programme note that follows the Fassbinder epigraph describes the show we will have seen, in a tone of seasoned knowingness, of the sports fan, the political spectator, the well-worn theatre and performance adept: 'Two parts, one show. Perhaps an hour and a half of expectation in your seat in the hard silence, inside and outside, from the one threshold to the other. In a state of half-immersion in the politico-sentimental inadequacy of the age, of this age like all those that have passed.' Which is where, I imagine, the emperor-actor Nero comes in, in the form at once of an overwhelming neediness, an indiscriminate need to be recognized by others – to be recognized as representing oneself: as intractable, as monumentally banal and as catastrophically tender as that. What follows is a litany of contemporary needs and desires, starting with the generalized terms of a merely personal demand (offer or demand, it may amount to the same thing), and then taking in both the expressivity of the theatre (that is to say this particular theatre that is Kinkaleri's *Nerone*) and finally the as-things-stand-now predicament of the collective themselves, a decade into a career that had brought them to this point. This is how the litany goes:

> I want to tell you: all my solitude, all my courage, all my anxiety, all my overdrawn accounts, all my happiness, all my beauty, all my discontent, all my love, all my burden, all my nudity, all my hope, all my influence, all my misery, all my death, all my coverings, all my layers, all about the basketball, all about the neons, all about my light, all about the women's toilets, all about the men's toilets, all about the volleyball, all about my dogs, all about my silence, all

about my threshold. A place of passage. A watershed in our lives contained in a single wrapping. Crumpled surfaces that cover volumes. To put things aside. The need to be objective now. To speak of death and the senseless sense of solitudes. Of biological time and the time of images. Everything is passing: you realize that?

To which the answer is, probably, yes, no doubt one does realize that. After all there is no better place for such realizations than here in the theatre, or the stadium, or the arena, or whatever cave of shadows we find ourselves held in for an hour or so, where everything is passing indeed – if not the elements of the spectacle (which are likely as not to multiply or to come round again as themselves soon enough), then our ephemeral selves, like Nero's hapless audience fading in the face of everything *else* that the performance demands of them: to be, to do, to acknowledge. As the programme note goes on to inform us, 'the title: *Nerone* is only an invocation to the theatre, to the play of multiple pos- sibilities between children, and to the unexpected evocation of the name of an Emperor who played the lyre and performed as an actor.'

To which we only want to add that the word Nerone is not only the name of an emperor, it also evokes a colour, an anti-colour, a darkness, the word 'nero' being the Italian word for 'black.' Indeed, everything that has to do with the look of the show – costumes, the décor of the performance space, any objects and props – will be monochrome, dark, black. Or almost so: there is still the flesh of the performers. As Rodolfo Sacchettini writes, in an astute essay on the limits of the gaze in Kinka- leri's work and in *Nerone* in particular, 'although [black] lends itself immediately to showing the physical connotation of a narrow and no longer perceptible emptiness, there are still figures there, leaking as faint luminescence. The timidity of the skin evokes traces of the human, just where the scenery seems to have come to terms with a profound and irremediable change.'[9] We will have to consider further what the nature of that change might be, but it brings things some way from the emperor of the gold-trimmed robe (as Suetonius describes Nero on his funeral pyre), of the golden masks and of the golden house. Some way also, we might add, from the sort of theatricality we are likely to project upon the Roman scene in comparison to this scene here: of the grossly personal against the impersonal and anonymous (the *Nerone* characters, or two of them at least, do have names, as we shall see, although hardly names that 'belong' to them), or the spectacle of state and empire against an indoor performance for a few hundred people on the modern arts festival circuit. Not to mention an asymmetry between consequential violence, power and desire such as an emperor can bring about, on himself and

others, and the representation of such things in the playful movements and interactions of delegated actors on the contemporary stage.

Then again, it may well be the case that in the sort of murky darkness that envelops, and at one point towards the end of Act 1 literally 'enwraps' Kinkaleri's stage, distances and distinctions are moot. In this indistinct night which we can imagine falling on every spectacle and performance, and on every life story (particularly given the play of appearing, disappearing and reappearing that characterizes the theatre situation), all sorts of mistaking and false acknowledgement and mis-recognition are possible, all sorts of mis-received transmissions, all sorts of 'cruel disappointments' and 'self-deception.'[10] None of which, of course, will silence the transmissions, or prevent the images coming. Which they do, at once, and not just once but twice, a tumble of multi-ples, reality and image, theatre and its double, memory and perception, each beside its other and then, for a moment, beside its other no longer. Alone again in the dark. The last sentence of the programme note stands as a reminder: 'Two writings, monologues, by Rainer Werner Fassbinder on despair, courage and utopia, are the response, most sweet and terri-ble, found for the desire to dialogue with a moment of existence that we confront: alone.' Monologue, dialogue, one into two into one, and counting. Biological time and a memory, still unfaded, of growing up in the time of images. Let's kick off with that.

First half

It is the start of the show. The only illumination is from a row of neon lights that glow dimly directly above the stage. A young man dressed in basketball kit – black vest, black shorts – comes on from the back, gets down on all fours, sniffs the floor, manoeuvres himself towards the front, faces the audience and begins barking like a dog. It may be a greeting of sorts. The opening of a performance would be a good moment for such a thing to take place, although the gesture doesn't really have that sort of complicity to it. It's more aggressive than that. At best the bark is directed 'at' us rather than 'to' us, and if it involves an acknowledgement of our being there at that moment, it has, if anything, to do with our being there too much. The dog barks at those who will not go away, who will not let the creature disengage from their presence, their attention. Or else it barks after the one who has already gone away: abandonment after all is an excitation that one can be present to, indeed bound to, as much as anything else. Go away, it says, come back, it says, towards a hall of shadows that are unlikely to do either, although they remain alive to what is going on. Alive, for instance, to

the familiarity of an ordinary dog, barking at the limit of its liberty, even if there is no actual dog to be seen or heard. The actor bears the image on his shoulders, about his face, in his voice; and the image, being weightless, is near impossible to shake off. The image attaches itself to him, although it also – like any idea that strikes us, like any mutt we might come across – has a life of its own.[11] It gets amongst us, it interferes, it runs ahead; and, when it will, it wanders off.

The young man retraces his earlier movements, stepping backwards quickly around the stage like a figure on a rewinding video. As if to start again. As if to orientate himself in his environment. It is an environment we are likely to have encountered before, if we have any basic familiarity with contemporary performance practice. The stage is bare and black: black linoleum flooring, black walls, black drapes against the back: the basic 'black box' configuration of latter-day studio or laboratory theatre, low-cost, unadorned, flexible, the sort of space where anything that happens can mutate into something else. Maybe I made too much of the barking dog a moment ago. I don't know what I was thinking. I don't know what anyone else was thinking either. Even when the young man was scrabbling about on his hands and knees, sniffing the floor, dog-like enough for a certain idea to take hold, there were other possibilities that might have been developed, by him, by us. He could, for example, given the pose and the sports gear he is wearing, have been taken for an athlete at the start of a race. Perhaps the dog came together by chance, bounding in from outside to interrupt that other development before it took hold. I don't know. There is anyway, in what the performer is doing, an air of actions being tried on and then shrugged off, testing the capacity to do something with the particular, momentary performance of something being done. Something gets transmitted, but then the actor is somewhere else already, in and amongst it all. He reaches out and a towel is thrown to him from backstage. He mops off the sweat. He lays the towel down on the floor. It has a black-and-white picture printed on it, which many of us probably find familiar (it is a famous image), of the actor Marilyn Monroe caught out by a gust of air and holding down the hem of her skirt. He lies on the towel like a sunbather, on his back, under the neon lights. He remains there until the end of the first act. His work is done. It is someone else's turn now.

A second young man comes on, wearing identical black athletic gear, with a basketball under his arm. A team-mate perhaps, although in this abstracted situation he might be taken for a double of the first one: a second self, one of the multiples. The only distinction between their get-up is the names printed on the backs of their vests, PARKER and then BARKER, the minimal difference between one signifier and another

Figure 3.1 Kinkaleri, *Nerone*, 2006. (Photo: Kinkaleri)

marking the difference between myself and the one I resemble, even in my own eyes, at a distance, in the dark. The new arrival performs a series of movements and gestures: acrobatic poses, contortions, stretches. He does a bit of this and he does a bit of that. He rolls the other one off the Marilyn bath-towel. He pulls back the edge of the stage flooring with his teeth, like a dog, or like somebody's idea of a dog. At times he goes slowly, free to do as he likes, letting the passing time be absorbed into the texture of the scene. At other moments it's like the exigency of the scene determines how he goes. During one episode he jerks around the stage like the first performer did, this time in fast-forward, shadow-boxing, lifting weights, unpacking a chest of props, making ready for something that is about to take place. He sets down across the front of the stage a large black bundle of what looks like paper or cloth. He lies down on his back some short distance away from his double, his other, his companion, who has himself been lying 'doggo,' 'playing dead' all this time, and engages him in a brief interrogation, a sort of life-consumer survey, cold-calling over whatever inconceivable distance, inches away from the receiver's ear. The chest of the 'dead' one rises and falls gently as they speak with each other, their slow exchange allowing just enough time for spectators to imagine their own responses to the prompts, and to note the undertow of aggression in the responses the other gives. There is an implication of violence, of struggle, of fight, although for now it gets no further than the talking. 'What is the nastiest thing you have done?' Pause. 'Spitting in the coffee without the customer knowing.' 'To run over or to be run over?' Pause. 'To run over.' 'Now tell me a form

of protest.' Pause. 'Armed struggle.' 'Text message or telephone call?' Pause. 'Text message!' 'To burn a city or be swallowed by a city?' Pause. 'To burn it.'[12] And so it continues. The questioner stands again and unfolds the bundle of material. It is a single sheet of tissue paper, as black as anything else here and, when it is fully extended, of the same dimensions as the stage. He lays it out. It settles over everything – his supine partner included – like a crumpled meniscus, like a country landscape, like the surface of a crinkled, moonlit sea picking up glints from the overhead neons. He crawls under the covering himself to smoke a cigarette. The glow of the cigarette tip from beneath the black paper shines out dimly in the darkness, like a distant light in a window, like a fire starting on a far horizon, or whatever we want to make of it. I am sure, as I watch, that the person we are watching knows what he is doing, knows where he is, and knows what sort of impression he is producing. When his cigarette is finished the lights fade and the actor exits the stage. Our first 45 minutes are over. There is an interval.

Half-time

The theatre is stifling. We go outside where it is cooler, to take the air, to talk, to think about things. I was seeing *Nerone* on an evening with friends during the summer of 2006 at the Santarcangelo Theatre Festival in northern Italy. It was the same summer that Italy won the football world cup. We watched the final on a public screen some days after the performance, with members of the company and a fair number of inhabitants of the town, a bunch of those inhabitants performing themselves, the *tifosi veraci*, on a mock-up terrace four or five steps high, a few yards wide, with scarves, rattles, sirens and flares, the lot. We were ready for all that. Our attention had been shaping itself over those weeks to two 45 minute sections and a 15 minute break. *Nerone* fitted right in. I had also been following the company's work for some years, and knew for instance that this was the first of Kinkaleri's full-length theatre works not to feature members of the six-person collective as performers. It was also one of the last works made by the company before the departure of two founder members, Cristina Rizzo and Luca Camilletti, and later Matteo Bambi, to pursue other projects. By this time the group (the other members are Massimo Conti, Gina Monaco and Marco Mazzoni) had been together for ten years, making theatre (including the trilogy *My love for you will never die*, <OTTO>, and *I Cenci/Spettacolo*) as well as dance performances, print publications, video art and installations, operating from their base in Prato near Florence in Tuscany, showing their work in Italy and abroad, mainly in Europe.

It had been at the Santarcangelo Festival some three years before when I had my first encounter with the company's work, seeing two pieces in the summer of 2003. One was an early installation of the video project *West* (2001–2008), playing on a TV screen above the bar in a daytime café, the sound muted, like sports or like news going on in the background, happening out there somewhere in the world. Two years earlier – or so I remember now, as I record these experiences – I had seen reports on the 9/11 attacks on Manhattan in the same sort of context, on an equally imperturbable small café-bar TV screen in London. *West* works like a collection of video postcards, arranged in episodes from the major cities of the Western – or we might say westernized – world, capitals of an epoch of nations still standing in a world of globalized capitalism: Paris, Rome, Amsterdam, Athens, Beijing, Tokyo, New York, etc. Each episode consisted of single, still-camera shots showing an individual – or occasionally a small group of individuals, passersby, people persuaded in the street to stand in as themselves – framed in full-length, standing in the sort of place where people take photos of themselves and of each other, staring straight into the camera and then, after a while, falling to the ground as if dead. A playfully performed mortality happening over and over again, while the 'real world' of trams and barges, small dogs, clouds and pigeons and other passersby seemingly carry on regardless.[13] That summer I was watching people, over my cappuccino, falling out of the space of attention into some more indifferent relation to the image one after another. I was curious.

The other work I had seen that week in 2003 was a bite-sized theatre piece, a fifteen-minute 'study' in preparation for the full-length *I Cenci/Spettacolo*, which would premiere at the Kaaitheatre in Brussels a year later.[14] The title of the project was an allusion to the modernist theatre iconoclast Antonin Artaud who staged Shelley's Romantic tragedy *The Cenci* in 1935, and whose theoretical writings in the same decade set out an agenda of fundamental challenges to the expectations, the satisfactions, indeed the very means and function of theatrical representation as such. Artaud, like Nero, is a name – a name and an image – to conjure with, and many still do. As with Nero, though, some time has passed. It is worth reminding ourselves what the name and image have stood for. Artaud it was, then, in the twentieth-century interbellum, who imagined theatrical communication functioning virulently and indiscriminately, with an affective violence akin to infection by the plague. It was Artaud who coined the phrase 'no more masterpieces,' deploring the dominance of text over other elements of the theatre such as physicality and sound and scenography, and who intuited in the performances of the Balinese dances at the 1931 Colonial Exhibition in Paris the possibility of a

rigorously coded faciality and gesture that might touch the spectators' consciousness directly. Artaud, in his own words, sought to bring into being a 'spectacle' in which 'violent physical images pulverize, mesmerize the audience's sensibilities, caught in the drama as if in a vortex of higher forces.'[15] Certain expectations, then, might follow on such a title as Kinkaleri gave to their Artaud project: if not exactly an archeological dig into twentieth-century avant-garde theatre history, then a reflection upon the state of theatrical representation today, with an acknowledgement of what is owed to, derived from, left behind in the hands of modernist forebears, if 'forebears' as such are to be recognized.

And, to an extent, that was what we got, both in the full-length work a year later and in the 2003 study, although with the high modernist temperature turned down somewhat: a shared space of performance that rubbed at the divisions between spectacle and spectators, a live and eroticized scenic writing generated out of the proximity of bodies and objects and the low-stakes intensity of a captured and corralled attention, along with a hint of casual orientalism, exhausted or turned self-conscious by then.[16] That fifteen-minute study that I saw in Santarcangelo was performed in a small curtained-off section of a room where the spectators stood about with little else to distract our attention except for each other, a disco mirror-ball suspended above our heads, and a young Chinese man in a sequined t-shirt dancing by himself to techno music. I remember the performer conducting some business for several minutes with a standing electric fan and a microphone – the microphone barely picking up the low hum of the fan while he squatted down beside the apparatus, mopping himself with a handkerchief. He then completed the short performance with a karaoke rendition of some Euro-pop number, while the mirror-ball scattered diamonds of kitsch illumination over the bemused, amused spectators' faces.

I say bemused. I have to admit that my experience on that occasion had little enough to do with understanding anything that might have been intended in the way of meaning or reference, Artaudian or post-Artaudian. In fact, never mind bemused, the piece befuddled me, although it did make me want to laugh. That is, I enjoyed it, but also felt I recognized something of the work's own self-enjoyment: a quality of involvement in its own operations, like a sense of humour, or a peculiar affective temperature that might persuade someone to feel something even before they know what it is they feel.[17] A kind of Artaudian turn after all, perhaps, although what I felt the company was up to had less to do with reading back into European modernist theatre history than it did with another level of recognition, an association with contemporaneous theatre and performance practices I'd encountered or

become aware of in London and other European cities (and also in the USA), through the 1990s and after.

This was a world of latter-day 'experimental' theatre which, while it still appeared to be in touch, even in the early twenty-first century, with the shades of avant-garde theatricality and modernism's sweeping relativization of codes, values, and frames of reference, had mutated into something more contingent, more circumstantially and economically entangled, less heroically transcendent than Artaud's manifestos for sure. It was work – to take just one particular trope – that often involved performers standing at microphones, proffering an intimacy, although not an intimacy 'for' anyone in particular. The microphone would function as a stage in itself, amplifying a particular voice or behavior pattern, amplifying something like a form of obligation, which would often take the form of a 'turn,' a sort of service entertainment: to deliver this slice of virtuosity, to sketch an orientation through this story fragment, to be the bearer and carer for this particular image-effect. These performances were characterized less by an 'anything goes' than a 'will this do,' as if appealing to whatever unspoken requirements their action might be adequate to. Put another way, the new work – the postmodern work, the postdramatic work or however we were learning to call it – as it rehearsed its own particular struggles for recognition, would do so not with modernism's perennial disdain towards the economic sphere, but rather with a highly developed sense of that sphere as something that human beings are ever falling short of, even if we are never quite out of it. If a lasting emblem of modernist theatricality had been Artaud's famous image of the actor as a sacrificial victim burning at the stake and signaling through the flames,[18] an exemplum of this later turn-of-the-century work was the more pedestrian image of a hired actor in a gorilla costume, standing in a theatre foyer – in a foyer, mind you, not on a stage – with a sign around their neck that read 'If you don't laugh I don't get paid.'[19] An appeal – of sorts – that is altogether discursive, altogether dependent on somebody else's response. But with the implication also that no particular response is really going to make any difference. Not even laughing will help. An image that addresses each one of us (literally, explicitly so), while presuming that 'we' are together in this. And presuming too that we recognize that.

Penalties

We go back into the theatre. We watch the second act of *Nerone*. In some ways it is like the first, except the two young men do not return. In their place are two young women.[20] And the stage is darker, even darker

than it was before the interval. And the game now is not basketball, it is volleyball. Or at least, that is what seems to have been going on while we were away. There are volleyballs all over the place, a great number of them littering the stage like black spherical fungi, to be played with, made use of, or else ignored. But the women have moved onto other games now: a game of 'horse,'[21] for instance, that involves one of the two women riding the other around the stage 'like' a horse. It is noticeable – noticeable to this spectator anyway – that each one of the four performers at some point will have gone about on all fours, evoking the infants they no longer are, or the non-human animals they can only emulate at best. Abandoned identities that self-consciousness won't allow any more, but which are tried on and re-rehearsed anyway, fit games for theatre's children, if that is who these performers are (it is how I am coming to see them). And at times it does just seem to be a game, trivial, silly and amusing, however seriously the game is played out. At other times, though, particularly in this second act, the playing appears to tip over into a contest, a struggle, a fight. A struggle, we might say, for recognition. As philosophical legend would have it, to have one's humanity recognized by others, to put one's humanity at risk in the social arena, where self-consciousness only 'comes to light' in the light of another's awareness, another's desire (we will give some names to the legend shortly).[22] The way it goes also in the theatre, between stage and public, where some play the lyre and offer themselves up on behalf of the images, and others (we call these the spectators) recognize *themselves* as human to the extent that they are able to say of themselves – with respect to these others – yes, I *see*.[23] Is that the sort of possibility that is being re-explored? And not just on the dramaturgical level, but on the 'professional' level also, for the company themselves: the sort of struggle for recognition that goes on also in the arena of international theatre festivals and the like, where all sorts of recognition – including cultural and economic recognition – are entangled with one other.

The epigraph from Fassbinder cited earlier might support such a reading, given that the acknowledgement of human finitude and one's own eventual nothingness (and hence of one's living being as a 'surpassed' or 'overcome' nothingness) that is articulated there, was one of the fundamental intuitions driving the philosophical legend evoked above, the Hegelian struggle of Master and Slave. That is to say, the fight to the death for recognition in which what is at stake is the history – or the historical becoming – of human self-consciousness as such. Alexandre Kojève's lectures on Hegel, delivered in Paris in the 1930s in the same years that Artaud was writing the essays that went into *The*

Theatre and its Double, rehearse the drama of this struggle, plotting out the 'social reality' in which 'the human reality can come into being' as a hierarchy of 'autonomous' and 'dependent' existences.[24] To recap on Kojève's argument: although we begin in animality, human desires are of a different order than animal desires, or they are supposed to be. Animals need and seek out what is necessary for survival, material things in the world which they act upon and consume, as Hegel would say by 'negation.' Human action is also negating, but it is not material things that human desire feeds on, so much as other desires. There are all sorts of other desires – indeed there must be (without this plurality, without the social fact of the human herd there would be no other desires to feed upon and compete with). But essentially humans desire to 'be' human, to be recognized as human. They desire to achieve what other humans desire, which is, in one way or another, to leave the animal behind. In order to be truly human and to leave the animal behind, however, human desire must win out over animal reflexes, that is to say it must win out over the instinct for survival, it must be prepared to die for what it desires, to fight to the death. What happens, then, in the anthropological drama (unless the fight actually does go to the death, in which case the one whose recognition is sought is no longer alive to do that) is that one of the contestants gives up. The winner at this stage, the Master, is the one prepared to fight to the death; the one who gives up becomes the Slave, who from then on works for the Master, although of course the twist then is that the Master – Nero comes to mind – is not being recognized by an equal, by one whose desire is worthy of him. The result being that it is only the Slave, who glimpses their own finitude as something overcome, and who transforms the world through the action of their work upon it – so that every action they perform takes place in a world they themselves have re-invented – who has any sort of future history to aspire to. Which is where modern political philosophy, or post-philosophy – the philosophy of political praxis, the philosophy of Marx for instance – takes over the drama, indeed takes the drama into the world, as social transformation.

A world, of course, of which the theatre remains a part. Not that Kojève himself draws attention to it, but his four basic premises for the anthropological drama of recognition would also stand as premises for the possibility of a theatre, just about any theatre. Those premises are, first, the human capacity for self-revealing through speech; second, action (the action that acts upon the world in the service of desire, the action of 'negation'); third, a multiplicity of desires ('the existence of several Desires that can desire one another mutually, each of which wants to negate, to assimilate, to make its own, to subjugate, the other

Desire as Desire'); and fourth, the necessity that the fight ends in such a way that both adversaries remain alive.[25] Which is pretty much always how it goes in the theatre; the adversaries get up again eventually, they take their bows, as actors. Or they have since the spectacles of Nero's day.

It is worth noting that the recourse to an often explicit theatricality is often the case in other philosophical or theoretical accounts of recognition – of which, like the plurality of desires in the Hegelian scene, there are several.[26] To draw attention to just a selection: W.J.T. Mitchell's account of primal scenes (street scenes, as it happens, or 'crime' scenes as Mitchell comes to characterize them) of greeting and hailing in Erwin Panofsky's iconological theory of perspectival recognition and Louis Althusser's theory of the *mis*-recognitions of ideological interpellation, involves a consideration – in Mitchell's terms – of 'theatrical figures' first (the various greeters and hailers), and then of 'the stage itself, the space of vision and recognition, the very ground that allows the figures to appear.'[27] The 'crime' that Mitchell has in view is a type of theoretical tendency which he characterizes as a 'temptation to science,' and by which he means 'the panoptic surveillance and mastery' of the object, the 'other,' the individual or the image in the given scene – a scene which is only ever as given as our ideological (and iconological) preconceptions take it to be. For Mitchell, then, the value of thinking about recognition in these respects is the movement it fosters from the 'cognitive' knowledge that a subject has of an object, towards more 'social categories like "acknowledgment."'[28] Much of which – in particular the play between perspective and acknowledgement – we will be taking up in later chapters.

An argument of a comparable temper is found in Paul Ricoeur's book *The Course of Recognition*, which also takes guard against more objectivizing theoretical tendencies. Ricoeur traces a movement of thought – and of philosophical history – that starts in the active, identificatory position of 'I recognize,' in which the thinking subject claims to 'master meaning' by mastering the object of cognition, i.e. through self-recognition and 'the variety of capacities that modulate one's ability to act, one's "agency."' This movement is then taken towards what Ricoeur calls 'mutual recognition, where the subject places him- or herself under the tutelage of a relationship of reciprocity.'[29] For Ricoeur, mutual recognition is not a smoothing out of the struggles and contradictions that Hegel and Kojève – and indeed Mitchell – bring to our attention, so much as a guarded vigilance against, and acknowledgement of, the injustices of mis-recognition (including the failure to recognize the asymmetries and inequalities inherent in just about any real situation of 'reciprocity'). A particularly interesting aspect of Ricoeur's analysis is the way in which he bases his account of mutual recognition on

situations that involve a complex entangling of commercial and non-commercial 'goods' (he is interested, for instance, in the working of gratitude as a sort of ethical supplement or undoing, or indeed radical renewing, of the gestures and economic values of gift exchange). That said, the experience of mutual recognition is most likely at best a 'clearing' amongst the complexities, a temporary suspension of the dispute. 'The struggle for recognition,' writes Ricoeur, 'perhaps remains endless,' although it may be we come to recognize 'that the motivation which distinguishes it from the lust for power and shelters it from the fascination of violence is neither illusory nor vain.'[30]

All of which begs a question of two of the forms this endless struggle takes in the particular cultural clearing that is the actual (and not just metaphorical) theatre. To return to where this philosophical diversion started out, we might borrow from Kojève the distinction between the two basic forms of negating action through which human 'becoming' is realized, those being 'the Action of Fighting and of Work.' To propose a no doubt simplistic dramatic analogy, fighting is what the 'characters' of a drama do (the characters in *King Lear*, for instance), in scenes that are repeated as part of the theatrical repertoire. Fighting is also what the Masters do, the figures of tragedy (perhaps); it is how they got where they are (again) today. Working, however, is what the actors do – 'an essentially humanizing action' Kojève calls it – even as they re-enact the fights of the Masters; and it is how they will get where they are going, wherever that might be.

Except, the actors don't appear to be quite working like that, at least not in Kinkaleri's *Nerone* they don't. Maybe it has something to do with the fact that the fight is pretend, that it really is not a fight to the death. (But nor can it pretend to be, the illusions just don't work anymore, although *that* begs a question of whether 'pretend' is ever just that, outside of the situations in which we insist it must be so, so as to keep image and reality from slipping into each other's space.) Not to mention the fact that the performance is delegated (why are Kinkaleri *not* out there on the stage playing the parts themselves?), or that the performers – for all their differences, for all their asymmetries as Ricoeur might say – really are, to all intents and purposes, equals. Parker and Barker. Her and her. Horse and rider, rider and horse. And, what is more, they know it. We can see that they know it: it is something they bear with them on stage, a sense of their own historicity, a particular and apparent quality of awareness that informs every movement and informs the way they look back out at us from the stage or from the publicity photographs.[31] It is as if they had the capacity – a capacity that Paolo Virno, who borrows the term from Henri Bergson's analysis of

déjà vu (or 'false recognition'), calls 'memory of the present' – both to perceive and to remember at the same time.[32] A kind of anachronism as Virno calls it (another anachronism, to add to the ones we will have collected throughout this book), in which the actions we presently perform take place alongside their potential to have been performed like that, or to have been performed differently, or not to have been performed at all. It is a precarious balancing of virtuality and actuality, in which the potentiality for rupture, for creative action risks collapsing into the possibility of mere actualization, into a repertoire of repeat performances. Something to be considered, perhaps, as one suns oneself under the neons on one's pound-shop Marilyn bath-towel, pondering the options, one's personal preferences, to run over or to be run over, to text message or to call. And to be considered also by the spectators, as the fight to the death really does get going at last, the two young women circling each other in the darkness, a movement sequence that is followed by a clinch, a 'stabbing' and an elaborate, choreographed agony. The one who has fallen turning and twisting, the sound of her naked flesh as it flaps against the stage floor recalling the gasping of a landed fish. The other one sitting on her haunches and watching, waiting in the hot silence.

Figure 3.2 Kinkaleri, *Nerone*, 2006. (Photo: Kinkaleri)

We watch also in the thickening gloom. It gets hard to see, but we look. There are various actions. A perfect circle is cut out of the lino-leum flooring exposing the school sports hall boards underneath. Aha, beneath the stage the gymnasium. One of the women uses a marker pen to draw the outlines of an athletics vest on her companion's body, while the other stands still with her mouth agape. There is also a particular action that is repeated throughout this second act. A song starts to play, a slow and rather dissonant pop song, just a voice and guitar, something corrosive or corroded in the singer's timbre: Scott Walker's 'A Lover Loves.'[33] The woman who is standing while her companion lies 'dead' picks up a leather whip and thrashes it about her, cracking it against the stage floor, as if to make the song go away – come back, go away – as if to replace *that* music with *this* noise, *this* action: as if, by her action, something else than this pathos of interpretation – of representation and recognition – might be conjured into existence. It is an action that appears to strive, in every repetition, for meaninglessness (which Fassbinder had so looked forward to enjoying), even while it takes cognizance of the images it can't help but put into play, and of the irreversibility – and the unrepeatability – of everything that has been done, of everything that has happened and passed through. There is a body to be buried. There is even a hole in the stage floor, a perfect circle, ready to receive it. Except the hole has no depth. It gives only onto another surface. Although, given the stage is now almost entirely dark, there are shadows aplenty into which one might flee.

The ends of art and the limits of the stage

There is still another matter we need to consider, which may speak to the sort of lassitude that seems to dominate *Nerone*, and which seems to be leaching – for all their exertions – the very life-blood from the actors' gestures and expressions. This is the so-called 'end of history,' an idea that goes back to Alexandre Kojève's lectures on Hegel in the early twentieth century, and which was debated with particular intensity in the 1990s at the time of the collapse of communist systems in the East, and in some quarters the proclaimed triumph of liberal democracy (and the forms of capitalism that went with it). It was an idea that Fredric Jameson, for one, characterized as having to do with 'a blockage of the historical imagination,' where imagination would be a matter of theo-rizing the next moves in a progressive social-political praxis. Not least with regard to globalized forms of contemporary capitalism, planetary ecological disaster, and the construction of viable alternatives – in poli-tics and thought and culture – to the self-serving market system.[34] The

debate has been alluded to again more recently in the titles of books such as Seamus Milne's *The Revenge of History*, works that address challenges to the current 'world order' arising from momentous and not un-related early twenty-first-century world events, from 9/11 and the economic crisis to the 2011 'Arab Spring.' In Milne's words, 'as communists learned in 1989, and the champions of capitalism discovered twenty years later, nothing is ever settled.'[35]

A similar diagnosis to Jameson's, which we will get to in more detail shortly, is rehearsed in Paolo Virno's text cited above, where the Bergsonian analysis of 'déjà vu' and the 'survival of images' (a topic that Ricoeur also addresses in his pages on self-recognition[36]) is put in the service of a renewed historical – and to that extent politicized – consciousness. I want to go back to Jameson's mid-1990s essay in this last stretch of the chapter, not least because of the coincidence that Jameson starts his account of the modern history of the political imagination (even if he does not finish it that way) with examples drawn from twentieth-century experimental or avant-garde theatre. But first, back to Kinkaleri's *Nerone* in the early twenty-first century, and the politico-sentimental inadequacy of the age: as they say themselves, of this age like all of the ages that have gone before.

I said that the scene is black – the stage, the costumes, the props and so on – but *Nerone* isn't just black, it is *dark* and black, and over the ninety minutes of the performance, like a game being played into the evening without benefit of floodlights (a distinctly *un*illuminated theatre in these terms), it becomes pitch-thick murky. If there is an invocation to the theatre taking place here, then what is called up is not so much the mad emperor-actor of ancient times but the black box laboratory theatre of modern times, whose promise of limitless possibility (where actions and images would answer to the sorts of freedoms and generate the sorts of enjoyments that Fassbinder looked forward to) has become a determining condition. Has become indeed a trap of sorts, to the extent that when at the end of the first act the tissue-paper was pulled over the stage as a second darkness, like a pall or like a stage curtain, it felt like a gesture that had to be performed with the sentiment drained from it, or performed at most with only half a hope.[37] As if a certain end of art had been reached, or at least touched upon. As if the black box theatre could no longer be what it was, or what it might have been say in the heyday of 1960s experimentalism and the ambitions of that time towards theatrical praxis as symbolic analogy of political resistance or as actual aesthetic revolt. It appears, rather, to have turned into something else, a thing of intermittent snarl and self-involvement, reaching out towards others – like a dog behind the wall barking at passing strangers – but without being able to reach all the way.

The theatrical example that Fredric Jameson offers in his lecture of 1960s political radicalism and its relation to an idea of 'the end of art' – as opposed to the generally conservative provenance of the 'end of history' idea – is not the black box studio theatre but the early performance art 'happenings,' and their promise of a 'spectacle of the sheerest performance as such.' Jameson figures the happenings within the context of a general movement of theatrical practice at the time away from the written text as a necessary pretext for stage performance (a movement in the wake of Artaud to that extent), a movement that sought to abolish as he says 'the boundary and the distinction between fiction and fact, or art and life.'[38] The wider context for this particular aesthetic and theatrical limit-case was, according to Jameson, an explicitly political critique that, during the era of the Vietnam War, viewed high-end cultural institutions and high art values basically as extensions and instruments of state power. Not that there is any reason to suppose that the impulse to worry at the boundaries and distinctions between whatever we call art and whatever we might call life is any less keenly felt in these later, grown-up days than it was in 'the halcyon era of the 1960s when the world was still young.'[39] Even so, there is considerable distance between what seemed possible to some in the 1960s and the more indirect political aesthetics of the mid-1990s, when Jameson was writing his essay and artists such as Kinkaleri were starting out. It is across this distance that Jameson's own critical theory kicks in with a reading of some themes from Hegel, the philosopher whose ideas on a progressive 'struggle for recognition' we touched on earlier. In short, for Jameson modernist art of the early twentieth century supplants the 'sublime' vocation that Hegel had once held out for philosophy as an approach towards an Absolute beyond art. But then, around the 1960s, modernism itself is supplanted, in part by critical theory with its disciplinary range, its pulling apart of the structures of representation, its commitment to a praxis beyond figuration. But supplanted also, in Jameson's account, by a newly commodified after-life of art, a postmodern culture of the 'beautiful' and the decorative focused on pleasure and gratification, which extended – through education, politics, economics – across every area of contemporary life and into every corner of the globe. It is with these several successive 'ends of art' in view that Jameson offers one or two perspectives on the end of history debate.

He develops his ideas in relation to Francis Fukuyama's thesis that with the end of the Cold War in 1989 market capitalism could be declared the final form of history itself. Where Fukuyama saw an end of history, however, Jameson finds, as we mentioned earlier, a blockage of the historical imagination and characterizes this not in the temporal

terms set out by Fukuyama but with respect rather to 'the feeling of the constriction of Space in the new world system.'[40] The key constrictions of Space are two-fold, or so they appeared at the time, in those years between the first Gulf War and the imminent public emergence of the internet. One involves an ecological dilemma, a concern that unchecked production and development are likely to result in ecological disaster, and that 'when the limits of the globe are reached, notions of intensive development become impossible to contemplate [...].'[41] The other dilemma, related to this notion that development can no longer be convincingly imagined in terms of a conquest of nature, has to do with what Jameson calls 'systematicity.' This has to do with the prevailing sense that so much that concerns and, it may be, controls our lives – information, finance, marketing and so on – is linked together in a world system from which no-one can 'de-link' or secede.[42] (We will be picking up on this particular theme in the next chapter.)

Jameson's call at the end of his essay is for an understanding of how the various 'ends of art' might be 'co-ordinated' with 'this new "closing" of the global frontier of capitalism,' as he says 'philosophically and theoretically.'[43] He doesn't, of course, say 'theatrically' even if that is where his essay started out. It would read trivially if he did – as perhaps it does here – although there might be something in theatre's very triviality that qualifies it, as well as any other cultural practice or form we could mention, to stand at art's threshold and take a measure of what gets in the way of future imagining. To continue to speak trivially, then: theatre – not least in its perennial advances and retreats around whatever frontiers where art and life dissolve into each other – operates with a literal spatial constriction of its own, which we call the stage. The stage – however it is figured – has an edge, it goes no further. Everything beyond (as psychoanalysis has taught us in its accounts of what is recognized in the self and displaced onto others) is projection.[44] And, as that edge is realized again and again – for example in later twentieth-century theatrical performance where the character-based productions of ego-centred psychology no longer stand up like they used to do, or not with the same integrity – it demonstrably becomes a place where 'the end of expansion,' to adopt Jameson's formulation, 'is not accompanied by any viable alternative of internal development.' Indeed, to look for such development tends to involve – even in the most scenic or 'environmental' productions – a further contraction of the phenomenal space, closing in around the presence, the appearance, of the actor on stage. This figure, like any figure in the theatre, may be situated securely enough in a 'system' of recognitions and exchanges, while at the same time evoking an interrupted orientation: an orientation, to borrow

Jameson's terms, towards a political, social and also economic delinking from the system. Or, to invoke Adi Ophir's phrase on the ontology of suffering (for Ophir presence is only ever a 'relation' between one who is present and another who recognizes that presence): a craving to disengage.[45]

Which brings me to the following, provisionally concluding comments. The various displacements that go on in *Nerone* – for example the way that each performer is doubled in the scene, and then the scene itself is doubled, from whichever side of the interval one looks, whether forward to the past or back into the future – do suggest that things are being played out in the shadow of a recognition. It is hard to say, though, what is being recognized exactly. The Roman theatre? Is that what this is about – that site of circus games, burlesque theatre, and the theatre of cruelty, as one writer has summed it up, which a certain received habit of thought would take as standing in for 'the self-consuming "spectacle"' of post-modernity, for 'the "logic of capital"' even?[46] Well perhaps, although another image that *Nerone* appears to present is that of an allegorical device that has somehow survived – in the sense of outlived – its context of understanding, even if everything it wants to say for itself, everything it has to show and tell, were still *there* (there on the stage or in what a spectator remembers of it all), its messages mutating into figures, into images as the significance leaches out of them, or as significant things start to get just a little bit silly. This piece of early twenty-first-century theatre, *Nerone*, with its obsessive doublings, its stygian darkness, its dimly luminescent memories and allusions, was touching on something broken in recognition, like something being recalled even as the darkness swallows it again. Or like something performing itself to death; and, in the same moment, to recall a phrase from an earlier discussion, dying to tell. As if the theatre itself were dying to tell about something it recognizes of itself. But then, theatre has a way also of shrinking from the conversation, back into the movements and gestures themselves, of stopping to mean the things it meant to say, even as it keeps on gesticulating. Unless, that is, it barks like a dog that sees and hears no further, senses nothing more, than what presents itself immediately, these shadows here, those noises there, the heat and the sheer persistence of what goes on right now.

Notes

1 Gaius Suetonius Tranquillus, *The Twelve Caesars*, trans. Robert Graves, revised Michael Grant (Harmondsworth: Penguin, 1983): 225.
2 Ibid., 240.
3 Ibid., 243.

4 Ibid., 246.

5 See Kinkaleri, *Kinkaleri 2001–2008 La scena esausta* [*The Exhausted Stage*] (Milan: Ubulibri, 2008): 153–69. All translations from this and other Italian sources cited in this chapter are my own, unless otherwise indicated. This 2008 volume contains a full bibliography and listing of the group's work up to 2008 along with substantial documentary and critical material. Further information is available at http://www.kinkaleri.it (last accessed 17 August 2014).

6 See Rodolfo Sacchettini, 'Il limite dello sguardo – Lo sguardo del limite' [The limit of the gaze – the gaze of the limit], in Kinkaleri, *La scena esausta*: 125–30; 130. 'As if it was impossible then to go all the way, to collapse into the black hole of the live representation while remaining anchored to the presence on the stage, the Kinkaleris as a group are completely removed from the scene towards an eerie and fierce introspective ascent.'

7 See Rainer Werner Fassbinder, *The Anarchy of the Imagination: Interviews, Essays, Notes*, ed. Michael Töteberg and Leo A. Lensing, trans. Krishna Winston (Baltimore and London: Johns Hopkins University Press, 1992): 173–6.

8 Ibid., 174.

9 Sacchettini, 'Il limite dello sguardo,' 128.

10 Paul Ricoeur, *The Course of Recognition*, trans. David Pellauer (Cambridge, Mass. and London: Harvard University Press, 2005): 256.

11 See W.T.J. Mitchell's essay 'The Surplus Value of Images,' in *What Do Pictures Want? The Lives and Loves of Images* (Chicago and London: University of Chicago Press, 2005): 76–106.

12 Kinkaleri, *La scena esausta*, 155. This dialogue was pre-structured but its content was improvised each night by the two performers.

13 For documentation of the project see Kinkaleri, *WEST (Paris) (Roma) (Amsterdam) (Athina) (Wien) (Berlin) (Bruxelles) (London) (Beijing) (Praha) (Tokyo) (New York)* (Prato: Centro per l'arte contemporanea Luigi Pecci, 2011). A clip of the work can be seen here: http://www.youtube.com/watch?v=UZ-8gebz9Wc (last accessed 17 August 2014).

14 The study was performed 11–13 July 2003 in Santarcangelo. The performer was Shulin Zheng.

15 Antonin Artaud, *The Theatre and its Double*, trans. Victor Corti (London: Oneworld Classics, 2010): 59.

16 As it happens, Kinkaleri's home town of Prato has a substantial population of people of Chinese origin. For more on the Artaudian echoes in Kinkaleri's work, see Fabio Acca's essay 'Per farla finite con Antonin Artaud: I Cenci/Spettacolo' in Kinkaleri, *La scena esausta*: 95–106. For Acca the allusions to Artaud are explicit, intended.

17 For a discussion related to these issues see Rachel Fensham's *To Watch Theatre: Essays on Genre and Corporeality* (Brussels, Bern: Peter Lang, 2009).

18 Artaud, *The Theatre and its Double*, 7.

19 The image was courtesy of Forced Entertainment, in the foyer of Frankfurt's Mousonturm, November 2003. An economic calculus of affect was being alluded to as early as Tim Etchells's essay 'On Risk and Investment' from 1994. See Etchells, *Certain Fragments: Contemporary Performance and Forced Entertainment* (London and New York: Routledge, 1999): 48–9.

20 The performers were Leandro Bartoletti, Carla Bottiglieri, Floor Robert and Davide Savorani.

21 'Horse' also happens to be a game in basketball, based on imitation and reciprocity. See http://en.wikipedia.org/wiki/H-O-R-S-E#H-O-R-S-E. Thanks to Ben Piggott for noticing this.

22 See Alexandre Kojève, *Introduction to the Reading of Hegel*, trans. James H. Nichols Jr. (New York: Cornell University Press, 1980): 7.

23 See the section on Marie-José Mondzain's thought in Chapter 1.

24 Kojève, *Introduction to the Reading of Hegel*, 8.

25 Ibid., 39–41.

26 For a comprehensive account on the theory and practice of *anagnorisis*, the dramatic moment of critical discovery, in drama and poetry from Aristotle to the twentieth century, see Terence Cave, *Recognitions: A Study in Poetics* (Oxford: Clarendon Press, 1988).

27 W.J.T. Mitchell, *Picture Theory* (Chicago and London: University of Chicago Press, 1995), 25, 31. See also Erwin Panofsky, *Perspective as Symbolic Form*, trans. Christopher S. Wood (New York: Zone Books, 1997), and Louis Althusser, 'Ideology and Ideological State Apparatuses (Notes Towards an Investigation),' in *Lenin and Philosophy*, trans. Ben Brewster (New York: Monthly Review Press, 1971): 127–86. I am grateful to Prof Kati Röttger for steering me towards Mitchell's essay in the course of a dialogue at the Stedelijk Museum in 2014.

28 Mitchell, *Picture Theory*, 32–3.

29 Ricoeur, *Course of Recognition*, 248.

30 Ibid., 245–6.

31 See Kinkaleri, *La scena esausta*, 156.

32 See Henri Bergson, *Mind-Energy*, ed. and trans. Keith Ansell-Pearson and Michael Kolkman (London: Palgrave Macmillan, 2007), and Paolo Virno, *Il ricordo del presente: Saggio sul tempo storico* [The memory of the present: an essay on historical time] (Turin: Bollati Boringhieri, 1999), especially the first section of the book, 'Il fenomeno del déjà vu e la fine della Storia' [the phenomenon of déjà vu and the end of history].

33 The song appears on Walker's album *The Drift* (4AD, 2006).

34 Fredric Jameson, '"End of Art" or "End of History"?' in *The Cultural Turn: Selected Writings on the Postmodern, 1983–1998* (London and New York: Verso, 1998): 73–92; 91. The supposed triumph of liberal democracy was proclaimed by Francis Fukuyama in his book *The End of History and the Last Man* (New York: Avon, 1992). For an overview and genealogy of the debate see Perry Anderson, *A Zone of Engagement* (London: Verso, 1992).

35 Seamus Milne, *The Revenge of History: The Battle for the 21st Century* (London and New York: Verso, 2013): xxii.

36 See Ricoeur, *Course of Recognition*, 123–6, and also Ricoeur's *Memory, History, Forgetting*, trans. Kathleen Blamey and David Pellauer (Chicago and London: University of Chicago Press, 2006), especially 50–54.

37 Sacchettini writes at the end of the 'melancholy secretion of a feeling [*sentimento*]', 'Il limite dello sguardo,' 130.

38 Jameson, '"End of Art" or "End of History"?', 75. For more on the Happenings see for example Mariellen Sandford's anthology *Happenings and Other Acts* (London and New York: Routledge, 1995) or the discussion in James Harding's *Contours of the Avant-garde: Performance and Textuality* (Ann Arbor: University of Michigan Press, 2000).

39 Jameson, '"End of Art" or "End of History"?,' 74.

40 Ibid., 90.
41 Ibid., 91.
42 Ibid., 91–2.
43 Ibid., 92.
44 For Freud projection was an important mechanism in paranoia, where an internal perception is suppressed, and, 'after undergoing a certain kind of distortion, enters consciousness in the form of an external perception.' But it is also a factor in normal psychic life. 'For when we refer the causes of certain sensations to the external world, instead of looking for them (as we do in the case of others) inside ourselves, this normal proceeding too, deserves to be called projection.' See Sigmund Freud's 1911 'Schreber' case-study 'Psycho-analytic Notes on an Autobiographical Account of a Case of Paranoia,' in Freud, *Case Histories 2*, *Penguin Freud Library*, vol. 9, ed. Angela Richards (Harmondsworth: Penguin, 1979): 131–223; 204.
45 Adi Ophir, *The Order of Evils: Toward an Ontology of Morals* (New York: Zone Books, 2005): 261–3.
46 See Jean-Luc Nancy, *Being Singular Plural*, trans. Robert D. Richardson and Anne E. O'Byrne (Stanford: Stanford University Press, 2000): 72–3. Nancy expresses his doubts as to any implied distinction between good and bad spectacle.

4 Is there anybody there? (on the crimes of representation)

Bock & Vincenzi, *The Invisible Dances* (2004–2006); Simon Vincenzi, *Operation Infinity* (2008–2013)

Black box (two fables)

We have not done with the end of history, or the ends of art. We will be getting back to both. But before we do, a story or two. The first starts a long time ago. An old fable relates how humans have learned to mediate their relations to a world they don't feel themselves to be fully of, or belong to. According to the fable the first, pre-historical 'media' were images: two-dimensional, magical surfaces made up of interdependent elements that tempted the eye to wander between them, finding significance in everything and investing significance wherever it would. Patterns projected upon the landscape and the sky. Shapes scraped in the earth or indelibly incised upon a body. Or else, more lastingly as we have already seen, hand stencils and animal drawings on a cave wall, still visible to latecomers such as ourselves thirty thousand years or so later. What happened, though, or so the fable tells us, is that these images came to stand between human beings and the world. They came to stand 'for' the world, hallucinations of a world that was only ever 'over there.' So it was that, five or six millennia ago, a new technology – writing – was invented to explain the images. In the language of the fable, writing would transcode the two-dimensional surface into the one-dimensional line. Put slightly differently, it would translate the mythical and magical repetition of the same that occurred in images into the linear sequence of one thing after another: a way of rendering the world historically – as process, as 'becoming.' As if translation of the seen into the said could be a means of restoring images to the world that they were supposed to have been images of. A way, of sorts, of going home. As it was, though, magical thought crept into writing too. Soon enough texts no longer disenchanted, nor did they elucidate. They became too beautiful and true, they became too interesting in themselves – or too *interested* in themselves – not least when specialists of all sorts had to be called upon

to explain what the writings were saying, to explain to people what their own writings were saying about themselves. Writing, then, came to stand between people and the world just as images had done, with the result that out of the critical and scientific thinking that writing generated another sort of image emerged. At the peak of the modern industrial age, just as literacy and the historical consciousness that went with it were becoming common in some parts of the world, so-called technical images or 'techno-images' were being developed. For example, around the mid-nineteenth century photography was invented, producing images that did not need to be decoded by specialists, whose significance appeared immediately on their surface, thereby trumping the opacity and exclusivity of texts and restoring images to daily life. Or such was the idea. This too, however, involved a kind of magic – this time of tricks and illusions and manipulative sleights of mind. Photography – not just the camera itself but the whole photographic universe, including the distribution, reproduction and reception of photographic images – came to function as a mysterious 'black box,' a sort of automatic apparatus in relation to which humans worked not as translators anymore but as functionaries, turning the apparatus around and about, playing with the apparatus creatively for sure, learning to exhaust its possibilities, but essentially feeding information in and taking product ('images') out, without really knowing what was going on inside the box to make the process work.

Our fable is assembled from various texts by media theorist Vilém Flusser, written from the 1960s and through the 1980s.[1] It will be familiar to some as one of several analyses from the mid and late twentieth century that contributed to the 'end of history' debate that we considered towards the end of the previous chapter, and which we will stick with just a little further here. I mentioned that revivals of the debate have tended to focus around the violence of world 'events' and the major movements of global political history. Aggression, occupation and delusion. Wars on terror. Capital meltdown and the crisis of the neoliberal order. Latin America, China and twenty-first-century socialism. Arab revolt and backlash.[2] As it happens, neither political events nor their immediate analysis will be the focus of what follows in this chapter, although as we shall see they do have a way of leaking into the discussion even so. Then again, events as such are not really Flusser's immediate concern either, although his post-historical vision of the mediations that take place in culture between words, images and programmable technologies, through which 'rational thinking and acting' fall into the service of 'techno-imagination,' remains essentially a diagnosis of 'crisis,' and crisis on a world-historical scale. As he summarizes

the matter at one point, returning to the metaphor of the black box: 'The easiest way to imagine the future of writing, if the present trend toward a culture of techno-images goes on, is to imagine culture as a gigantic transcoder from text into image. It will be a sort of black box that has texts for input and images for output [...] which is to say that history will flow into the box, and that it will come out of it under the form of myth and magic.'[3] Flusser concludes: 'history in the strict sense of that term will come to an end, and we may easily imagine what will follow: the eternal return of life in an apparatus that progresses by its own inertia.'[4] In the context of our own discussion, something further might strike us about all this, something obvious enough on the face of it. If we consider text not simply as written script, but all of the discursive input that goes into the rehearsal and production of a performance, then this same vision – of a 'black box' that receives text and histories at one end and puts out myth, magic and images at the other – could stand as a pretty compact summary of how it goes and has gone for a long time with a great deal of theatre. It might also persuade us to rehearse another sort of fable or proposal, though doubtless it has been said in other words before this.

The proposal is that theatre has been suffering (or should that be enjoying?) its own post-history for some while now.[5] Not so long ago in these pages we were looking into a mid-nineteenth-century world where philosophizing young men were unable to shake themselves out of a theatricalizing habit, even as various kinds of light-filled black boxes – photographic, theatrical and domestic – were being re-codified or codified for the first time around the same moment. At the same time we chanced upon a twenty-first-century film and video culture where school plays are still rehearsed as a matter of course and the *Brigadoon* sleepers will be re-awakening for their one day in the sun – or their one evening under the lights – any time soon, without the sleepers having had any say in the matter. Theatre, it would appear, in these particular cases at least, is a self-remembering apparatus, irrespective of our input or how we shake the apparatus about. Here, then, is the second fable. In this story people had forgotten about the theatre, in the sense they had forgotten why they did it, what they did it for, even in some places how to do it anymore. All that remained – if only because people had been doing theatre for so long – was the fact, the empirical fact, that they *did* do it. It had become a sort of reflex. Actors came on, they uttered sounds, they performed what looked like gestures. It was perhaps all that they were capable of doing. Unfortunately this meant that they were no longer as adaptable as the modern societal apparatus or economy or whatever we wish to call it, within which their theatre-doing activity

was produced and consumed, needed them to be. And in this – although the theatre had only ever been a medium for generating and validating forms of humanness[6] – they became, or were becoming, strangely enough, something other than human as it was generally understood. Either a little less than human or else human plus, as they grew closer to the objects, images and other forms of life that the theatres had scooped up along the way. A kind of suffering of images came into being, whereby actor-figures continued to perform gestures of ingratiation but without managing to ingratiate anyone anymore, and audiences watched with a certain detachment, bordering at times on indifference. A theatre of the historically inflexible, but out of which – this is the strange thing – something like an historical effect, a sort of oozing historicity, came forth. This is the thing, it came forth anyway in and around what the actors were doing, and something seemed to be at work after all: pricking at all that horror and indifference. How did that happen? And how was it, in such moments, that we felt we remembered, that we recovered a sense of what it was we were doing there, of what it was we had looked for – in the first place as it were? I offer an example from my own experience: or rather two examples – two multi-part theatre projects that took place over several years, churning the time in which they happened, there as if they were not, here as if they hadn't been at all. I remember and, as I do so, I try to think through.

A translated world

My first encounter with *invisible dances ...* (1999–2006), a research project by choreographer and dancer Frank Bock and director and designer Simon Vincenzi, happened in London in 2004 at the Royal Opera House's Clore Studios. I was there to see *Prelude* – advertised as 'a prelude to a show that never happened' – which was to be the first part, or Act I, of *The Invisible Dances*, the concluding theatrical phase of the seven-year project as a whole.[7] *Invisible dances ...* was, to an extent, itself a sort of vast theatrical translation apparatus. Dance scholar Martin Hargreaves has described the project as an 'exploration of various technologies to archive the disappearing traces of dance.' He continues: 'These archives are then subjected to further translation, manipulation and re-editing. Whether audio-describing pedestrians' journeys in the streets, capturing dance on video in the studio or using infra-red technology to stage dance which lights itself, the research has used electronic recording devices to expand the live moment, not to notate or "save" images which might otherwise disappear but, conversely, to bring this disappearance to bear on any "present".'[8] Those

disappearing traces were grasped at wherever their tails had been glimpsed. For example, the advertising for *Prelude* made an allusion to the ballet-based film *The Red Shoes*, which was in part shot at the ROH. In Michael Powell and Emeric Pressburger's 1948 film the climactic dance, hungrily anticipated by a packed auditorium, was eventually 'performed' not by the ballerina, who had already thrown herself in front of a train outside the theatre, but by her invisible spirit: a spirit conjured in the imaginations of the spectators in the film with the aid of a theatrical follow-spot and a pair of red shoes on the stage. In *Prelude* we get nothing so cathartic. What we do get is a video loop on a small monitor at the front of the stage, showing a nervous looking older gentleman in evening dress peering around the stage curtain towards the theatre audience, and then peering again, and again, jerking through the repetition. A ghost from an earlier theatrical age with an inadmissible message for our time: perhaps that the theatre is no longer able to keep its promise. Or worse, it will be keeping its promise now incessantly – the essential contract with what we don't know will happen having collapsed into a sickening certainty that *this* is going to be how it is.

Admittedly at some distance from the occasion now, I recall the following from the rest of the short performance. A male figure covered in black body paint, decorated in black ostrich feathers, who appeared to be waiting for something to take place, or else loitering in the wake of some disruptive occurrence. A tall woman patrolling the front of the stage, reporting on things unseen, which may well have been out there, somewhere just over our shoulders. And a small ensemble of dancers, some of them blind, others blindfolded, several wearing headphones, performing what looked like uncontrollable movements at spasmodic moments during the performance, or when cued to do so by companions who guided them around the stage. Martha Fleming, in a text from earlier in the process, has written of the peculiar effect of these twitching, unsighted, headphone-burdened dancers, evoking a 'strangely welcome purgatory' in which 'all are equal under the light or lack of it.' She speaks of 'a strange feeling of seeing multiply in close-up,' 'as if each event of each spasm were getting randomly from me an attention I am more used to having directed.'[9] All of this, meanwhile, was underwritten by a musical score that fed upon the amplifications of whatever sounds happened to resonate from the stage during the performance, churning over its own waste matter, voracious like that.

An earlier phase of the larger research project, a performance titled *from afar: a show that will never be shown*, had taken place for one performance only, on 20 March 2003. It happened in a theatre in London's entertainment district, the West End, although this was not a

commercial performance by any means. It wasn't even a public performance. It was an evening when that theatre happened to be 'dark.' There was no public present. As chance would have it, on the same day – in another 'theatre' altogether, or so it was presented at the time through a global techno-imaging apparatus that might have stretched even Flusser's imagining – the invasion of Iraq was being launched. There was little enough public participation in that one either although there were people at the other end receiving its effects, but more of that anon. In the theatre in London a select group of individuals had been invited to take up specific relations to what was happening on stage, and to record whatever responses they could as the performance took place: real-time exercises in performance description, a sort of multi-voiced raw theory generator, as if the theatre might attach to itself its own self-service analysis, place itself at the centre of its own little knowledge economy. Onstage, over two hours and thirty-six scenes (each scene lasting three minutes and twenty seconds) 'nine performers explored the different relationships between the external body, communication technologies and absence. Through personal ear pieces they responded to an assortment of texts played on cassette tapes, minidisks, video monitors or stethoscope.'[10] As they did so, a single Watcher (Fiona Templeton) sat in the auditorium, making a speech-recording of her moment by moment responses for an audience that was not there. A Medium (Simon Brown) was licensed to move around the auditorium and attend to any spirit audience in the building. A Witness (Rose English) occupied a passage between the stage and the dressing rooms, hearing but not seeing the performance, writing about report and rumour at the edges of what was going on. Finally, a Photographer (Henrik Thorup Knudsen) set his camera at the back of the stage facing out towards the stalls, the shutter kept open for the duration of each of the individual scenes that made up the show. In Knudsen's photographs, which are printed along with the various texts in the publication documenting the event,[11] the movements of the performers are written in figures of light soaked in red and black tones, the figures who were standing or lying still – dead still – seeming almost whole and material; whilst the more lively ones, the ones in movement, the ones the camera couldn't keep, are the ones that look like ghosts fading in or out of being.

We could call this a sort of seeing in parts (like part-singing in music) or, to tangle the metaphors further, a kind of auditory-visual-affective *anamorphosis*. Anamorphosis is a term associated with special effects of distorted perspective in paintings, which require the viewer to stand at a particular angle or look through a special device in order to see the intended image constitute or re-form itself. The example that is often

cited is Holbein's painting, *The Ambassadors*, in the National Gallery in London where, if the viewer stands to the edge of the picture of the two finely-dressed young men, the brown blob across the bottom of the painting reveals itself to be a skull, a symbol of the givenness of mortality and decay.[12] For phenomenologist Jean-Luc Marion anamorphosis is a way of thinking about whatever touches us in the visible beyond what we can actually see. Marion writes of 'the contingency of what appears insofar as it touches me. To appear by touching me defines anamorphosis.'[13] We might also say that anamorphosis has to do with knowing there is a place from which you would be able to see what's what, and a place from which you would not be able to see, but being unable to remain in both of them at the same time. This there-and-also-not-there displacement was no less the case for the Watcher, sat so to speak in the prince's seat at the centre of the auditorium, than it was for the Photographer Knudsen whose camera could only register the fact of an impossible mediation between the living and the dead, the passing instant and the reconstituted duration of the performance image, and hold that fact over for future use. As Hargreaves writes of Templeton's recorded commentary, her voice registers 'the overwhelming impossibility of documenting the present moment of a performance that was already ruptured by the host of bodies on stage and the reiteration of their future disappearance.'[14] But then as Templeton herself wrote a while later, 'an emotional and mental operation of another kind' is generated out of the peculiar demand that this performance makes on the attention, so that 'in this emptied (unoccupied) but active (occupied) place, appear images, gestures, meanings, all taking place, shaping co-constructing what is supposedly not there.'[15] Call it a future of images, in the sense that the recorded words and the photographs do not unpack the workings of the performance itself, but rather render their own image-making processes, a giving and receiving of images to come. Pretty much any fragment of Templeton's text gives a sense of this:

> Let these people be
> As if they're doing it for themselves
> But no, they're doing it for me to tell you
> Let it come through your body like this
> If I can give you in your body
> This
> One brings the other forward
> The other two of The Three
> Two men almost to the edge of the stage
> He turns and ...

They're giving to each other
They're giving letting to each other[16]

Templeton's words were later published as a book-length transcription, and then extended to another latecomer audience when the text was re-recorded and made into a telephone performance. For a period individuals could dial a number day or night and listen to an account of a show that will never be seen except as words into the ear, the speaker effectively 'dead' to the listener, just as the listener is unknown, unforeseen, 'faceless' to the speaker – who may not have envisaged her voice being used in this context, and who is removed from the pleasure that the others take from her performance. In this theatre of generalized lateness the audience is late to the occasion just as the actor-figure is late to the world; and both are invisible to each other, although both are in attendance at the 'givenness' of what goes on. Something like a non-economic economy of performance, if that is imaginable. A 'gift' economy that does away with the obligations of reciprocation (there being no-one and nowhere to return the gift).[17] A circulation of goods that 'brackets out' for each other the image-maker and the image consumer as agents of the economic exchange. Not inappropriate for a project that performs to no audience in the commercial theatre's un-illuminated gap between productions, and then makes what remains available, practically for free, to anyone who cares to call.[18]

Or consider how it was for the spectators, not on the telephone but at the theatre, when we were eventually invited to encounter the performance ourselves 'multiply in close-up,' a performance around which the appurtenances of the theatrical apparatus had been disposed for the sake, or so it appeared, of a complete scrambling of the stage-auditorium 'contract.' The second act of *The Invisible Dances*, titled *L'Altrove* [*The Elsewhere*], was performed in Venice in 2005. The third and final act, *Here, As If They Hadn't Been, As If They Are Not*, premiered in Brussels in 2006.[19] By the time these performances came to the public stage the work had been dilated, distended, I won't say to exhaustion, but as if pressured into an irreversible shudder. The last short scene of *L'Altrove* involved a single performer seemingly pinned against the darkness by his own appearing, through a device that involved projecting an infra-red recording back upon its source as the recording was being made. The longer, second scene, which took up around two hours of the two-and-a-half-hour show, involved a dozen performers, blindfolded, unsighted, alone or in clumps, enacting the same, spasm-like movements across the vast no man's land of the echo chamber stage. Again, as in *Prelude*, Rose English prowled the proscenium, sniffing the air like a Sybil, speaking

the words of the spirit medium James Brown from the closed performance in London, recorded, as noted earlier, on the first day of the 2003 Iraq invasion. The speech – not unbefitting the occasion on which it was produced – was a thing of grim guesswork and ready association, summoning even earlier shadows to the crisis of the now (I write this out in August 2014 during the centenary of the First World War, when these same echoes are again very much in the air): 'As the curtain went up and as I was looking at the, the dancers with their masks on, it made me immediately feel ... of skeletons and ... and some kind of shock as well, and it's making me feel strongly about, about war and about death ... '[20]

As for what the dancers were actually doing, the catalogue for the Venice Biennale theatre festival where *L'Altrove* was presented tells us how elements of Luke Stoneham's score, generated out of the sounds of the performers' movements, was fed back to the performers as an aural environment that only they could hear, effectively abandoning them to the interior of their bodies, disorienting them to the space in which they moved. It tells also of video cameras that had been strapped to company members' bodies when they went out of the theatre into the city, a sort of hunter's vision, the recorded images serving now as cues for the actors' movements around the stage. It tells also of recordings made with hidden video cameras of pedestrian movement in Venice, and then the verbal transcription of these videos as scores for the dancers to follow, instructions for upper body movement being fed in by headphones to one ear, and lower body movement into the other.[21] In this, the performers themselves functioned – how else to say it – as a sort of fleshly 'black box' translating machine, homeless we might say in a world of translated images, processing the invisible instructions, departing in every moment from that point.[22] The invisibility of those instructions – along with the fact that the spectators as they watched the performance had no indication of what was being translated or transcoded, or where the translation was being directed to – meant that the movements of the performers were in that respect unreadable.

Something of the same goes in the other direction too. By that I mean to say that if a theatrical stage is, in all sorts of ways, a place of power where words and images and ideas are organized to make a persuasive impression, here it appeared that the usual rhetoric was all undone. As Fleming puts it, 'there is no unspoken contract with the audience' and 'a strange freedom is loosed for an audience otherwise trained to respond to a shackling narrative and to a direct address.'[23] Of course the usual paraphernalia of curtains and wings, of stage and auditorium, of speech and blocking and costume and scenography and so on were still there. However, the manner in which the performers tended to bunch onstage

throughout the show, occupying the space in ways that obeyed none of the conventions of theatrical proxemics, rendered the apparatus of theatrical rhetoric redundant, dispersing its authority, leaving the audience alone together with what had been abandoned by the performers: the given that comes between us, whoever we happen to be. I might imagine that we were at a threshold of sorts: with the sort of recognition that comes before knowledge, with the sort of risks that love takes, the trust we might put in the delayed and unforeseeable encounter.[24] Except for one last and obvious element that we need to fold into the account, which is the fact that what went on here was not simply given, it was made. It was made by the theatre-makers. And this too we might come to see by anamorphosis, by looking – or listening in – from the side. Recall Rose English again, as Witness to the closed performance *from afar*, back in 2003 on the day the war started, removed from the performance in her place at the top of the stairs leading from the stage to the dressing rooms, hearing but not seeing what is happening on stage, sat there for two hours writing and thinking:

> Is it better to open or close the door between the stairs and the dressing room/office area? I feel placed between the two. I hear voices from far off, perhaps the auditorium. I hear the word 'mask' coming from the stage? I hear a small plane. 'Has everyone got a mask?' asks Simon. I hear only one 'yes' in response. I decide to close the door.[25]

Something was indeed being 'made' out there. Amongst all the translations, some sort of *funny* business, I want to say, was going on.

Operation Infinity

In 2008, a couple of years after the conclusion of the *invisible dances …* project, I attend a performance of Simon Vincenzi's *The Infinite Pleasures of the Great Unknown* at Toynbee Studios, the London base of performance producers Artsadmin in East London. All sorts of objects, including the bodies of various performers and other paraphernalia of theatrical image-production, are distributed about the theatre – around the edges of Toynbee Hall's proscenium platform stage and spilling out into the auditorium – like the detritus of an encampment. It is as if these things are still waiting to be put to use, unless they have been used up already and these are the empty remains, the skin and bones, the leftovers. There are spools of film, water bottles filled or half-filled with some murky-looking liquid, illuminated by red and yellow emergency

lights that flash on and off. I see a smoke machine, a paper-shredder, and there are actors asleep on camp-beds in the aisles. A diffused semi-darkness links together stage and auditorium in a single purgatorial environment. And there is noise. There are devices for making sound effects: sirens, a thunder machine. I hear a drone of speech from a television monitor, although it is hard to distinguish against a brutal electronic soundtrack, which sounds – as much as it sounds like anything – like the thoughtless grindings of a machinic system, the 'going on' of an incessant mediation.[26]

Amongst all this the main event is a sort of detourned cinema, its virtual images re-populated by live, labouring performers. The way it works is that the theatre proscenium is dominated by a large black screen, behind which a cast of young dancers imitate film material that they can see on a monitor. The choreography, made up again largely of minimal and repetitive spasm-like gestures, is being filmed on infra-red surveillance cameras and projected onto the screen in front of the dancers in a blinking, flickering monochrome throughout the two hours' duration of the show. The projection is interrupted occasionally by the flashing up of the slogan 'NOW SHOWING,' enticing us to the event we are already at, as if the theatre had not noticed us there. The figures on screen meanwhile appear to move according to reflex – or by compulsion. There is a wretchedness to them, but they are livid in their wretchedness.[27] It reminds me of the scene in Plato's allegory of the cave, again, except we see now both the shadows on the cave wall and also the 'actors' (slaves in Plato's account) that are producing the shadows, the spectators no longer having even the comfort of their delusion. One could take it for a horror-show, a sort of burlesque horror-show in which real nightmares have been collapsed into a debased form of entertainment, the incessant and functionless banality of something going on, something being produced and something being consumed.

There are various guest appearances: visitings, hauntings, intrusions. A tall young man covered in black body paint wanders in slowly at one point from the back of the auditorium, some creature of the stage shaken loose from the apparatus and trying to find his way back there. Later, another young man in a black shiny gown heads in the other direction, coming down from the stage to serenade us with a spaced out, lip-synched, drag-ball cover of the Velvet Underground's 'I'm Beginning to See the Light.' He holds the microphone away from his body, as if it were some decorative accessory not a piece of functioning technology, while another figure, costumed identically – although I may be mis-remembering, it was hard to see in the gloom – hovers on stage like the vacated shell or the

Figure 4.1 Simon Vincenzi, *Naked Singularity* (*Operation Infinity*), 2011. (Photo: Henrik Knudsen)

denuded substance of the performer-thing that has descended amongst the spectators.

There are also celebrity appearances, visitants from other times, other worlds. One, who should be familiar to us by now, is King Lear – 'Shakespeare's character of tragedy and loss,' as a programme note for *Infinite Pleasures* has it. This, though, is a Lear translated, in all senses of the word. When he appears – if indeed it is a 'he,' it is hard to tell – Lear is a mute and rather destitute figure, wrapped up in what looks like a black plastic rain-mac, intoning something or other against the grinding of the soundtrack, stood beside the screen upon which the text of the famous 'storm scene' is projected. Except, the text has – literally – been translated too, from English into German and then back-translated into English again through the online translation engine Babel Fish, and it comes out now, if not unrecognizable or senseless, then reduced to the bare bones of familiarity, upon which bones a strange textual flesh has infested:

> Another partial heath. Storm still. Announce to KING LEAR and WOULD AMOUNT TO them KING LEAR: And your cheeks crack effect, lifting machine! Rage! Effect! It Qatar document and

hurricanes, case, until you have drench'd our steeples, drown'd the
Hahnen! It sulfurously and fire, Vaunt special courier, who thought-
completes verse to oak-splitting up Thunderbolts, toward to my
white head![28]

Not so much a horror-show, then, more like a joke, a farcical exit or
departure, but which goes nowhere after all. The stage figure stands
beside the text from which he is conjured up, put out of doors, aban-
doned to the stage, 'unaccommodated' as Shakespeare's poetry would
have it at one of its humanistic high-points. 'Thou art the thing itself: /
unaccommodated man is no more but such a poor bare, / forked animal
as thou art.'[29] The legend on screen reads 'King Real against the guidelines,'
and so it appears to be.

The other special guest, according to the same programme note, is
'Fritz Lang's diabolical Dr. Mabuse,' the arch-villain of Lang's early
twentieth-century Berlin-set films *Dr Mabuse, the Gambler* (1922) and
The Testament of Dr Mabuse (1933), the latter of which was made
shortly before the Austrian director's full-time departure to America at
the time of the Nazis' accession to power in Germany. Like Lear,
Mabuse has suffered a translation of sorts, having become the very spirit
of the theatrical apparatus. At the end of Lang's 1933 pot-boiler Mabuse
had been incarcerated in an insane asylum, scribbling notes for an end-
less criminal dramaturgy on countless sheets of paper, to be enacted
through psychic possession and acousmatic instruction – i.e. directing his
followers through a recorded voice obscured by a screen, a sort of dark
Wizard of Oz.[30] In the fictional Berlin of the movie Mabuse was intent
on bringing about his own 'state of emergency,' a parodic shadow of the
actual state of emergency that was taking hold in Europe at this time.
Hence the ensemble of young dancers, in London in 2008, whose images
are being projected onto the screen at Toynbee Hall, as they take their
movement cues from the monitor showing Lang's film on their side of
the screen. They are Troupe Mabuse, an out of work theatre company
now under the control of the spirit of Mabuse, whose 'act of desperate,
deranged cunning' is 'to re-invent an entertainment of terror: an all-
singing, all-dancing investigation into the crime of representation.'[31] It
sounds desperate indeed, but there is a joke in there too. As the specta-
tors go into the theatre the performance is already taking place. We
bunch up at a desk inside the door where we are asked to sign a release
form that, in the darkness, maybe we do not pay proper attention to. I
take one with me and read it later at home. I laugh out loud when I do
so. 'By attending this event and accepting this document you absolve all
rights to your image. I hereby assign that I surrender all rights to my

identity in perpetuity, and for the full period of copyright exist as naught.' The performance is still in progress two hours after we have gone in, when security staff will eventually shout at us to leave and hurry us out of the building. During the show we see the documents we have signed being put through a paper-shredder in front of the stage.

Some context is called for. *Infinite Pleasures* – 'a mesmerizing show of terror for our times' – was an early part of Simon Vincenzi's next long-term project *Operation Infinity*, which he began after the completion of *The Invisible Dances*. In the years that followed, the Operation advanced its activities on several fronts. For example, a February 2010 email invited its recipients to the Arches nightclub in central London for a 'one-off guerilla presentation' of *Club Extinction*, with the promise of 'an unremitting virus of dancing – an abject curtain call of surrendering within a DNA discotheque.' Seen up close on this occasion, the Troupe were costumed identically in simple t-shirts above what appeared to be tights stuffed with bundles of rags, with a circular black arse-hole stitched on to each behind. The bulbous, waddling body-shapes that this get-up produced were quaintly ridiculous and also slightly disturbing – the dancers' similarity to each other coming across not so much an aesthetic choice as an evolutionary condition: or we might do better to say, an historical symptom. It was like these particular representatives of everyday twenty-first-century humanity had been crossed with abstract figures from an early twentieth-century modernist ballet and set to perform a dance that was either so dimly remembered – or else had been repeated, re-enacted, reconstructed so many countless times over the decades – it had been rendered down to its basic elements of impulse and twitch.[32] At Club Extinction the dancers stood on the spot, wherever they happened to be, upright, facing forwards, elbows bent, arms in front of them, fixed in a sort of spasm, as if going through a kind of collective disturbance, their dance as defiant as it was (oddly) deferential. A few simple actions punctuated the spectacle. Now and then a dancer would bend over and shuffle backwards, arse-hole to the fore, and take a position somewhere else on the floor of the cavern-like night club to start up the dance again. Occasionally another would go and lean against a wall and shake their behind for a while for whoever might be watching or for no-one in particular, it didn't seem to matter. Another wrapped themselves in black plastic bin-liners and rustled around on the floor like some bagged-up but still alive who-knows-what. Another performed a simple hula-hoop gyration on a small raised platform at one end of the space, watched over by an invited audience of maybe a hundred people, call them spectators, call them consumers, call them celebrants, standing against the walls. It is the sort of set-up that has been

played out on countless occasions over the last century in spaces not unlike this, in nightclubs, in galleries, at avant-garde revues, in fit-up 'underground' performance venues: the performers going through their *schtick*, the spectators adopting these same sorts of postures we were adopting now, in twenty-first-century London, whispering with friends, absorbed into the structure of distraction, scanning the scene for detail and dynamic. A situation with just enough theatre in it to keep the fiction in place, while taking what it can from the being together and bumping into each other of the disco dance that ground on endlessly, revel without repose.[33] Here, coloured lights went on and off as if according to some inscrutable programming of the machinery, just like at a real disco – or just like somebody's memory or imagined idea of one – the whole thing overlaid by a ghost-ridden soundtrack based mainly around the guitar riff from David Bowie's 1972 hit 'The Jean Genie.' Every so often the song's chorus would rise out of the sonic murk, dragging behind it the weariness of nearly forty years of having to stay young forever. 'Jean Genie, he screams and he bawls, Jean Genie let yourself go.' The dancers howled along with the chorus. Or at least some of them did, although you could barely hear them against the noise. You could see their mouths move, shaping themselves to the words; imagining, I imagine now, escape routes and exit strategies of various kinds, ways of departing indeed, or just letting go. Not that anyone did, on that occasion, let themselves go, either among the performers or the spectators. They didn't, we don't, because we have been here before and know how it works, know too well how it is likely to turn out.

A website attached to the project suggests that *Operation Infinity* has been active – if 'active' is the word – not only in other places, but across other times, if not for time immemorial then stretching a little further than living memory is likely to. The fiction is put over with deadpan relish for the arts of theatrical pretending. We can let our imaginations run with the phrase 'operation infinity' and the sort of project it might suggest: an insatiable apparatus of de-subjectification;[34] an endless, trans-historical avant-garde; or a nervous, propulsive system of production and consumption, of bodies and objects turned into images, of images turned over to the vacancies of desire. A not untypical blurb for the work describes a 'never-ending choreography of chaos, possibility and prophecy,' invoking 'a state of emergency – a storm in which the fear of the unknown conceals its own controlling force.'[35] *Operation Infinity* would appear, then, to be the brand name of a going concern, a somewhat faceless organization that has opted to pitch its activities in the live entertainment business of all places. Or maybe all this is just the continuing adventures of an old-style cabaret outfit, on the make and on

the run. There is, as with any operation of this sort, no way of distinguishing a back-room, one-man-and-a-laptop outfit from a set-up with an international network of operatives, although from the rather quaint phrasing that makes up its public pronouncements it does appear that they have been in business for quite some time. A facsimile newspaper clipping on the website, which purports to be a review of a 1922 sighting of the Troupe (1922 was the year that Lang's first, silent, Mabuse film, *Dr Mabuse, the Gambler* was released), is worth quoting from at length:

> In this interminable production one solo compels, more for its shocking content than its artistry. Mme Abusé, a rangy masculine figure, adopts a series of plastiques then begins to cut, hack and finally shaves off her hair accompanied only by the sound of soft weeping. What happens next cannot be described in relation to the theatre as we understand it, dancers are humiliated, they cower, crawl, stagger, frequently falling off their pointes. The classical line is not so much distorted as mangled. They appear impelled forward by some inner force to deliver a terrible warning, perhaps of what the moderns would do not just to the noble art of ballet, to the world order but in fact to our very souls. The Endless Time Enterprise that sponsored this, the Troupe's first visit should be called to account.[36]

It may be, after ninety years, that the dancers still have a warning to impart, that the moderns are not finished with us yet, that there remain regions as yet uncharted by cultural and spiritual historians where the soul's tatters are nurtured and preserved, where an order of inequalities staggers on regardless of the best efforts of the historical avant-garde, and where the noble art of ballet continues to hold sway. It is also possible that the Operation, condemned to endlessness but devoid of criminal purpose now, has simply survived its own modernity only to fetch up in someone else's, a relic of disturbances that don't touch us anymore, or not in the way they might have done before.

Against the guidelines

I noted earlier that the sort of work we have been considering here, for all of its apparent automaticity, its sense of a 'black box' apparatus performing itself to exhaustion, is very much 'made' work, which draws attention to its madeness. The same goes for any sort of theatre, I suppose, and it is not only theatre that is 'made' in this sense. Paolo Virno makes the same point about jokes. He cites Sigmund Freud on the matter: 'Jokes, for Freud, are "made", as opposed to the comical

situation, which must simply be traced down and recognized.' Virno immediately follows this up with the observation that 'whoever coins a joke does something new.'[37] These remarks appear at the opening of Virno's essay 'Jokes and Innovative Action: for a Logic of Change,' in which the Italian philosopher elaborates – as did Flusser, we will recall – a theory of crisis. More particularly, Virno analyzes what he designates a 'logic' of crisis and the function in any crisis situation of the sort of creative or transformative performances (for Virno these are largely verbal performances) that challenge the established 'grammars' of everyday life, the so-called 'rules of the game.' Virno defines crisis – both its logic and its phenomenology, how it works and how it feels to live in it – as a situation where on the one hand the empirical facts we think we know about ourselves (but which 'in fact' are open to assertion and contestation), and on the other the background to these facts (the 'grammatical' substratum, the assumed rules according to which these facts are asserted and contested), slip over into each other's territories. What we take for facts are as often as not opinions and historical–social beliefs. Virno's examples: 'I know that I have two hands,' or 'submission to authority is ingrained in human nature,' or 'God created the world.'[38] Although such beliefs or propositions get established as norms, any proposition that has been established as a norm can be cracked open and revealed as only one proposition amongst others, even as new rules of the game – new historical 'forms of life' – are coming into being. The means by which this cracking open comes about is what Virno calls innovative or transformative or creative action, which is always urgent action, performed under the pressure of unrepeatable circumstances, taking place as it inevitably does in 'a state of emergency,' which means having to take place 'now.'[39] Jokes, then, for Virno are like this sort of creative practice in miniature, or 'diagrams' of innovative action, involving as they do, irrespective of their trivial, immediate, throwaway nature, 'the practical know-how and the sense of proportion that guide those who act without a safety net in the presence of their equals.'[40] Which could be any of us, on any occasion. Joke-telling, basically, adopts – adopts, adapts and abandons – the rules of the game and turns them into empirical, which is to say disputable, 'facts.' Jokes do this by applying rules to particular cases in surprising and inventive ways, and also by abandoning rules altogether – 'pure application,' Virno calls it[41] – for the sake of an 'exit strategy' from norms as such. 'Jokes,' Virno writes, 'reside in a no-man's land that separates a norm from its realization in a particular case.'[42] However, this no-man's land is not unpopulated. Jokes do their work in the presence of others. That is to say jokes, like theatre, need an 'indifferent audience' of 'third person'

spectators, intruders whose very presence makes the action of joke-telling into a *praxis*: a doing that takes place in the presence of outsiders, a public action, a political discourse, a call to insurrection.[43] What is more, jokes involve a perpetual return to what Wittgenstein called the 'common behaviour of mankind.' In other words, they return us – however momentarily – to the habits and repetitions of our species-specific behaviour. For Virno – as for Wittgenstein – this very ground of common human behaviour is historical, and changeable. It equates, Virno writes, to the 'threshold' we are always returning to as we attempt our acts of self-translation, as we enter 'the *passage* from the cry of pain to the phrases in which one expresses one's own suffering; the *passage* from silent sexual desire to its articulation in clausal form; the *passage* from perceptive-motor imagination to the metaphors and to the metonymies that mould it from top to bottom.'[44] It is to this same threshold that the joke – in Virno's phrase 'the "black box" of innovative action' – retraces its steps, to a zone of precarious regularity in which human life appears, or a form of life steps forward to appear, as a figure of historicity, 'in the movement by means of which we pass from one grammar to another.'[45]

Vincenzi's theatre is, I would say, amongst the many other things that it is, a comic theatre. Comic, for instance, in the way that the various elements that feed its productive machinery can seem reduced – if 'reduced' is the right term – to the same level of value or significance as each other (something of the sort, we might feel, also happens in the later scenes of the tragic drama that King Lear has wandered in from). This principle is intrinsic to the madly over-productive, all-consuming ambition of *Operation Infinity* – as mad as any of Mabuse's schemes for world domination – a kind of 'poetics of (just about) everything' that claims to reach back nearly a hundred years, devouring cultural forms such as ballet, cinema, the classical theatre, not to mention social dancing, and dragging along in its wake not just the nightmares of our own times, but those of the previous century too. A representational hubris that cannot help but draw attention to its own inadequate locatedness and partiality, having staked its claim – of all places – on the ground of an impoverished (grab one of the thin-paper two-colour flyers scattered around the playing space, get an eyeful of those bin-liner and padded tights costumes) but even so intransigently interventionist (Mabuse has been playing these mind games since the days of silent film) *theatrical* experiment. To which one wants to say: Mr Mabuse. Theatrical, *really*? In these lights, any ambition the theatre might harbour towards the sort of transformative creative action that Virno seems to be talking about, would appear to be at risk at any moment of shrinking around the finitude of gesture and utterance, shrinking and disappearing we might say

into the dark circles stitched onto the backside of each member of Troupe Mabuse. Meanwhile, the work invites its audience not only to acknowledge the shadows on the cave wall, or the figures to be found within the shadows, or the actors that throw the shadows from the fire behind our backs, but to look upon a projection of the cave itself, its 'entire machinery,' the audience included, ourselves no less a part of the apparatus than any other element that appears to be there. The joke now, to rehearse a line from a noted theoretical joker Slavoj Žižek, is that 'the theatre of shadows works as the self-representation (self-model) of the cave. In other words, the observing subject itself is also a shadow, the result of the mechanism of representation [...].'[46] In other words, in answer to the query 'is there anybody there?' the answer comes back clearly: 'No.' Except, we would have to add, the joke is not only a joke. What the joke does is it indicates a lurch, a fall – or in Žižek's term a 'parallax view' – towards another experience, another reality, that is not to be mediated and can only be grasped across a gap between incompatible positions: if there is a joke, there is a horror story, a 'show of terror' there too. Or, if it is the case that the ultimate absence of the observing or of any other 'self' – 'the "nothing behind" of the open skull'[47] – *is* the horror story, then there is a joke that turns on that image also.

Later sightings of the Troupe have included the two-minute ensemble performance *Naked Singularity* at the Barbican in London in 2011,[48] as well as the *Ouroboros Recordings* and *Luxuriant: Within the Reign of Anticipation*,[49] the latter two works a video project and a theatrical installation, the first of which found the Troupe dressed up in Mickey Mouse headgear, churning out screen tests for a back-stage, bargain-basement, Depression-era money-spinner that never was and probably never will be made, a production that was bankrupt from the start and which is fast regressing, when we encounter it, if it hasn't done so already, into a sort of end times peep-hole pornography. The soundtrack is a jingle, like an advertiser's blazon or a ridiculously amplified ring-tone, a jagged edged loop of 'We're in the money' from the film *Gold-iggers of 1933*. But those were old times already, and the lucre was long changed for paper, and the paper recycled to print flyers on. At the theatrical installation *Luxuriant* a number of the Troupe, masked and anonymous, tensed up to the nines and on the edge of riot, swarm amongst the standing audience, forcing us aside, or pulling us into their orbit. Solo figures – a woman whose speech is all echo, at once resonant and indistinct; a youth in a hoodie who dances to oblivion – are like punctual phantoms, claimants, disputants, on the spot and on cue, innocent and not so innocent bystanders. A cluster of tech equipment includes a camera that turns and turns about, the indifferent surveillance

for the security files, the inevitable documentation for the performance archive, the indiscriminate self-representation for the sink-hole of social and a-social media, where the images, for what they are worth, might as well be taken for real. After all, one is as good, or as wretched, as another. So it is that after the deformed cinema of *Infinite Pleasures*, the nightclub non-encounters of *Club Extinction* and the downbeat extra-vaganza of glitter, kick and twist that was *Luxuriant*, the final part of *Operation Infinity* returns to the illuminated theatre, even to a play of sorts, or to an image of a play. *King Real Against the Guidelines* (2013) involves six performers on the Toynbee Hall stage, the stage raked in reverse so that as the performers walk forward in turn – which they do continuously over the three hours duration of the piece – they rise into vision before us, before disappearing from sight again as they return to the back of the stage. As they do so, their hands and arms are held out in the mode of rhetorical gesture, like figures in a picture, their faces turned upwards towards hidden monitors (presumably) from which their gestures are being copied, their mouths as they come forward lip-synching to a recording of a woman's voice on a thirty-minute cycle, articulating with all the beauty and precision of a *real* actor's diction the *Lear* mal-translations from years earlier. Perhaps this was the 'abject curtain call' promised at *Club Extinction* – although at the last not so abject after all. Removed rather. As if, amidst the horror and loss, the chink of filthy lucre and the hopelessly ever-hopeful reflex of image production and consumption, the theatre itself were to acknowledge, in the depths of its oblivious self-remembering, a vocation of its own: its way of honour-ing – in the very poverty of its means – the nameless, forgotten and translated subjects of history, or at least of the history of representation. But there's a joke here too. These days the *individual* tragedy comes pre-cooked. What can the theatre hope to do but warm it over a bit to make it fit for consumption? And so we find ourselves looking away from the sacrificial-ritual centre of the drama and attending to the periphery of the operation, where the bodies are still unburied. The curtain call here is the entire show, an interminable termination. One might even imagine, in these later phases of the Operation, the whole elaborate fiction that had sustained the project – Mabuse and Lear and all the rest – being sloughed off like a skin, like an alibi no longer required, no longer fit for purpose. As, then, other forms of life squirm into view.

Notes

1 See for example 'The Future of Writing' in *Writings*, trans. Andreas Ströhl (Minneapolis and London: University of Minneapolis Press, 2002), and

Towards a Philosophy of Photography, trans. Anthony Mathews (London: Reaktion, 2000).

2 These phrases are liberally taken from chapter titles of Seamus Milne's collection of journalism written between 1999 and 2012 in *The Revenge of History*.

3 Flusser, *Writings*, 67.

4 Ibid., 69.

5 Accounts of theatre's post-history, as it were, are not unforthcoming from the visual arts, as implied for example in the title of the exhibition (and valuable catalogue publication) *A Theater Without Theater*, eds. Manuel J. Borja-Villel, Bernard Blistène and Yann Chateigné (Barcelona: Actar, 2007).

6 See the discussion of Lambert Wiesing's ideas in Chapter 1.

7 *Prelude*, 30–31 July 2004, performed at *Snagged & Clored*, The Clore Studio, Royal Opera House, London.

8 Martin Hargreaves, 'invisible dances ... in a body of text,' in Bock & Vincenzi, *invisible dances ... from afar: a show that will never be shown* (London: Artsadmin, 2004): 125–34; 129.

9 Martha Fleming, 'On Invisible Dances,' 2000. http://www.artsadmin.co.uk/artsonline/69/a-text-on-invisible-dances (last accessed 17 August 2014).

10 Bock & Vincenzi, *invisible dances ...* , 7.

11 Ibid.

12 Jean-Luc Marion, *Being Given: Toward a Phenomenology of Givenness*, trans. Jeffrey L. Kosky (Stanford: Stanford University Press, 2002): 350. See also Dominic Johnson, *Theatre & Visuality* (London: Palgrave Macmillan, 2012): 28–31.

13 Marion, *Being Given*, 130–1. Anamorphosis is also for Marion a way of considering, in painting particularly, how visibility is informed by the invisible, for instance in the 'crossing over' of the flatness of the painted surface by the attention and perspective of an 'invisible gaze.' Marion, *The Crossing of the Visible*, trans. James K. A. Smith (Stanford: Stanford University Press, 2004): 12.

14 Hargreaves, 'invisible dances ... in a body of text,' 126. Hargreaves' exploration of a haunted quality to the *invisible dances ...* project draws upon insights in the writings of Peggy Phelan and others, developing these into a critical gesture that seeks to remain, as he says, 'welcoming to specters and hospitable to future rewritings by absent bodies,' 132.

15 Bock & Vincenzi, *Here, As If They Hadn't Been, As If They Are Not* (London: Artsadmin, 2006): 7.

16 Bock & Vincenzi, *invisible dances ...* , 60.

17 For the classic anthropological account of the workings of the gift (from 1950) see Marcel Mauss, *The Gift*, trans. W.D. Halls (London and New York: Routledge, 2002).

18 See Marion, *Being Given*, 122–3. Marion – whose formulas we are still indebted to at this point – sets out the phenomenology of a givenness that is neither transcendental nor tied down to a social economy of giving and receiving, that is neither caused by nor comes from somewhere else, so much as 'the elsewhere' is intrinsic to it, as a character of its mode of appearing.

19 Act II *L'Altrove*, 15–16 September 2005, performed at Venice Biennale International Theatre Festival, Teatro alle Tese, Arsenale. Act III *Here, As If They Hadn't Been, As If They Are Not*, 4 May 2006 nottdance, Nottingham;

18–20 May KunstenFestivaldesArts, Brussels; and 30–31 May, Laban Theatre, London.

20 Bock & Vincenzi, *invisible dances* ... , 15.

21 *La Biennale di Venezia 37. Festival Internazionale del Teatro*, dir. Romeo Castellucci, catalogue Milan: Ubulibri, 2005.

22 On translation 'within the image' in Flusser's thought see Hubertus von Amelunxen's 'Afterword' to Flusser, *Towards a Philosophy of Photography*, 86–94; 94.

23 Fleming, 'On Invisible Dances.'

24 The comments are again informed by Marion's arguments.

25 Bock & Vincenzi, *invisible dances* ... , 11.

26 *The Infinite Pleasures of the Great Unknown*, 19–21 June 2008, Toynbee Studios, London. Soundtrack by Luke Stoneham, Frederick and the Fields. Designed and directed by Simon Vincenzi.

27 One figure on stage, apparently, dressed unlike the others in head-to-toe black, is invisible to the infra-red camera and only becomes visible to us, momentarily, when another performer walks behind him. Conversation with Simon Vincenzi.

28 http://www.operationinfinity.org/translate.html (last accessed 17 August 2014).

29 William Shakespeare, *King Lear*, Act 3, scene 4.

30 See Mladen Dolar, *A Voice and Nothing More* (London and Cambridge, Mass.: The MIT Press, 2006): 61–3.

31 http://www.operationinfinity.org/theinfinitepleasures.html (last accessed 17 August 2014).

32 The modernism, I would say, is generic. Schlemmer's costumes for the Bauhaus ballets come to mind, but the point seems to be that the appropriation – if appropriation there be – is imprecise, indifferent, opportunistic. Troupe Mabuse's costumes anyway downplay the abstract shape in favour of the human performer who has to carry it off. See Walter Gropius and Arthur S. Gropius, eds., *The Theater of the Bauhaus* (Baltimore and London: Johns Hopkins University Press, 1961).

33 The phrase alludes to Gillian Rose. See *Love's Work* (London: Vintage, 1997): 99.

34 See for example Giorgio Agamben, *What Is an Apparatus?*, trans. David Kishik and Stefan Pedatella (Stanford: Stanford University Press, 2009).

35 http://www.artsadmin.co.uk/projects/operation-infinity (last accessed 17 August 2014).

36 http://www.operationinfinity.org/archive/19220606.html (last accessed 17 August 2014).

37 Paolo Virno, 'Jokes and Innovative Action: For a Logic of Change,' in *Multitude: Between Innovation and Negation* (Los Angeles: Semiotext(e), 2008): 67–168; 79. The Italian text was published in 2005.

38 Ibid., 155.

39 Ibid., 92–3.

40 Ibid., 73.

41 Ibid., 119.

42 Ibid., 119.

43 Ibid., 82–3.

44 Ibid., 121.

45 Ibid., 153.
46 Žižek borrows the inversion of Plato's allegory from brain scientist Thomas Metzinger's book *Being No One: The Self-Model Theory of Subjectivity* (Cambridge, Mass. and London: MIT Press, 2004). See Slavoj Žižek, *The Parallax View* (Cambridge, Mass. and London: MIT Press, 2009), 162.
47 Žižek, *The Parallax View*, 163.
48 See http://www.youtube.com/watch?v=SbJjew1NY4c (last accessed 29 August 2014).
49 *Luxuriant: Within the Reign of Anticipation*, Crisalide Festival, Forlí, Italy, May 2010. The work was developed further towards performances in 2013 at the People's Palace, London and Malta Festival in Poznań.

5 Climates of attention (on the imaginary theatre)

Alvis Hermanis, *The Sound of Silence* (New Riga Theatre, 2007); *Fathers* (Schauspielhaus Zurich, 2007); *The Ice. Collective Reading of the Book with the Help of Imagination in Riga* (New Riga Theatre, 2005)

Pretenders

Or imagine it like this. A square-sided (15 cm x 15 cm) glass tube one metre long – a hollow and transparent beam, a column of air and light – is suspended horizontally in the art gallery at head height: the height of an average human adult. The tube leads straight to a window, which it pierces by a centimetre or so. A direct opening to the world outside, except the tube is a sort of pretender. You look into it and you see that opening to the outside multiplied like the view inside a kaleidoscope. And the view moves as your eye moves. You put your nose to it and you smell, well ... I hardly remember now, but we are in the middle of the Italian city of Naples, one or two floors above street level. You feel the air on your face and you smell from outside what you imagine is there to smell, you smell something of the city or perhaps you don't. And, as you put your ear to the opening at this end, here in the art gallery, listening now to what you can't see, what you hear may well be the voices of the young men in the street below talking around a moped, but what it sounds like is the city itself baffled and captured, as imaginary as it is seductive.

In the play we saw later that same evening the stage was divided into a series of rooms, one beside another, all exposed under the same light. All in colour. In every room there were transparent glass jars about the place. Small jars for braiding one's hair over to make a beehive hairdo. Jars of all sizes for the young people who inhabit the rooms to practice kissing on, in expectation of the real kisses to come, whenever they will. And jars for holding up against the imaginary partitions that separate

the rooms from each other, to hear what the others are doing next door. What the others are doing is exactly the same thing, listening with another jar on their side of the wall. What everyone hears is music, but a music that is bottled up and confined. It isn't a music that anyone is playing in their room, on their radio or gramophone; it is an imaginary music that exists only in the ears of the listeners – the listeners on stage and those in the auditorium also. That is to say the listeners turn out to be everybody, just as the imaginary partitions between the rooms turn out, at once, to be imaginary indeed, enabling another imagining to take place, so that the girls in one room and the boys next door can dance with each other just by putting down their jars and turning to face the person beside them, dancing for as long as the music lasts, a music that is not in the ear anymore but in the air where everyone lives.

The play is set in the late 1960s, a time before any of these people on stage were born, a time conjured out of the pictures, sounds, objects, ways of dressing and behaving, ways of living and doing and of sharing the world with others, of a remembered or imagined past. A time which did not happen in some places at all. Except in the theatre something does happen, or is imagined into happening and then kept going, for a

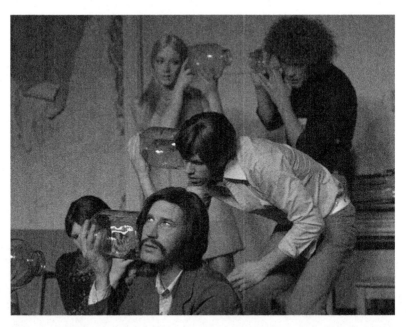

Figure 5.1 Alvis Hermanis and New Riga Theatre, *The Sound of Silence*, 2007. (Photo: Gints Malderis)

while at least, like the scene where the entire cast of fourteen young actors keep a feather in the air on their collective breath and the music that we hear measures their success, shutting off as soon as the feather touches ground or is touched by someone. Or like this afternoon at the glass tube. Someone puts their ear up to the glass to listen, and although you hear nothing at that moment of what they are hearing you can imagine the sound coiling in their ear as it coiled in your own a moment ago and the way your face reacted as it did so, as theirs does too, each in its own particular way, unscripted.

The glass tube, as I've been calling it, turns out to be a late 1960s remnant itself. It is a 1969 artwork called *Barra d'aria* [Bar of Air] by Giuseppe Penone in the collection of MADRE, Naples' contemporary art museum. The play is *The Sound of Silence*, a three-and-a-quarter-hour performance without words for a cast of fourteen actors made in 2007 by the Latvian company Jaunais Rīgas Teātris (New Riga Theatre), directed by Alvis Hermanis, with costumes and scenography by Monika. Pormale. Any relationship between the gallery piece and the performance is tenuous no doubt, contingent upon my having visited the gallery and the theatre, with friends, on the same day in June 2008.[1] That said, the play admits something of the tenuousness, the fragility of its own claim – if we can put it that way – upon a certain image or idea of the 1960s in a subtitle that is part documentary fiction, part joke (or so I take it), and part respectful tribute to a small number of recalcitrant Latvian hippies who experimented with communal living in communist Riga back in the day. *The concert of Simon and Garfunkel of 1968 in Riga that never took place*, the subtitle announces, the entire show being constructed from scenes devised collectively by the cast and shaped and arranged by Hermanis around twenty or so tracks from a Simon and Garfunkel greatest hits album. The songs are pretty much the only sounds heard during the performance. Large-format black-and-white photographs of those long ago times, pictures of those few historical hippies (who have bequeathed their resistant gesture to future times) preface the show on the walls of the theatre before the scenography is revealed.[2]

A performance, then, made out of a history siphoned from stories and documents and images, the available, remaining, held-in-common stuff of shared recognition. Those photographs already mentioned as well as familiar pop culture materials that include not only the songs of Simon and Garfunkel, but also the fashions and hair-styles that inform the actors' appearance – all Zappa moustaches and Mary Quant coats and dresses – and essential 1960s films like *Blow-Up* and *The Graduate*, episodes of which (scenes of seduction mainly, as I remember it) are re-enacted or

alluded to in some of the onstage scenes. Indeed not so much historical as mythical stuff, as Annalisa Sacchi puts it in her reading of the show, which for Sacchi – for all the vividness of what takes place 'in the here and now of the scene' – introduces a 'deformation' into the historical rendering, as audiences recognize the extent to which the history that is being performed is drawn from collective memory.[3] Donated we might say from our CD collections. Leant to the spectacle and received back in turn, with interest. Or such might have been the expected promise. I recall a young man fiddling with the dials and several aerials of a radio to capture a transmission that only comes through intermittently. It is being broadcast from far away, from forty years in the future where we are playing over in our minds the songs again from forty years ago in the past. He is having some trouble picking up the signal, but the opportunity is there and he is determined to succeed.

'Theatre is a conservative art, an old-fashioned art,' Hermanis says in a conversation with theatre and performance scholar Alan Read during one of the last ever performances of *The Sound of Silence*, in Amsterdam in 2013. They are talking at this point about dissolutions of geographic and national identities ('Latvian' theatre, for instance) in today's globalized contexts. Hermanis goes on: 'Comparing it with music, with visual arts in the twentieth century, theatre is always "climbing backwards." Perhaps this anachronistic quality,' he continues, 'is to do with the storytelling that is about to happen, the audience is waiting to hear the *story*.'[4] We might add that this particular work, *The Sound of Silence*, is 'conservative' also in a quite literal sense, reflecting as it does on the conserving and passing on of its basic substance. This passing on occurs for instance in the scene where a woman in a head scarf and a heavy outdoor coat soaks what looks like an old white gown in dissolved sound (specifically the guitar riff from Simon and Garfunkel's 'Mrs Robinson'), which she pours as water from an unsealed jar into a bowl and then returns to the jar when the soaking is completed. Several brides gather in the next room in their new white dresses and they wait. The jar is brought on again by the head-scarved woman, the lid unscrewed and the music is poured into the hands of each, poured over the brides' heads, down the front of their dresses, splashed into the air as the volume of the music is pumped up and the one who brought it in squats beside the door to watch what happens. She is, I take it, something like what Elin Diamond refers to as the ancient and anarchic *mimos*, 'who makes and simultaneously unmakes mimesis,'[5] one who brings the *mimesis* on stage from a source that has less to do now with our CD collections than it does with some unspecified origin in the primitive, in former times, 'or in the magic of myth.' As Celia Lury points out in her book on mimetic

experimentalism this traditional mimetic function is inevitably aligned with the feminine, and a generalized and anonymized feminine at that, associated with 'nature' and 'its fecundity or powers of *reproduction*,' to the extent also of obscuring the ambivalences and potentials of specific mimetic practices (Lury's focus is on self-extensions of 'the experimental individual' in contemporary image culture, particularly through photography).[6]

Mythical, then – or conservative – in that sense too, although there is no shortage of specific, localized mimetic experimentation going on here. As for example at the very beginning of the show, when two young women wearing 1960s clothes enter the stage as intruders and discover the scenography for the first time, finding themselves in a sort of playground for ghosts, ghosts such as themselves, which doubles their own long-gone historical moment back upon them in tangible form. And of course immediately they have to play, to pick things up and sit on the sofas and turn the dials on the music machines. As if they might at any moment be tempted to take it all apart; although what they choose to do instead is enjoy it for a while. Hello darkness my old friend. Something whispered from the past or conjured from the future or simply borrowed from next door, something actual or imagined heard inside a glass jar pressed against a wall that isn't a wall at all and where the music passes through, this way and that. And then I am thinking again of *Barra d'aria*, Penone's seemingly ageless 1969 glass tube, still there in the MADRE gallery, piercing the museum wall into the Naples air, suspended like a telescope or maybe some sort of a listening device, from the gallery into the city and from the city into the gallery – although only accessible from the gallery floor. As noted earlier, it does not 'give' straightforwardly on what is there to be seen and heard: it baffles the audible; it reflects and refracts the visible. It also tempts and seduces, just by hanging there at the eye line of an average adult, as if there really were such a creature as an average adult – one of us, so to speak, standing in for all – who would be suited to use the thing, to train her senses, to sniff and to listen and look.[7] But then, what if the whole apparatus were nothing more than a mimetic seduction into the imagining of such a creature and such a scenario? What if the glass tube were not 'for' looking and listening at all? What if it were simply what the label says it is: a bar of air?

In a final scene of the play one of the characters dies of a surfeit of troubled water. There are ways of imagining that are opportunistic to the point of self-sacrifice. You put your head into the bucket and Simon and Garfunkel's song about fidelity to one another over time plays for a moment; you take your head out and the music stops. Eventually, one of the young men does not come up for air and the song plays through. As

if the song really was for him. Or he could make it so by giving himself up to it entirely. As if one really could drink deep of the images, the sounds, the memories, and keep on drinking. As if history and passing time had no prerogatives here. Although of course they do. Hermanis tells Alan Read that the 2013 performance of *The Sound of Silence* that is taking place in Amsterdam even as they talk, as they wait for the audience to come out for their interval drinks, will be the last, or one of the last. A 'funeral performance,' the director calls it. But that's nothing peculiar, that's how it goes in the theatre and this show has gone as well as could be wished. The show has been around the world, it has played in 25 countries, it has had 'a great life.' 'Performances sometimes function like a computer but emotionally they are in a continuous state of drying up as they circulate,' says Hermanis. And anyway, he adds, realistically enough, 'the actors are getting older.'[8]

After realism

Sometimes, though, the shows stick around for a while, or they come back into circulation, even *as* the actors get older. That is to say, there are also ways of imagining that we inherit or that are bequeathed to us by others, in a climate of acknowledgement and, again, a kind of respect. In Riga in January 2014 I saw a performance of *Fathers*, a work made in Zurich in 2007 (the same year as *The Sound of Silence*) and now being played for the first time in the home country of the director and two of the three actors. *Fathers* is another long work but with a simple structure.[9] Three male, middle-aged performers – playing themselves, or at least speaking in their own names: Gundars Āboliņš, Oliver Stokowski and Juris Baratinskis – take turns telling stories about their fathers. Each has his own space, a chair and a little table, placed across the width of the stage. They address the audience directly, although there is a sense also of something if not with-held or self-absorbed exactly, then kept all the same for their own. They are 'in' the part, the part of themselves: the sons, the actors, the storytellers. Sometimes the stories are simply narrated; and sometimes they are acted out with the aid of a few props: bread, pickles, a glass, a line of half-bottles of vodka. 'This is how he drank,' Baratinskis tells us in one episode. 'He had a rule, no empty bottles on the table.' The father's drinking is performed by the adult son as a discipline, something that somebody once dedicated himself to doing just like this. There are rituals: the pour, the wait, the sharp exhalation of breath, the swallow, the silence. And then another bottle, a repeat performance. While each performer tells or enacts a tale the other two actors are attended to at make-up tables at the side of the stage. They

are being made up to look older and this continues through the evening, as gradually they come to resemble their fathers, whom we are also getting to know from the large flats lining the back of the performance space, on which snapshot photographs of the fathers have been rendered as scaled-up paintings by Monika Pormale and her assistants. The flats, like the narrative episodes, are succeeded during the show by new images so that the fathers in the paintings get older as the sons do too, each pursuing the other through the passing time, already gone.

A souvenir, Susan Stewart has written – a family photo for instance – is an incomplete object, in the sense first of being a 'sample,' metonymic to the scene of the souvenir's 'original appropriation,' 'an experience which the object can only evoke and resonate to, and can never entirely recoup.' A souvenir is also, though, Stewart argues, required to remain partial – 'partial and impoverished,' she says – so that it can be 'supplemented by a narrative discourse,' a story. That is to say, 'a narrative of interiority and authenticity' that has something in it of longing: manufacturing a past 'voluntarily remembered' out of an assemblage, a collage of present remains.[10] The fact the photos here are enlarged and hand-painted only underlines this sense of made-ness, along with the precision, the intentionality of everything that the audience is given to see and hear. At the same time, what we might imagine that we see – as the fathers come into view, not only on the painted flats but on the heavily made-up faces of their actor sons – is the sons themselves, the image-carriers, taking the places of the virtual, the imaginary, the 'artificial' father-images they have been conjuring in their stories. The stage is very wide, and there is open lighting right across the space throughout the three hours or so of the performance. Our attention is put into a swim, or encouraged to wander, to over-stay, to edit and construct the stories we hear and the images we are given to consume. Towards the end of the show it is as if we hear the images speaking, and speaking as if we had imagined them there ourselves, as if we had projected them onto the stage, speaking directly to us. You might almost want to speak back in reply.

Hermanis's theatre, we could say, operates within the tradition of a certain historical and social realism, although a realism marked by a nuanced relation to illusion. W.J.T. Mitchell, in his book *Picture Theory*, makes a distinction between realism and what he calls illusionism. Realism, he tells us, is 'associated with the capacity of pictures to show the truth about things.'[11] It stands in for the observer's eye, puts itself so to speak at the service of the spectator, but with the understanding that the spectator it addresses itself to is an ideal, rational and – ultimately – replaceable spectator, for whom the representation says 'this

is the way things are.'[12] (And sometimes adds by implication the directive 'act accordingly': there is no presumption that how things are is how they must continue to be, there are plenty of realisms that would persuade us to imagine and bring about *changes* to the way things are.) Illusionism meanwhile has to do with playing with illusions, i.e. with representations that have the capacity to deceive, to trigger responses upon particular bodies and upon one's own body too. A capacity, we might say, to perform ideology, to make and unmake mimesis from any seat in the house. Illusionism emerges from Mitchell's discussion as a power of the human beholder, whose power includes the freedom to take pleasure. Or, as Mitchell puts it, echoing the historical dialectic we discussed in an earlier chapter, to 'conquer himself, enslave himself' in the face of an illusion: the verisimilitude of a painting for instance, or an immaculately rendered late 1960s commune that the beholder *knows* is only a painted or constructed scene.[13] This is an enjoyment also, in Mitchell's thinking, that is predicated upon a power over others, or at least on knowing how such power works, which includes the knowledge that '[i]llusionism is itself an illusion of play, freedom and mastery of illusion.'[14] I am thinking now of how often Hermanis's theatre has depicted people entertaining or occupying themselves with situations of illusion-making that are given – or rather taken and appropriated – *within* the given that another, prior and encompassing realism concerns itself with. Spaces set apart, home spaces and private spaces but also designated spaces of collective gathering – 'Temporary Autonomous Zones' to borrow a form of words.[15] A transparent chamber in the centre of the stage to which the characters of Gorky's realist drama of extreme poverty in early twentieth-century Moscow, *The Lower Depths* (or more strictly speaking the contemporary actors who are reading the historical characters' parts) can repair to for other sorts of fun and games, other sorts of experimental sociality (*By Gorky*, New Riga Theatre, 2004). Or the time-filling and survival activities, the solitudes and also the conditioned reflexes of collective living – and yes, fun and games and shared enjoyments also – with which elderly people living in extreme poverty in Latvia at the turn of the twenty-first century occupy themselves in the hyper-realist silent drama *Long Life* (New Riga Theatre, 2005).[16] Or, for sure, an imaginary 1960s that is given a space to happen, to pretend (and to make itself legible[17]) in the temporary ghost-world of *The Sound of Silence*.

Then again, maybe illusionism – even if it is 'the only weapon against illusion'[18] – is just the sort of thing that *realism* seeks to be realistic about, including the singular illusion at the heart of the whole affair. Call that latter the *anthropocentric* illusion, the human-centred illusion,

which includes the illusion that the figures on the stage are indeed human beings and that the rest of us involved in the operation are creatures of the same sort. At the very least the proposal 'that illusion provides the link between history and nature,' which Mitchell rehearses at one point in his argument,[19] would appear pertinent to an actor-based, twenty-first-century theatre practice whose core technology is the Stanislavskian technique and its various derivatives. A technology which is dedicated not only to an imaginative immersion in that history–nature link (Hermanis: 'either you are doing it for real, here and now, or what you do will very simply look empty'[20]) but also an exposure and working through of its very historicity. A working through that takes place in settings of blatant historical pretend, or in environments stuffed with all sorts of obsolescent tools and recalcitrant machines (apparently *Long Life* deployed over three thousand props), not to mention an unfathomably over-familiar pop music that comes out of nowhere, or out of the strangest places, out of anywhere at all: a book, a jar, a feather, a bucket of water, even out of someone's belly. We see it too in the most realistic of settings, for example a roomful of green plants and flowers that make their daily demands on an old man who still remembers the corpses piled three deep, and who marched across the same bog in the 1940s his father had marched across in World War I, and who follows the world outside now through a small TV, on which the images *he* is given to consume might as well be beamed from the moon.

The latter character is someone we encounter in Gints Grüber's documentary film *More than Life* (2014), which follows Hermanis and his actor collaborators in the making of three productions – *Cologne Affair* (Köln, 2008), *Grandfather* (Riga, 2009) and *Call of the Wild* (Munich, 2011) – according to the 'documentary' method he had been working with at New Riga Theatre for some years.[21] The method (a sort of verbatim theatre approach, as it might be called in Anglophone theatre, developed from actor training exercises[22]), involved individual actors identifying 'prototypes': people in the locality that they would meet and spend time with and invite to tell their story into a voice recorder, material which is then worked up in rehearsal into a script. Hermanis does not meet with the prototypes himself but develops the stories and their presentation with the actors, selecting and shaping the material, building up figures, characters – recognizable forms of human life. That is to say, forms and images that draw on the audience's shared recognition of the type, on the actor's personal acquaintance with the prototype and also on the visible presence of the actor him- or herself, who comes forward to 'carry' the image, as the refashioned stories are told or acted out on stage.

So it is that we see, in Grüber's film, New Riga Theatre actor Vilis Daudziņš attending a World War II veterans event on the border of Latvia, Russia and Belarus, in search of anyone who may have known his grandfather who, like the other older generation people here, lived through a period that included occupations by Nazi German and Soviet forces and which drew Latvians into the violence on both sides. Daudziņš finds no trace of his grandfather amongst the be-medalled veterans he speaks with – male and female – or amongst the day-tripping family groups, the marching bands and the uniformed open mic singers of nationalist songs. He does however talk with one gentleman who fought as a guerrilla against the German occupation – 'we are now referred to as Soviet fighters,' he tells Daudziņš, 'history twists everything' – and who becomes one of the two prototypes whose stories Daudziņš will work on. They sit in a tour coach together and the man tells of the time he saw the dead Red Army soldier 'with a bullet in his head, like so, sitting on horseback and the horse had also been shot dead.' He tells also of the day that he and the other members of the family heard that his brother had been shot and killed. He tells of going to the place where his brother had been buried, near the guardhouse where the killing had happened, where a gooseberry bush used to be, and digging through the soil to find his brother's body, which eventually he was able to do. 'There is black soil, there is sand and clay, so we are digging layer by layer, but in that spot suddenly it's all red, there is clay and sand, altogether.'

The film also introduces us to the second prototype for *Grandfather*, a man who fought on the side of the Germans in the 1940s, in the Courland Pocket he tells us, where the bodies were piled three-deep, and who shows Daudziņš the swastika flag he still attempts to display on Hitler's birthday, and the home photocopier he uses to reproduce holocaust-denying, moon-landing denying factsheets in the small apartment where he lives surrounded by living things, surrounded, as Daudziņš says in the course of the play, 'with green plants and flowers.' Hermanis and Daudziņš, back at the theatre, work together on a small, marked-off area of the stage which is crowded with hanging baskets and pot plants of all sorts, piles of papers and a stack of plastic-wrapped bags of garden soil. They discuss the soil, the need for the right kind of soil, how it sounds, how it spills when one of the bags is thrown down onto the stage; how it looks, how it crumbles when the search for the dead brother is performed by Daudziņš with his hands in a box of soil balanced on his lap. We don't know, we hear Hermanis say later in the film, what we would have done, how we would have acted, if we had been alive in those times. If you shot someone at that time, says the actor Daudziņš, you

would want to have had a motivation for that. You would want to believe that you were shooting from the right side, in order to be able to live with that. And then towards the end of the film, during rehearsals for *Call of the Wild* – a play about lonely people in Munich and their solitude and their dogs – Hermanis says that this will be the last performance based upon this method. The way of making has to change. 'We figured out the technology,' he says to camera, 'how to extract, how to suck out the poetic images and emotional knots from any personal gobbledygook documented in a tape recorder. At some point it becomes rather cynical,' he says. 'That method becomes cynical.'

With the help of imagination

And then there are ways of imagining, certain climates of attention, which may be said to fall upon us in weakness.[23] They involve delusions, mis-perceptions and also pathological hallucinations, although I am thinking in particular of everyday, non-pathological experiences that come upon us in tiredness, or when we allow or are encouraged to allow our attention to wander, to fold up upon itself and to conjure imaginings from between the folds. Experiences which, I want to suggest, may have something to do with an attention 'to' weakness, to what presents itself to our regard as weakening in one way or another in the beam of our concern. Hypnagogic vision is one form of it, which Jonathan Crary describes as 'the singular state between wakefulness and sleep in which sensory input and motor activity is reduced, leading to the sudden releasing of vivid sensory memories and images.'[24] For myself, that kind of weakened attention happens most often at the theatre (and not just in visual but auditory form) and usually early in a performance on occasions when 'sensory input' might be expected to be at its most intense. For which reason I tend to consider the experience a weakness first of all on my own part: a failure of focus and concentration and a 'letting down' of what is being presented, not just for myself, but for everyone else that is there to attend the occasion and to share what goes on. It is an odd sort of experience in that these theatre hallucinations can seem personal, as if image were some sort of animate substance oozing from the representational form and seeking me out, setting up odd little repetition patterns to ensnare me, snagging a thread of my distracted thought and giving voice and shape to it there on the stage, whispering to me, collapsing the distance between us. As if 'the ground of the image' – to appropriate a phrase from Jean-Luc Nancy – 'rises to us in the image.'[25] At such times I wonder how it is for everyone else in the theatre. It is a strange form of detachment after all, from one's fellow spectators and

from the spectacle that we are all there to witness, involving as it does such an intense adherence of the individual spectator to images that only appear to appear.

I presume, though, that such experiences are by no means unusual.[26] For instance, I've long wondered whether this was the sort of thing Gertrude Stein was referring to in her lecture 'Plays' of 1935 (a text which deals with the problematic derivation of theatrical 'sight and sound' from dramatic literature) when she wrote about how 'your emotion as a member of the audience is never going on at the same time as the action of the play.'[27] It is often in such situations of non-synchronization with the dramatic action, before the interval if there is one, before settling in is established, that the sights and sounds that are not strictly 'there' make their claims on the imagination. And they seem to do so immediately. As Jean-Paul Sartre puts it, the images that appear in this state 'are never prior to knowledge. Rather, all of a sudden one is abruptly seized by the certitude of seeing a rose, a square, a face. Up to that point one did not take notice there: now *one knows*.'[28]

For Sartre, the characteristics of hypnagogic vision include not only the weakness of the perceiver ('the motor basis of attention is missing,' he says) but also a quality of fascination ('we do not contemplate the hypnagogic image, we are fascinated by it') and specifically a fascination with 'radical falseness'; or to put it more bluntly, with nothingness, with 'what is in fact but an empty intention.' As he says, 'I really see something, but what I see is *nothing*.'[29] The situation is intensified, as we might expect, in pathological hallucination, which for Sartre 'does not take place in the real world' so much as it excludes it. Here, hallucination involves a collapse of perception, 'a sudden annihilation of perceived reality,' and also a 'disintegration' of the subject. As he says: 'The hallucinatory event [...] is always produced in the absence of a subject.' He continues: 'In a word, *the hallucination is presented as a phenomenon the experience of which can only be made by memory*.'[30] As if the experience of the event were constructed retroactively, post hoc.[31] In ways, I have been suggesting, that we do in the illuminated theatre that hovers before us, and which we seek, when it does so, to repopulate with images, with forms of imaginal life.

For Sartre there is a distinction to be made between imagination and perception. As he argues throughout *The Imaginary*, his book on the psychology of imagination from which our current remarks are drawn, the essential nothingness of the imagined object is enough to distinguish it from the object of perception. In this respect, imagining involves a sort of escape from the world, a certain liberty of perceiving, a capacity to stand back. Sartre: 'for consciousness to be able to escape from the

world by its very nature, it must be able to stand back from the world by its own efforts. In a word, it must be free.'[32] However, if this appears to mean that an image – an image produced by the imagination – is in a sense a denial or negation of the world, it 'is not purely and simply *the world denied*, but is always *the world denied from a certain point of view*.' To summarize: imagining involves an escape from the world and a denial of the real, but a denial from the point of view of a particular situation, in which the real is constituted – or re-constituted – as a world, but a world that does not contain the imagined object. An object which has the character of nothingness. As Sartre puts it, a double nothingness: 'nothingness of itself in relation to the world, nothingness of the world in relation to it.' The nothingness of an image that – for a while at least – negates the world 'as is,' but does so, as Sartre insists, '*on the ground of the world* and in connection with that ground.'[33]

As for hallucination, Sartre's translator Jonathan Webber argues that for Sartre hallucination – even pathological hallucination – is not so much a malfunction of perception as a different sort of attitude to the world, an attitude of stipulation rather than discovery:[34] an attitude that insists we are not compelled to live in the world as we find it, that we can imagine it otherwise. Webber evokes the Sartrean concept of bad faith, which encompasses those strategies we deploy to deceive ourselves into believing what we want to believe, or that we feel ourselves obliged to believe about our capacities and prospects: hallucinatory self-portrayals in which we hide our freedom from ourselves. For instance, the sort of self-imaging in which we imagine our professional occupation, if we have one, to be 'what we really are,' and in which we perform that role – with all the virtuosity we can muster – like the most accomplished sort of Stanislavskian actors. Suffering this self-image to stand in for ourselves. Of course, there may be an opening to freedom in such performances, where we act as if the world were other than we find it. There are, however, shadows to that illumination. Paul Ricoeur, in his own work on memory and imagination, picks up on Sartre's discussion of hallucination, and in particular the earlier philosopher's comparison of hallucination to 'obsessive thinking,' to propose we consider personal hallucination as analogous to the 'hauntedness' of collective memory – 'hauntedness is to collective memory,' Ricoeur suggests, 'as what hallucination is to private memory.' In particular, he remarks, as regards the 'past that does not pass,' the 'pathological [...] incrustation of the past at the heart of the present.'[35]

There is a sort of hallucinatory imagining in Hermanis's theatre. I think again, for instance, of how the Simon and Garfunkel songs we hear in *The Sound of Silence* are not given to the action as a

'soundtrack' but rather conjured by the characters as the sound, we might say, of the irreal (although for the audience of course the sound takes place in the perceptual real). Or I think of how shows such as *The Sound of Silence*, or the 2006 work *Sonja*, are born out of a stipulatory improvisation, if we can put it like that, upon the possibilities of an hallucinatory situation. We have already mentioned how *The Sound of Silence* starts with two young women finding themselves by chance inhabiting the scenography of the show. Something similar happens in *Sonja*, where two stocking-masked male thieves break into what appears to be an immaculately (hyper-realistically) reconstructed 1940s Leningrad apartment, which is also the stage-set for a theatrical adaptation of Tatyana Tolstaya's short story, which the thieves then proceed to enact (one reciting the words to the story, the other dressing up to play the eponymous *Sonja*). The very action of the drama, then, involves a conjuring of the irreal, an externalizing – or manifesting – of distraction, albeit a distraction made material, realized retroactively – as Adrian Kear has elaborated in his reading of the show – as a body, an event, a name.[36] This, as it happens, is also the theme of Tolstaya's story, which is about someone who is cruelly tricked into a delusion. Sonja is deceived by a fake letter-writing campaign into believing she has an ardent admirer, a delusion which – in an historical situation of extreme impoverishment: the 1941–43 siege of Leningrad – she commits after all to live by. Whether Sonja knows in the end that the admirer is non-existent is never quite clear. A trick, then, but whose trick is it?: an illusion, a delusion perhaps, a hallucination maybe that suffices in this case to sustain a person's humanity: a figment which – or so the story imagines – might be just real enough.

Or to come at the matter from a rather different direction. Much of what interests me here is touched on in Rei Terada's 2009 book *Looking Away*, in which she explores tensions between private and shared (or collective) experience through an examination of what she calls 'phenomenophilia.'[37] Phenomenophilia is Terada's term for the sort of distraction that involves giving one's attention to transient, ephemeral, 'pointless' phenomena – things that flicker momentarily and insubstantially at the edge of the more important stuff, things that appear to appear apart from the main scene, whatever that scene is supposed to be. In the philosophical and poetic examples that Terada considers, phenomenophilia is a deliberate practice, cultivated if not exactly as a means of turning away from the real world, then a way of avoiding – at least for a while – the felt obligation to accept the world 'as is.' Such experiences, given that the world 'as is' is the one we share with other people, tend to be private; we might even say selfish. They suit those

occasions when we don't want to think of others as sharing our percep-
tions, experiences that we seek out – Terada suggests – as a response to
dissatisfaction: dissatisfaction with the world and our relations to the
people in it, and with what we might feel as a coercion – not only to
accept things as they are, to accept the facts of life, but to *value* those
facts within certain normative frameworks.[38]

However, Terada also argues that we 'mind' these feelings of dis-
satisfaction when we recognize them, finding them unworthy of us and
inappropriate to indulge in. Which is why there is something self-withdrawn
in those moments when we look away to the film of ash, the 'stranger,'
flickering in the grate of the fire; or focus our attention – to cite another
of her examples – on the patch of grass outside the Walmart super-
market rather than having to deal with the ubiquitous fact of Walmart
itself.[39] There are also, then, freedoms to be found in looking away.
Terada writes about the promise of non-coercive relations that the
objects of phenomenophilia can offer, and about the liberating or faux-
liberating effects of the appearance of appearance and its temporary
suspension – a sort of rhetorical suspension she calls it – of fact percep-
tion.[40] She also reminds us that these experiences are indeed short-lived.
As she says, the hope for freedom surfaces, but then it is timed out.[41] In
part this is to prevent others from intruding on our experience. But it is
also a sort of self-policing, to the extent we do not believe in this hope,
or do not trust our belief, or we feel we are betraying something in such
activity, betraying the world, betraying the others who share it with us.
We convince ourselves that we don't deserve such relief from our obli-
gations to the world, or at least don't deserve so much of it. I remain
mindful of what Terada says about 'minding' throughout her book,
about a certain sense we may have that not only our familiar experience,
but even the interest we take in that experience, might be illegitimate in
some way or other. As illegitimate, if you like, as nodding off and letting
your attention wander in the theatre, when the work has been made on
your behalf, when you have paid for your ticket and everything.

There is, though, another direction to take all this. Terada's conclud-
ing response to the aporias and dissatisfactions that generate phenom-
enophiliac behaviour is to rehearse the imagining of more unconditional
spaces of thought: respectively, spaces of infinite justice and infinite
patience. That is to say, the infinite justice of a 'court of appeal'[42] that
would attend to *every* particular resentment; and the infinite patience of
a therapist who would have time to hear the discontents of an entire
civilization. From a text of Theodor Adorno's she borrows the example
of the individual resentments of the slighted or offended lover, who knows
that his unhappiness has nothing to do with fairness or unfairness, at

least not in any universal conception, and who *knows* that the happiness of any depends upon the free choice and activity of all, but who *feels* hard done by even so. An analogous example is taken from Sigmund Freud, a point so obvious, Freud himself declares, it is hardly worth the pen and ink or the compositor's and printer's labour to write it down and have it published. The point being that any pursuit of happiness will at some point impede the happiness of others, just as other people's pursuit of happiness can only get in the way of one's own satisfaction.[43] As it is, no-one has the time or the patience for such impossible tasks, although Terada proposes at the end that such figures are worth considering if they help us understand better 'whether and how to think about impossible projects' and why 'an unconditional space is a better idea than the few seconds of tolerance we usually give ourselves.'[44] Fair enough indeed, although it is also to be noted – an objection raised by the realist Freud and cited by the provisional idealist Terada – that the only perspective from which such infinities of justice and attention might be imaginable would be a perspective 'from outside "the human species."' Which brings us back, again, into the foyer of the theatre.

The images in our hands

Or brings us at least to the images we carry with us from the theatre. For example, those black-and-white photographs of 1960s commune experimenters that we saw in Naples; or those scaled up paintings of the family album dad snaps that lined the back of the stage in Zurich and Riga; or – our final instance – the set of colour photographs that Monika Pormale produced for the 2006 New Riga Theatre production *The Ice. A Collective Reading of the Book with the Help of Imagination in Riga*, and which I saw for the first time in publicity materials for a 2007 performance of that show in Brussels. This time the pictures were not confined to the scenography or the publicity, but could be encountered both inside and outside the theatre: ultimately as large-format reproductions suspended behind the audience around the four-sided playing area. Unlike the photo-based paintings in *Fathers* or the archive images that preface *The Sound of Silence*, these latter images depict a staged action, something being done or performed. And it is a peculiar sort of action. The photographs show citizens of a contemporary city in various everyday settings – a library, a railway platform, the aisles of a supermarket, the foyer of a bank, or in the water of a public swimming pool – paired off or in small groups, hugging each other chest to chest. This same action will be reproduced on stage for about a minute or so towards the end of the three-and-a-half-hour show, the entire cast of more than a

dozen actors embracing each other in pairs, holding onto one another like that as if the rest of the watching world could hereafter by all means be ignored, like motionless dancers, absorbed in their part in an image that is striking for its combination of outright banality and unworldly weirdness. That is to say, the banality, the everydayness, the immediacy and tenderness of the hug as a basic expression of human sociality. And along with that an utter indifference, seemingly, to any environmental element that would give that sociality its grain and context: the built world, its places and devices and structures and institutions, let alone the peculiarities and particularities of human difference, which remain conspicuous if unremarked both on stage and in the photos. As I say, it looks a little like people dancing, but not to any music we can hear (I cannot help remembering the young people in *The Sound of Silence* holding the jars to the walls), or with any sort of motion we can discern.

As it turns out, taking these as images of human sociality – or indeed of anything human at all – will have been a mis-reading, at least at the level of the story. *The Ice* is an adaptation of Russian author Vladimir Sorokin's dystopian 2002 sci-fi novel of the same name.[45] In Sorokin's fiction the huggers are a non-human species in human form deposited on earth by means of some stray inter-stellar block of meteoric ice, who recognize each other by communicating, literally, heart to heart (hence the hugging). They identify each other by hammering on the chest with an ice-hammer until the heart 'speaks.' Or until the 'meat machines' (which is how they refer to our particular species) die. They otherwise have little use for us or our benighted planet. Not the sociality of the slow dance at all, then, but rather that of the supremacist cult, itself a form of seduction no doubt, but not one that the theatre audience are likely to recognize themselves by.

An aside. One thing I might have made more of, although it was mentioned briefly at the start of this chapter, is that most shows by Hermanis that I have seen I happen to have seen in the company of friends. The one show I did not attend in company was *The Ice* in Brussels in 2007, where I was alone with my linguistic limitations at a long and talk-filled show – it is after all basically a collective reading of a novel – in a language that is foreign to me, i.e. Latvian. As it turns out, *The Ice* – as I might have guessed from the long title ('a collective reading of the book') – was a show 'about' ways of being together, both at the level of the theatrical situation (a group of actors and a group of spectators working together for a number of hours to realize the fiction imaginatively) and also that of the fiction itself (in Sorokin's novel, if not in Pormale's photographs or the New Riga Theatre cast, the heart-whisperers are a blond-haired Aryan group, with obvious resonances

with the Latvian history we touched on earlier). As Nicholas Ridout explores in his essay on the show, the challenge to imagine instructive ways of being together is also projected at the level of a political imaginary that borrows from those two modes of material cultural production – theatre-making and historiography – to evoke a mythic and seductive form of community (made up of storytellers and their listeners) that at the same time refuses – or is unable – to integrate its participants completely.[46] The audience is kept at a formal and actual distance from the performance of intimacy (although we do get to watch and enjoy), just as the cast continue to carry about them their particular differences from each other, acting out but never quite convincingly *becoming* the Aryan cult, the inhuman group. The illusion then – the illusion at the heart of the story's horror-fantasy of social and ecological melt-down – is the illusion of that humanity, there on the stage, here and there in the audience (the arrangement on four sides of the performance space meant we were all visible to each other), going about its business of performing the human community, *whatever* the story that was being told. That, anyway, was the basic image I brought back from the show and carry with me still, having drifted between the monotone and soporific French of the simultaneous translation in my earphones and the more lively (but to me incomprehensible) spoken Latvian that I would listen to occasionally in the 'air' outside. Along, that is, with the now altogether forgotten image-disturbances that punctured the afternoon, the hypnagogic delusions that – I confess – came upon me as I wandered occasionally between waking and sleep, while continuing to 'hug the boundary of the crossing' as I did so.[47]

But let me say something of what I remember being *shown*. The performance takes place 'in the round,' the cast seated on a ring of chairs encircling the performance space, from where they read out Sorokin's novel from typescript copies that look like rehearsal scripts. Occasionally one or more performers will go into the central space and sketch out a rudimentary action that relates to the action being narrated from the text. The actors are wearing everyday clothes. It all has the look of an open rehearsal, a text workshop. A few props and pieces of furniture are brought into play. A couple of chairs are made to serve as a motor car. A table and a bathtub appear to be doing service as a table and a bathtub and sometimes as other things: a bed, a boat, maybe a mortuary slab. From time to time there is some business involving actors slamming each other on the chest with ice-hammers. At the time I am unsure what that is about (I had not read Sorokin's novel in advance), but it suggests that the story involves some rough violence, interspersed it would appear with moments of intense tenderness: as I say, couples just standing there,

hugging each other, chest to chest, for what seems minutes at a time. Call this – the action that takes place on stage – a first order of images (or a first order of realism), a reading towards an enactment, a rehearsal of what is to happen, to be worked up later but good to be going on with for now.

The second order of images is more unexpected. The spectators are given aides to provoke our imagination, picture books basically, handed out by the cast, as if to nudge us into imaginative capability right now, while the images can still be gathered up amongst us, rather than later when we go home and think about it all in private, if that is what we will do. The first book is an album containing photographic snaps of the same actors that we see on stage before us, except 'in character' in real world settings, costumed and posed, enacting scenes from the fiction. Our focus is pulled between what is in our hands and what is happening on stage, not to mention the spectacle of the other reader-spectators around us. Even as the album might be supposed to direct our attention, it allows us to roam. With the images in our hands we are able to flick through at will and to read 'ahead of' or behind the story, with whatever licence 'the imagination' might take from that. My imagination, our imagination. Are we all imagining the same thing?[48]

When the second book is handed out there is a likelihood that we become aware that we are, at least, all *seeing* the same thing. This second volume, which now we are obliged to share with our neighbour, whoever our neighbour happens to be, accompanies a section of the show when the men in the cast leave the performance space and the reading is continued only by the women. The volume consists of a specially commissioned set of comic-book drawings expressing the argument of the tale through the medium of vividly pornographic Nazi kitsch. Negotiating the 'sharing' of these images with the stranger sitting next to me is no more straightforward than the task of measuring the degree of excess deployed in the representational means, not only in relation to the story that the women on stage are currently telling, but also in relation to them as actors, as people. They are over there and the representational framework – if this is the one that counts, the one of the moment (there may be another along later) – is here with us, the audience, the spectators, and in our hands: my fingers at the corner of the page, someone else beside me, with still that disembodied voice turning over in my ears. The third and last book, which accompanies a more elaborate passage of on-stage activity involving bath-water, and then the long scene of the hugging couples, and then the sharpening of ice skates on motorized whetstones by the whole cast that sends up showers of orange sparks as the theatre lights come down at the end of the show, is another photograph album. This one contains sepia-tinted snaps of uniformed

figures in some icy landscape maybe a century or so ago, posing for the record as people do in old photos, called to attention for the remembered moment and at the same time already a little bit lost.[49] Historical images that have something to tell us of what happened in those places, but which are silent against the screeching of the whetstones and the flying sparks at the conclusion of the show, this strange and strangely moving spectacle of a shared and at the same time distributed action, each performer behind their goggles attentively focused on sharpening their skates. For a journey north I presume; unless they are making ready for a time when the ice comes south, as soon it might. As it may have already in those billboard photographs of Pormale's that we spoke of earlier, suspended around the theatrical space: a space that contains us all, actors and spectators; showing us our civic spaces abandoned to an all-consuming – or should that be self-consuming? – species-attention, the weirdness of which still won't go out of mind.

Notes

1 The production was showing at The Napoli teatro festival in Italy, June 2008, a year after its opening in Riga.
2 See the discussion between Hermanis and Bonnie Marranca in Marranca, 'The Poetry of Things Past,' *PAJ: A Journal of Performance and Art*, PAJ 94 (2010): 23–35; 29.
3 Annalisa Sacchi, 'False Recognition: Pseudo-history and collective memory in Alvis Hermanis' *The Sound of Silence,*' *Meno istorija ir kritika/Art History & Criticism*, 6 (*Performing History from 1945 to the Present*) (2010): 32–37.
4 Alan Read, 'Hello Darkness My Old Friend. Alan Read in Conversation with Alvis Hermanis,' in *Theatre and Adaptation: Return, Re-write, Repeat*, ed. Margherita Laera (London: Bloomsbury, 2014): 181–95; 191. Audiences also have their own expectations of what that story should be. Audiences in Germany, apparently, where the piece premiered, were exercised by the fact that there is very little, if any, of the 'political' 1960s – and of 1968 in particular – in the version put together by Hermanis and the company; although this was an issue that played differently back in Riga where *that* 1960s did not happen, or not in the same way.
5 Elin Diamond, *Unmaking Mimesis: Essays on Feminism and Theatre* (London and New York: Routledge, 1997): 38.
6 Celia Lury, *Prosthetic Culture: Photography, Memory and Identity* (London and New York: Routledge, 1997): 37.
7 Universal subjects have tended to be gendered male. To the extent that Penone's tube is indeed for looking and listening through, it is for any and every subject, although some may have to bend down (or be lifted up) to get the benefit.
8 Read, 'Hello Darkness,' 183.
9 Andrea Erdmann is credited with the 'play' for *Fathers*.
10 Susan Stewart, *On Longing: Narratives of the Miniature, the Gigantic, the Souvenir, the Collection* (Durham and London: Duke University Press, 1993): 136, 145.

11 W.J.T. Mitchell, *Picture Theory* (Chicago and London: University of Chicago Press, 1995): 325.

12 Ibid., 323–8.

13 Ibid., 339.

14 Ibid., 329.

15 Temporary Autonomous Zone is a concept developed by the anarchist theorist Hakim Bey. See Joe Kelleher, 'Human Stuff,' in *Contemporary Theatres in Europe: a Critical Companion*, ed. Joe Kelleher and Nicholas Ridout (London and New York: Routledge, 2006): 21–33.

16 *The Sound of Silence* is in a way a companion piece to *Long Life*, performed by many of the same cast, but set forty years earlier.

17 'To pretend is not to put forth illusions but to elaborate intelligible structures.' Jacques Rancière, *The Politics of Aesthetics*, trans. Gabriel Rockhill (London: Continuum, 2004): 36.

18 Mitchell, *Picture Theory*, 344.

19 Ibid., 340.

20 Margherita Mauro, 'Interview with Alvis Hermanis,' in *Le Signorine di Wilko, or how to make poetry visible: the diary of a production*, ed. Mauro, trans. Vena Cantoni (Rome: Ponte Sisto, 2010): 178. In this same discussion Hermanis speaks of his own training as an actor and his commitment to the Stanislavsky-derived tradition.

21 Gints Grüber, *More than Life* (2014).

22 The term 'verbatim theatre' was coined by Derek Paget in '"Verbatim Theatre": Oral History and Documentary Techniques,' *New Theatre Quarterly*, 3.12 (1987): 317–36.

23 For Henri Bergson a relaxed or weakened attention was a sign of a deficiency of the will. Daniel Dennett in the twentieth century writes about the lowering of the threshold for gullibility in hallucinations and epistemic 'passivity.' For Jonathan Crary on Bergson see Crary's *Suspensions of Perception: Attention, Spectacle, and Modern Culture* (Cambridge, Mass. and London: MIT Press, 2001): 325. For Dennett see his *Consciousness Explained* (London: Penguin, 1993). For a critique of Dennett's 'argument from illusion' and an alternative view which considers hallucination in terms of 'belief-forming mechanisms' see Pierre Jacob and Marc Jeannerod, *Ways of Seeing: The Scope and Limits of Visual Cognition* (Oxford: Oxford University Press, 2003): 13–14.

24 For Crary 'a case could well be made that hypnagogic perceptions are the most common subjective conditions under which most individuals have known a powerful penetration of the present by memory.' *Suspensions of Perception*, 325.

25 Jean-Luc Nancy, *The Ground of the Image* (New York: Fordham University Press, 2005): 13.

26 Max Milner makes the point that illusion was a development of baroque art (he refers to the invention of the magic lantern, trompe l'oeil images, and developments in illusionistic theatre decor) whereas the discourse of hallucination relates more to nineteenth-century realism and hyper-realism. See his introductory comments in Silvia Bordini, Donata Presenti Campagnoni and Paolo Tortonese's collection *Les arts de l'hallucination* (Turin and Paris: Museo Naxionale del Cinema and Presses de la Sorbonne Nouvelle, 2001): 8.

27 Gertrude Stein, *Last Operas and Plays* (Baltimore: Johns Hopkins University Press, 1995): xxix.

28 Jean-Paul Sartre, *The Imaginary*, trans. Jonathan Webber (London and New York: Routledge, 2004): 39.

29 Ibid., 44–8.

30 Ibid., 150, 153, 158.

31 I have in mind here the work done more recently by Zabreb-based artist collective and theatre makers BADco on 'post-hoc dramaturgy,' a term coined by Tomislav Medak, developed in writings by Medak and dramaturg Goran Sergej Pristaš, and exhibited at the company's contribution to the Croatian pavilion at the 2011 Venice Biennale. See http://badco.hr/2012/06/04/whatever3_4/ (last accessed 17 August 2014).

32 Sartre, *The Imaginary*, 184.

33 Ibid., 186, 185.

34 Jonathan Webber, 'Philosophical Introduction,' in Ibid., xxv.

35 Paul Ricoeur, *Memory, History, Forgetting* (Chicago and London: University of Chicago Press, 2006): 54.

36 See Adrian Kear, 'Naming the Event: Alvis Hermanis and Jaunais Rīgas Teātris' Sonja,' in Kear's *Theatre and Event: Staging the European Century* (London: Palgrave Macmillan, 2013): 92–118.

37 Rei Terada, *Looking Away: Phenominality and Dissatisfaction, Kant to Adorno* (Cambridge, Mass. and London: Harvard University Press, 2009).

38 At the very opening of her book Terada also acknowledges a debt to Stanley Cavell's thinking on acknowledgement and scepticism, touched on earlier in the present volume.

39 Both are examples that Terada discusses, from Samuel Taylor Coleridge the nineteenth-century poet and Michael Vahrenwald the twenty-first-century photographer. Terada acknowledges that Vahrenwald's photographs 'are not, perhaps, phenomenophiliac, except for their emphasis on color and their choice of a nearly worthless object to spend time with,' *Looking Away*, 201.

40 Terada, *Looking Away*, 21.

41 Ibid., 203.

42 Ibid., 190f.

43 Ibid., 199. Freud's comments appear in *Civilisation and its Discontents* (1931). See Sigmund Freud, *Civilization, Society and Religion* (Pelican Freud Library Volume 12), trans. James Strachey (Harmondsworth: Penguin, 1985), 308. The relevant passages of Adorno are 'Court of Appeal' and 'Golden Gate' in his 1951 *Minima Moralia: Reflections on a Damaged Life*, trans. E.F.N. Jephcott (London and New York: Verso, 2005): 97–8, 164–5.

44 Terada, *Looking Away*, 204.

45 New Riga Theatre's production was made in 2006. Sorokin's novel was published in English translation as *Ice*, trans. Jamey Gambrell (New York: New York Review of Books, 2007).

46 See Nicholas Ridout, 'The Ice. A Collective History of Our Collectivity in the Theater,' in *Theatre Historiography: Critical Interventions*, ed. Henry Bial and Scott Magelssen (Ann Arbor: University of Michigan Press, 2010): 186–96.

47 Pavel Florensky, *Iconostasis*, trans. Donald Sheehan and Olga Andrejev (Crestwood, New York: St Vladimir's Seminary Press, 2000): 44.

48 For a fine essay on related themes see Dan Rebellato's 'When We Talk of Horses, Or, what do we see when we see a play?' *Performance Research*, 14.1 (2009): 17–28.

49 For another take on these picture books see Jeff Johnson's comment: 'For Hermanis, these three assemblages represent the current collocation of theatrical motifs in vogue in Latvia: everyday social concerns [...], titillating voyeurism (decadent attempts at prurient entertainment), and traditional depictions of historical theatre [...].' Johnson, *The New Theatre of the Baltics: From Soviet to Western Influence in Estonia, Latvia and Lithuania* (Jefferson and London: McFarland, 2007): 179. See also Nancy, *The Ground of the Image*, 106: 'in a photograph there is always something hallucinatory, something that has lost its way or is out of place.'

6 Everybody acts (on friendship)

Edward Kienholz and Nancy Reddin
Kienholz, *The Art Show* (1963–1977);
Split Britches, *Lost Lounge* (2009);
Forced Entertainment, *The Thrill of it
All* (2010); Wendy Houstoun, *Pact with
Pointlessness* (2014)

Art show

If we start this chapter as we ended the last one, with an image of a
group of people standing around in a public space (as we might say up
to no good), this time the figures are more substantial, more fixed and
three-dimensional than Monika Pormale's ambiguous photographs of
ordinary-seeming citizens who may turn out not to be citizens of this
world at all. This time we are dealing not with photographs but a
sculptural installation, although given the lay-out of the place we see the
figures before finding out who or what they are. They might strike us at
a distance like a group of performers – actors, dancers – who have been
gathered to do or to show something, or else an audience who are here
to attend to something that other people are showing and doing. As it
turns out, neither designation quite fits although, as we will see when we
do get close, the group are identifiable members of a world where
showing and attending is very much part of what goes on. Specifically,
art world people. Art lovers and art workers. Transmitters and com-
municators. Gallery owners and curators. Collectors. Critics. Art his-
torians. Art theorists and cultural philosophers. Some artists too. There
are even some art world children – three of them – squatting together on
the floor by a far wall. They are all here, most of them with drinks in
hand, cigarettes poised, as if they were attending the opening of a show,
which is appropriate enough given that where they are is an exhibition
room in Berlin's Berlinische Gallerie. They have been here for quite a
while, I imagine since the gallery itself re-opened in its present location
in 2004. They are, after all, part of the permanent collection and in fact
some of them have been striking these poses and holding onto their

drinks – which appear to be made of dyed wax or something of the sort packed thick into the dusty cocktail glasses and tumblers in their painted, papier-maché hands – for even longer, since 1963, when American artists Edward and Nancy Reddin Kienholz started assembling their multi-figure installation *The Art Show*. The last figures were completed fourteen years later in 1977.

They are a peculiar bunch up close, like living figures that have become to an extent inorganic, although this is not to say there are no signs of life in them still: built-in, legible and testable signs at that.[1] For instance, attached to the chest of each figure is a device, a transparent plastic box exhibiting the entrails of some radio-like contraption. Press a little chrome button on the box and you can listen to what they have to say for themselves: a fragment of recorded speech, tinny and not always easy to make out, in one of a variety of languages, English, German, Italian, French. Lean in closer to listen better, noticing as you do so that the plaster and papier-maché figures are dressed – or so, I would say, we might well imagine – in their actual clothes and that those clothes are thoroughly impasted in a thick gloop of hardened varnish, and it is like you can still feel their breath upon your face. At least, you can feel a thin stream of warm air being blown out of the recovered car radiator facings that have been placed in the places where these figures' faces should be. Eyeless, mouthless, featureless, they commune with each other across the room: Edward and Nancy Kienholz's friends, their bodies cast in plaster and their voices recorded on tape to function, one imagines, as an archive of sorts – is that what this is? – of a social world, a cultural milieu. Documentary evidence of a particular place and historical moment that is now lost and gone, although something still attaches itself to the figures, in friendship as it were: a peculiar 'air' of attachment as such.

There are, as it happens, archival documents already on the gallery walls: photographs of the plaster-casting sessions, letters and contracts, sketches from the installation plans. It is almost as if these wall exhibits – these evidences of their own making and memorialization – were the 'artwork' that these revenant art cognoscenti had assembled to witness and discuss. Except, there is something of detachment here too, to the extent that the figures seem orphaned from the very environment that their being here together would appear to constitute. It is a typical effect of gallery installations that invoke a fictional or historical 'world' such as this one: the floor remains the gallery floor, it never becomes a stage, it is not the ground from which the fiction grew and on which it can continue to live. The sense of detachment has to do also with their immobility, the way they keep their particular places in the gallery so

that it is oneself that has to make a movement and go over to them, intruding upon the small group configurations, getting in someone's faceless face to press those little chrome buttons. Or say, if there is a fiction at work here, it is a fiction of distances. So, the distances the figures keep from each other can be read as those across which their relations to each other – as friends, as collaborators, as trusted repositories of expertise and taste and opinion – are recognized, respected and assured. As if they know where they stand in that respect, whereas we are not really there for them at all.[2] These friends may not be talking to each other anymore, or not through any channels we can tune into, but for sure they are not talking to us. The social poses, the warm breath, the speaker-box contraptions, it is all something of a put-on, something that has been done to them rather than anything that they are doing. As if there is nothing to transmit, nothing to communicate, at least not outside the network of friendship, which we have no part of. And if there is nothing to transmit – this is what I am thinking as I move from group to group, standing up against these figures that feel strangely enough just a little larger than life-size – maybe there is nothing being remembered, and nothing *to* remember either. No eyes, no mouth: nothing to see or say with. Friends, so to speak, united in refusal. Or not even refusal, but a sort of inorganic indifference to it all.

Indifferent, for instance, to any case that might be made for the artwork as 'contemporary art,' even though cases of this sort would seem to be these figures' particular *métier*. And maybe there is no case to be made, not today anyhow. After all this is not contemporary art anymore, it is a work from the 1960s and 1970s that carries a strong sense of the passing of its own contemporary moment (however dilated that passing over two decades of figure-making), in which the figures were already provenanced and documented up with pastness and, as I say, impasted forehead to foot in a varnish gloop. What is exhibited in this installation that you can enter and 'interact' with (press those buttons, check those voices, feel that pretend breath) without ever becoming a guest at the party is not so much an address to the contemporary – their contemporary, our contemporary – as a sort of surviving of images, in spite of all. That is to say, in spite of what ages and ends and gets lost, of what gets forgotten and abandoned, and what just seizes up, in whatever renunciation (voluntary or involuntary) of action, feeling and of thought, to the point of immobility.

Or to the point of feelinglessness: their feelinglessness and maybe then ours too. At which point I am minded to consider what the Greeks called *aisthesis* (feeling). Or 'sense apprehension,' as Susan Stewart puts it in a 2003 essay about 'the face-to-face encounter between persons and

the face-to-face encounter with artworks' and about what, in a future ethics of art founded in the facticity of nature (and in the wake of realism's attempts at 'adequations of reality' and 'concreteness'), 'cannot be totalized in the representation of other persons.'[3] Or 'sensation' as Daniel Heller-Roazen refers to it in a 2007 book called *The Inner Touch* that seeks to historicize those elements of experience and 'nature' that we might imagine to be most resistant to historical perspective, including the fundamental awareness, common to humans and other animals – an awareness that is felt as much as thought – of existing, of being alive in the world.[4] Or what philosopher Jacques Rancière in his 2011 book *Aisthesis* (translated into English in 2013) refers to as 'the sensible fabric of experience' within which works of art are produced, and which includes both the material conditions of production of artworks ('performance and exhibition spaces, forms of circulation and reproduction') but also 'modes of perception and regimes of emotion, categories that identify them, thought patterns that categorize and interpret them.'[5]

Rancière's focus in *Aisthesis* is on historical forms of artistic expression and their relation to experiences of thought and sensation, and how these get to be recognized at particular moments as properly 'belonging' to the art show. Recognitions which bring about each time a change in the models and habits of understanding of what 'allow[s] for a form, a burst of colour, an acceleration of rhythm, a pause between words' to be 'associated with the idea of artistic creation.'[6] In Rancière's version of modern art history where innovations involve a breaking down of the genre divisions and hierarchies of representation that determined what sorts of experience 'count' as being worthy of artistic expression (as well as the forms that expression was supposed to take), this means that there is a chance, at any moment, of artistic allowances dissolving back into the forms of everyday life, previously excluded from art, from which the art had shaped itself.[7] Shapes, forms, allowances and operations which, according to the structure of Rancière's book, are not, as we might expect, presented in a look-ahead argument towards the future (or even to the contemporaneity) of art and politics. Rather they are gathered retroactively, belatedly – dramaturgically we might say – as a series of chapter-length 'scenes' built around analyses of short historical texts (paragraphs from journalism, essays, personal letters and the like) in each of which a new allowance of art is recognized. As if we were to press one of those buttons on one of the speaker-boxes of the Kienholzs' friends and listen a little closer to the words that come out, hearing at least, even if we do not speak its languages, the sound of a world saying something about itself, even as those figures withdraw from our world into their own history, staging that withdrawal in our very midst.

For example, a chapter of Rancière's book that opens with symbolist playwright Maurice Maeterlinck's famous invocation of 'an old man seated in his armchair, simply waiting under the lamp, listening, without knowing it, to all the eternal laws which reign around his house' develops into a detailed exploration of the 1890s symbolist theatre of immobility, or 'theatre without action,' the theatre of Maeterlinck himself and also his contemporaries Lugné-Poe and Adolphe Appia.[8] This particular allowance – of a seemingly actionless stage image that Rancière refers to elsewhere as the 'withdrawal of action' and which we might take as an allowance for critical thought, for imagination, for sensation as such and its reflections – is figured as an ambiguous, experimental but in its time necessary condition for political freedom. That includes the freedom of art from a 'representative order' that defined (in Aristotelian terms) 'the poem as a plot, and a plot as an order of actions' and also, in what may seem another realm entirely (but isn't, entirely), the freedom of workers who 'could not repudiate the hierarchical model governing the distribution of activities without taking distance from the capacity to act that subjected them to it, and from the action plans of the engineers of the future.'[9] The point being, for Rancière, that these realms are not so readily coupled *or* uncoupled. Or at least, if the lessons to be taken from the history of the art show are indeed to be turned towards a future – a future of the image, for instance, to borrow the title from another of Rancière's books – then the sort of images we might want to concern ourselves with would not be those which establish a ready resemblance to something imagined or in the world, but rather images that bring together unlikely elements in the kinds of complex relationship that trouble the structure of resemblance as such. These are images, for example, that articulate seemingly incompatible potentialities: that of 'the image as discourse encoding a history,' 'a cipher of a history written in visible forms,' but also as 'raw, material presence,' as 'obtuse reality, impeding meaning and history.'[10] Phrases that would appear to capture the sort of thing we have to say about *The Art Show*, although Rancière takes the matter further (as, I would say, does the Kienholz installation).

Rancière, in *The Future of the Image*, asks what sort of image might stand as a measure of the common – of what 'we' have in common with ourselves, our others and, by extension, the rest of existence – and he proposes that any workable common measurement can only be a 'singular production' and this production can only be workable to the extent that it confronts, stands up to 'the measurelessness of the melange.'[11] Or, as we might say, the vast and indifferent (and, as we have learned to think of it in this age of social media, 'friended' and unfriended) everythingness of it all. Where Rancière's argument is heading is towards

what he calls the 'sentence-image,' again a bringing together of elements in a sort of 'parataxis' or side-by-side relation – for instance visual elements and verbal elements, or material substance and historical discourse – in such a way that not only are relations between text and image put under pressure but also the relations of any 'phrasal power of continuity' or any 'imaging power of rupture' to suppositions of meaning and affect, of feeling and sense.[12] (We should note that parataxis was one of the main features of 'postdramatic theatre' identified by Hans-Thies Lehmann in the 1990s.)[13] Only through such means, in the realm of art at least, can the measurelessness of what surrounds us all – the 'great schizophrenic explosion,' the sentence reduced to a 'scream' as meaning is reduced to the 'rhythm of bodily states' on the one side and the numbing consensus of commodification on the other – be faced down. In a sort of broken middle (to recall Gillian Rose's phrase from one of our earlier chapters) where, in Rancière's illustrative image (borrowed from a Marx Brothers movie) a comedian without speech is keeping a wall from collapsing, until a policeman makes him move away (at which point the wall collapses). But then, prior to the realm of art – as Rancière allows in a brief aside – there was always the 'entertainer' and their 'indefinitely repeated abrupt switch of subject, capable of combining everything with everything.'[14] And it is to the entertainers that we come next.

The thrill of it all

I won't have too much more to say about *The Art Show* in what follows, but it is worth noting before moving on that when I came across the work in Berlin it presented itself as something of a gift. At the time I was preparing a paper (out of which this chapter has grown) for a symposium on the topic of 'Affective Archives,' concerned with modes of communication and transmission of emotions that attach to our encounters with works of art. That is to say, concerned with how such emotions and sensations ('attention, desire, involvement, boredom' and so on[15]) might be documented and archived, held in store so to speak. Or, to remain for a moment longer with the term we invoked above, how *aisthesis* as such might be held in store *as* speech, although this was not the only medium explored during the symposium.[16] It was a question also of how the store of affections might be activated, enacted and transmitted performatively, or *as* performance, with all the complications that would imply for the remembering of experience, the sharing of experience, the retroactive invention of experience after the encounter, and of course the editing, the miscegenation, the re-purposing and the

forgetting of experience, any of which may be effective approaches to 'affective archiving.' The nature of the gift that *The Art Show* presented me with, then, was the possibility of considering the performance of friendship itself as a means of affective archivization: a sort of durational encounter in which the contingency of attachment (and of encounter also) is sustained by some sort of mutual agreement or commitment (or joint perception) between people, as friends. It also struck me that something of the sort was a way of revisiting particular encounters – in the theatre by and large – that had remained with me, in which what appeared to be at stake was something to do with this mutual sustaining (and contesting) of the grounds of mutuality, to the extent that it was this same troubled mutuality that had left the affective impression – a surviving image – beyond any detail I could remember or adequately describe. I should say that most of what touches me in this respect has something to do with an accumulation of years, my years and other people's, and something to do no doubt with ageing and a tendency to retrospection, although each instance also involved the immediacy and insistence of a theatrical occasion, a certain being-performed-now, or what Susan Stewart in the essay cited above refers to as 'a recognition of indeterminacy in the encounter between makers and receivers.'[17] Recognition anyway of the contingency of what happens *to* you, even if what is really going on is something that is happening, or happened, to somebody else.

I remember, for example, some years ago at another symposium, in London, listening to four former members of Tehran's Theatre Workshop speaking in public for the first time in thirty years about the work they made together before the door of their theatre was – literally – bricked up as a result of the 1979 Iranian revolution.[18] The conversation went on for three hours or so. There was weeping (and also some laughter) both on stage and in the auditorium. Something was being shared out, distributed amongst friends and strangers, although the group's leader Arbi Ovanessian, who shared reminiscences that day in English along with Susan Taslimi, Iraj Anvar and Shohreh Aghdashloo, refused to speak publicly about the work in Farsi, the language in which their theatre was made: a linguistic context from which he considers the work's memorization to be – effectively – orphaned still. I remember also from further back – it must have been around the same time that in another part of the world the doors of the Theatre Workshop in Tehran were being bricked up – seeing another two guardians of repertoire, Joe Strummer and Mick Jones of The Clash, arguing with each other on stage – I think they may have come to blows or maybe that's just how it felt at the time – as to whether they would or would not play their early

punk anthem 'White Riot.' Did they play it? I don't remember. I do remember more concretely and from more recently – although the occasion is already some time ago now – watching two no less legendary performers, Peggy Shaw and Lois Weaver of Split Britches, performing their cabaret show *The Lost Lounge*, a theatrical meditation on what is lost, on what is recalled, on what gets replaced – and replaced by what exactly – in a working relationship, in a personal relationship, in a landscape and environment in which the work and the relationship were fostered, in a performance repertoire that also belongs to one's audience, in one's physical and emotional capacity to put that repertoire over and in the audience's capacity to receive and respond to it.[19] And then what shifts and sustains from one relationship – or one part of a relationship – to another. As Nicole Eschen puts it in her essay on the show, while there is a case to be made for 'the disruptive power of forgetting,' Shaw and Weaver remind us that 'repetition and disjuncture are often not chosen; they are results of an unavoidable normative temporality of the aging body.' So it is then that 'Weaver and Shaw sit at the bar of their lost lounge and remember meeting each other, neither for the first time nor the last but rather as repeated routine.' And so it goes that a dance break, which is supposed to take place on a trapeze but which Weaver performs supported by a stool and by Shaw's arms, 'exemplifies the grace and beauty of the lesbian relationship at the heart of Weaver and Shaw's performance collaboration,' so that 'even when failing and arguing, they support each other and complement each other.' As Eschen concludes, the performers endure: in their work, in their collaboration and as an image (for Eschen a 'vision of lesbian endurance') and they do so by 'pressing back against both negative affects and positive progress models.'[20]

These are all occasions that exhibit or acknowledge the strain of the relationship we have been calling friendship, strained to the point where friendship reveals itself as part of the very fabric that holds the work together. It is the sort of strain that is integral to the stage-craft of an ensemble company such as Forced Entertainment, who through thirty years (at the time of writing) of making theatre would appear to have taken custody of a machinery of affects, readily transmissible, generated out of particular ways of working together, which we might hazard have something to do with friendship, or friendship's rhetoric: or say, what looks and sounds like friendship from where the audience are sat. Shortly after I had come across the Kienholzs' *The Art Show* in Berlin I saw Forced Entertainment's annual touring show at Riverside Studios in London, which that year (2010) was a large group piece *The Thrill of it All*, involving all the core members of the company and also various new

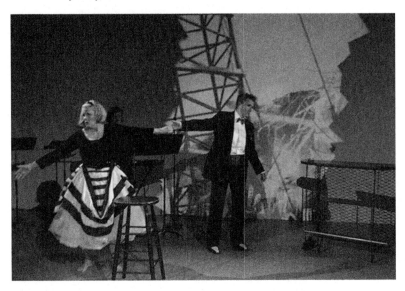

Figure 6.1 Split Britches, *Lost Lounge*, 2009. (Photo: Lori E. Seid)

and familiar special guests.[21] Not unlike *Lost Lounge*, which recalled mainstream cabaret double acts such as the 1950s husband and wife act of Louis Prima and Keely Smith, *The Thrill of it All* (which included its own repertoire of judiciously inhabited dance breaks, choreographed by Kate McIntosh) evoked old-style popular entertainment, the last days of television-age vaudeville, the men all in white jackets and red shirts, the women in spangly dresses, everyone in black or blond gender-specific wigs, the microphone voices crudely turned to high treble for the women and deep bass for the men. In the course of the performance, and irre-spective of the funny voices, the ensemble emphasize their familiarity with each other, for example through the use of real names, although this familiar behaviour is not particularly 'friendly.' In fact it is all rather niggly, as if touching on the insecurities and resentments of those whose job it is to appear before others and occupy their attention. And indeed every single thing that any performer did in this show seemed intended to get a rise (as the phrase goes) or to 'make a connection,' to raise a laugh and to gather the gains of theatrical seduction. Except the come-on was rather threadbare, the show including a number of extended sequences where the performer onstage appeared emptied out, full of nothing to say, nothing to do and rather desperately trying to make the best of it, desperately trying to remember something that would serve, trawling their repertoire of bits and devices for something worth

offering, something that will do the trick, something worth putting over. The whole operation, then, came across as a sort of hyperactive but at the same time insecure and over-compensating entertainment machine. Except – and this felt crucial, although it remained unacknowledged from the stage – the audience that was being addressed (and indeed referred to explicitly throughout the evening) was not really us. It wasn't ourselves that were being worked on, niggled at, sentimentally button-holed. We just happened to be sitting there, as if the entertainment machine, however inorganic, were also a machine that calculates, that thinks; and what it thinks – sitting where we were sat it was like you could feel that thinking at work, you could sense it happening – is that all this desperate gathering and putting out that appears to be going on, all this exhaustive and exhausting remembering and transmission of whatever comes to mind, isn't the point at all. Or say, nothing really *depends* on whether the laughs happen or not: if it really is the case that the spectators and performers, the makers and receivers, need nothing from each other and have no demands to make either. All of us at some level withdrawn from the *eros* of the entertainment scenario and facing instead another sort of responsibility – between them, between us – to do with another sort of liking, sourced from some forgotten (or forget-ting) self, where we face each other's differences for a start, and to no particular end, as we might say: unconditionally.[22]

Everybody always acts

To recap. With its dances and costumes and direct address speeches and whatnot, there is a rhetoricality of persuasion, of seduction on show in a work such as *The Thrill of it All*, which would appear to be addressed directly *to* the audience, as if to provoke us into a response, to make us feel something or other (or at least make us laugh). Except 'we' the audience are not in fact being persuaded, seduced or provoked into any-thing at all (which is not to say we don't feel things – or indeed laugh). Rather, it is as if we are there to witness another sort of image entirely, an image withdrawn from the action it purports to represent and which shows instead something like the following: a group-based activity in which each member of the group performs a function – all are perform-ing the same function more or less – through which the individuals are tested, pressured by the group situation and everything the situation is responsible to. In this situation, the actor – or so it appears – is not required to inhabit (or imitate) a character, but to generate and deliver items, messages, for broadcast outside the group: bits of knowledge and experiential perspective, like a sort of ongoing theorization at the most

quotidian and 'common' level of discourse, and at the level too of par-
ticular, personal bodies (irrespective of the generalizing effects of the
wigs and costumes and voice treatments). Knowledge that has to do with
an individual's being there, their own sense of existing, which is to say
existing amongst others in the world and registering a responsibility *to*
the world (however reflex that responsibility, and however irresponsibly
it may be carried off). I think for instance of Fredric Jameson's phrase
'everybody always acts,' from his book about theatre-maker Bertolt
Brecht's 'method,' which Jameson characterizes as 'a kind of ethos, or at
least a moral training of a specific type,' and which has to do with
bringing to appearance the forms of 'productivity' that inhere in human
'activity.'[23] It is a matter, Jameson writes, 'of what people say about
what they do – in other words, about the inherent and verbal knowledge
their gestures and actions carry with them, and how they explain
these to themselves and to others.' It is in this sense, for Jameson (and, he
proposes, for Brecht too) that everybody always acts, to the extent that we
generate a sort of phrasal continuity about this 'proto-dramatic' quality
of even our most ordinary acts, in which we 'ceaselessly tell stories to
explain ourselves, dramatizing our points in all kinds of ways, the
undramatic as well as the ostentatious and self-parodical.'[24] What the
theatre does, then, according to Jameson (or at least the mid-twentieth-
century pedagogical theatre of Brecht) is it shows, it stages 'the showing
of showing, the showing of how you show and demonstrate.'[25] In the
dramatic theatre of rhetoric and representation (which arguably *all*
theatres partake of), informed by Aristotelian perspectives that not only
link action to plot as an order of cause and effect but also establish
aisthesis as an 'ontological ground' for friendship and the common
measure, it may be that we gather in the theatre to show ourselves and
each other that we do exist in the world, that we feel ourselves to do so,
that we find joy in this sensation, and that we share this joy with others
as a shared image, a 'joint perception.'[26] But then again, perception –
and the suffering of images – can be a scaly, discontinuous, 'hetero-
simultaneous' state of affairs,[27] involving continuous rupture, breakage,
loss and other sorts of interruption. When Jameson, then, writes about
'those instances in which the theoretical content of our everyday move-
ments suddenly intrudes upon us and our fellow "actors"' I think for
example of those moments of sideways glance and niggle in Forced
Entertainment's work, or of the *sense* of exhaustion in the performance
of the 'feminine' role on the part of the multi-petticoated Lois Weaver in
Split Britches' *Lost Lounge*. The art show, or so I imagine, was made to
show us this too. As if, in those shows where the performers appear to
be wearing labourers' uniforms rather than actors' costumes, there

followed an obligation for these actor-figures to say something for themselves, and in so doing acknowledge a responsibility (how far would it extend?) to say something too of the world, for the world, to say something of 'it all.' But then, however would someone do that? How would they ever get close?

Of friendship, and promises[28]

We come back to friendship. Paul Ricoeur: 'Proximity would be the counterpart to friendship, that philia celebrated by the Greeks, halfway between the solitary individual and the citizen, defined by his contribution to the *politea*, to the life and activity of the *polis*.'[29] But before we come back all the way, we return to the visible and the sayable, with recognition (again) and (glimpsing ahead) the making of promises, and with another theory of images to add to the others we have been accumulating throughout this book. Ricoeur distinguishes psychical traces – what we might call affective traces, the sort we might seek to gather in our affective archives – from two other sorts of traces: documentary traces on the one hand (which would have a social, archival dimension and relate to historiographical operations) and cerebral, cortical traces on the other (which belong to biological materiality and would be the concern of the neurosciences).[30] Affective, psychical traces, then, have to do with the persistence of first impressions, impressions that 'touch' us and which continue to leave a mark long after. Or so at least it seems when these impressions return – and are recognized – as images. There are two fundamental qualities to these impression-affections: one is that they appear to remain, or endure, or survive; the other is that they maintain a relation to absence and distance. What survives is an impression of what did, but does no longer, act upon us, of what is no longer there. The shape, if you will, and the emotion of an encounter. Where Ricoeur goes with this notion – in the wake of Henri Bergson's thought on 'the survival of images' – is to consider the enduring of affections as a form of forgetting, but a very particular form of forgetting. Not the forgetting that is caused by the destruction or erasure of traces (which may come about from ageing or death) but forgetting as a sort of putting-in-reserve. The proof of this reserve of affection is the unlooked-for experience of recognition; which means also that one's archive – so to speak – of impression-affections can only be affirmed retrospectively. Only through recognition and the 'reliving' of images do we retrospectively presuppose, according to Ricoeur, the birth of memory at the moment of impression. We are our own affective archive, to the extent that we forget ourselves – and imagine then to recover

ourselves when the images come. As we might, for instance, in the theatre when we find it functioning, as in the examples we have been discussing so far, as a sort of extra-personal store of tropes and affects that may still 'work,' a lost lounge that remains – as long as we can carry a tune, shake a leg or improvise a punch-line – open for business.

If what binds us to ourselves is a matter of images, that is to say a phenomenology of memory and what Ricoeur calls 'the small miracle' of recognition,[31] then what binds us to other people – relocating the phenomenological to a social sphere and enacting a shift from memory into the field of historiography – is the verbal action of promising. I make the promise to you. I promise to do something for you, or to give you something that will be to your benefit, and what underwrites any particular promise that I make is the fundamental promise to keep my word in all circumstances. I promise to be constant to this promise. Indeed, my constancy is nothing else than this commitment: to be, and to be the one that acts, irrespective of our differences, irrespective of my differences from myself. As Ricoeur puts it, the issue is not far from 'what we call fidelity when speaking of friendship.'[32]

There is provenance for all this, at least as far back as Nietzsche's characterization of humanity as the promising animal in *The Genealogy of Morals* ('This fully emancipated man, master of his will, who dares make promises [...]'), remarks that are cited by Hannah Arendt at the end of the section on 'Action' in her 1998 book *The Human Condition*, where she speaks about promises – and forgiveness – as forms of action performed in the face of human unreliability.[33] As Arendt sets it out, a person cannot guarantee who she will be tomorrow, what she will be capable of, or incapable of. In addition, whatever an individual's personal capabilities or steadfastness, we are all of us unable to guarantee the consequence of our actions, given those actions take place in a world made up of other free individuals with the same capacity to act as ourselves. In the theatre of promises however – of the promises we make to others and ourselves, and which we credit each other with being able to keep – some partial alloying of present and future is at least allowed for (forgiveness would be the action that sustains a relation to the past). As Arendt says of morality, 'it has, at least politically, no more to support itself' than the 'readiness to forgive and to be forgiven, to make promises and to keep them.'[34] So long, that is, as promises remain 'isolated islands of certainty in an ocean of uncertainty,' so long as there is no attempt to 'cover the whole ground of the future and to map out a path secured in all directions.'[35] So long, in other words, as there is an ongoing rupture of totality, rupture that Arendt figures as 'natality,' as beginning again, the action we 'are capable of by virtue of being born.' And so long, we

are inclined to add, as this or that action stands apart, that it not be taken for the world, that it not attempt to stand for 'it all.'

Unless, that is, friendship is indeed more unconditional than that. To cite another twentieth-century French thinker, Simone Weil, whom Ricoeur also alludes to,[36] friendship is the approval of another's existence, irrespective of one's approval of another's actions or attitudes. Friendship is a relation where meeting and separation, mingling and distance, are entwined; where disillusion is put to the test, along with one's capacity to be alone; and from which the desire to command as much as the desire to please is removed: a relation that 'has in it,' in Weil's words, 'at the same time as affection, something not unlike a complete indifference.'[37] There is an insight here which may help us move towards a conclusion, through two last examples – two scenes of friendship – in which the sentence-image is pressed to breaking (but does not break). The first is a text by one more twentieth-century French writer. The second is a performance that the current writer saw in London a day or so before these sentences were prepared. The affective impressions are still being felt.

Maurice Blanchot's text 'Friendship' is a piece of writing issued on the death of his friend Georges Bataille in 1962. It is, though, a text that barely mentions Bataille (he is named only once) and which says next to nothing about him.[38] Over three short sections Blanchot appears to resist not only speaking of his friend, even though the public gesture of the obituary might lead us to expect otherwise ('How could one agree to speak of this friend?' is his opening line), but he also forgoes the remembering – not just the act of remembering but the very capacity to remember – that such speech would supposedly draw upon. Of course Blanchot admits that remembering can – and will – happen and he enumerates some of the ways in which it is likely to happen. As he says, images return, and we allow them to do so. 'We can let the images come,' is how he puts it – or how his translator puts it – a phrasing that suggests something of what we call upon and grasp at in recognition, in supposedly involuntary memory. As the next phrase has it, 'we can appeal to an absence that we will imagine, by deceptive consolation, to be our own.' We can – or so I take it – imagine not only our friend's absence, but our own absence from the conversation: as if by such means the conversation could be recovered, carried on, as in some sort of afterlife, as imaged in the seemingly ageless – but still dust-gathering – intellectual gathering assembled by Edward and Nancy Reddin Kienholz.

That, however, according to Blanchot, is not where loyalty to our friends resides. As he puts it earlier in the text, there is 'something in us that rejects all memory' and that something has to do with the way we

watch over the 'fading movement' in which both our proximities to our loved ones and also our specific – and it may be carefully nurtured – distances from them dissolve, level out, disappear. As he writes at the end of the piece: 'thought knows that one does not remember: without memory, without thought, it already struggles in the invisible where everything sinks back to indifference. This is thought's profound grief. It must accompany friendship into oblivion.' As it is, in friendship itself, in the life of the relation, 'the recognition,' according to Blanchot, 'of the common strangeness [...] does not allow us to speak of our friends but only to speak to them, not to make of them a topic of conversations (or essays) [...].' In the death of one or the other of us, in whatever abyss of duration such a moment opened onto, in the tearing down of the stars that left only a remains of light fast-dimming in the darkness and which leaves us with the vertigo of immeasurable illusion, it may be one cannot even do that, cannot even speak 'to.' What, then, of transmission and communication, if indeed it is true that 'one does not remember': that one remembers nothing at all – whatever the images (whatever the words, the recovered gestures and rituals, whatever the thoughts and feelings) that appear to come, or that one lets come?

Coda: dance breaks

Wendy Houstoun begins her 2014 solo performance *Pact with Pointlessness* by avoiding the microphone stand in the middle of the stage.[39] She approaches it but then she swerves and instead runs round and round the stage, to no obvious purpose, while the title of the show, projected blatantly on the screen at the back, shifts through various zany multi-coloured fonts. The title is a pun, of course, denoting fullness and a contract, a treaty – a relationship, a promise of sorts – but then a relationship with what? A contract 'packed' with purposelessness? And like a pun, Houstoun's work itself will ever be on the point of dissolving – or dissolved already – into something other than itself, into the parts of the lived life from which the artwork has been formed and which the work 'allows' into its purview: its scope, its concern. When Houstoun does get to the microphone she has to stand on a chair to speak into it. She treats the situation as if lowering the height of the mic stand is not an option. Maybe it was set like this for somebody else, someone taller than herself (she is not a tall person), or maybe it is just that some things have to be taken as given, and dealt with like that. Anyway, she makes a speech, which she introduces tentatively, roughly, with stumblings and repetitions as just a bit of 'stuff,' an offering of some thoughts and questions, although what it becomes – or what the speech pretends to become – is

an attempt to ask – and to answer – all of the questions, to speak about it all, on behalf of it all, what it's all about when you work it out … Alfie, in a semi-automatic tumble of talking driven by addition and overlap. A kind of word-play that is ever going back on itself, to what it has just discovered, what it has just recognized of itself, and then pushing out again from there to see if there is something else to be found, the thing found before gone now in that pushing out, forgotten already. The video projections on the back screen and a sort of benevolently galumphing tune that accompanies her speech are interrupted from time to time. Presumably all of these materials – and their interruptions – have been organized by Houstoun as part of her work, but, like the over-height microphone stand, she treats them as if they were not, or as if there were some sort of obligation, some responsibility she is supposed to acknowledge in these prompts and stutters, these slight collapsings of the theatrical environment, to which she is never able to respond adequately or in time (at best a momentary standing to attention and then carrying on). As the work progresses, mis-function and error messages fill the screen along with screeds of unintelligible computer code. At one point we see screen-shots of someone seeking to get away from it all: Google searches for a sea-and-sun holiday, room and flight options, swimming pool photos. However, Houstoun is going nowhere, at least not yet. There are dances to deal with, and 'deal with' seems to be the operative approach. It is not so much that Houstoun dances in this show – although she also does that, throughout – but that she shows the dances, demonstrates the dances, as in Jameson's phrase from earlier, showing the showing, and adding to the movement and the demonstration a constant flow of talk, although often the soundtrack music is up so loud (again life and world do not necessarily observe our agendas) that it can be hard for those of us in the audience to hear what she is saying. A central sequence seems to be set in Brazil, in the Amazonian forest (I may be misremembering, the sound was loud indeed at this point), involving two dancers one of whom here is represented by Houstoun herself, and the other by a bright red fire bucket that happens to be to hand. The dance is told, shown, demonstrated, somewhat under sufferance although not without vigour, just as for much of the latter part of the show she gamely wears a large cardboard box over the upper part of her body. The box makes it hard for Houstoun to bend to recover the microphone; indeed it makes it hard for her to move at all – or at least makes any attempt at elaborated movement rather pointless, or so we might think. But Houstoun carries on, her recorded voice telling us about steps and rhythms, about how it goes when I step like this, how it is when I strike out in that direction or shuffle on the spot, with

this particular rhythmic gesture, just like this. And look, she seems to be saying – although she says nothing about it, she simply shows – look what it looks like when I throw fistfuls of sand from the fire bucket into the beam of the theatre lights (she tells us all afterwards in the post-show Q&A that it is in fact cat-litter). Look how it scatters and falls. And look what it feels like to kick at these settled piles of cat-litter, in every which direction. And it is funny when she does that – the show is funny right through: laughter again is very much what this performance is about – but that funniness is layered, engrained, choked (like an atmosphere clouded with cat-litter dust) with other concerns. Not least bereavement.

Houstoun's performance is a memorial for fellow dancer and choreographer Nigel Charnock, who died in 2012. She has spoken of her friend and frequent collaborator's death as the event that made her 'question everything.'[40] After seeing *Pact with Pointlessness* I was remembering Charnock's last choreographed work, the two-hander *Haunted by the Future* (posthumously performed by Talia Paz and Mike Winter a few months after his death at London's Dance Umbrella festival) and spent the day after seeing Houstoun's show watching clips – whatever Youtube affords – of earlier pieces from his career, some involving Charnock as a performer, others not. What strikes me as I work on my own memory, but above all as I trawl this haphazard archive – I am looking at episodes from works such as *Made in Brasil* (2005), *Happy* (2009) and *Revolution* (2011) made with groups of young dancers in Brazil, Poland and Hungary respectively, and ensemble pieces such as *Stupid Men* (2007) or the beautiful short film from the uncompleted project *10 Men* (2012) – is the no doubt obvious observation that all of this work is 'about' being with, being alongside other people.[41] Of course, that captures a vast range of experience, and Charnock's work was distinctive (amongst other things) for the range and mixture of what it included in its own 'art show,' an art it appears that he was happier to think of in terms of the inclusivity of 'entertainment,' and an eclecticism that included 'serious' dance alongside jokes, rants and other verbal forms, and a range of concerns from religion, literature and music in all its forms, to 'languages, politics, rubbish TV, action movies and chick-flicks.'[42] But in this too the work exhibits the alongsideness of things. It witnesses we might say a certain 'withness': exhausted at times, vicious at times and straining (particularly in what I remember of the very bitter marriage dance-drama *Haunted by the Future*) but at the same time inexhaustibly reiterative, as if having to return (there being no other option) to the fact of our worldly co-habitation and whatever that affords – if not of meaning or 'point,' then of feeling and of thought, an exhilarating sense of being alive.

Houstoun's solo piece is also of course a performance of withness: a pact 'with' pointlessness. Or a sort of with and withoutness, in which she does not speak of her friend – what is the point, although doubtless he is 'in' the work in all sorts of ways – but even so gathers something sayable, and where not sayable showable, a raw and tender appearing that props up and strains against a 'historical' discourse that goes on as it can, in the company of us, a theatre audience, a bunch of common strangers. And she does so while pseudo-news items run along the bottom of the screen, bulletins from the empire of consensus, ironic push-button illustrations of the madness out there: PEOPLE KEEP LOSING THINGS AS MORE THINGS GO AWAY. EYES GET TIRED AS PEOPLE FORGET TO BLINK. ORDER OF NUMBERS JUST BORING, SAY PUPILS. ALPHABET NEEDS A RETHINK, SAY TEACHERS. In homage to Charnock, I take it, Houstoun ends and exits with a joke, about the relations between parts, about rupture and dependence, about what goes together and what does not, if going is what's going on. She tells the one about the two body parts having a drink in a bar, a jaw that can't stop jawing on and an eye that is beginning to droop. Both know that it is getting late in the evening and the jaw calls on his mates, the other body parts, if they are ready to head out with him and one by one they make their excuses and depart ('There were a couple of elbows, they slipped off the bar … '). Houstoun shuffles off also, still talking as she goes, wrapped in her cardboard box, the light fading, fading.

Notes

1 Sigmund Freud writes of aging in a 1936 letter to Lou Andreas as 'a crust of indifference creeping up […] a way of beginning to grow inorganic.' Cited Kathleen Woodward, *Aging and its Discontents* (Bloomington, IN: Indiana University Press, 1991): 48.
2 Compare Cavell on *King Lear* in *Must We Mean What We Say? A Book of Essays* (Cambridge: Cambridge University Press, 2002): 332. 'A character is not, and cannot become, aware of us. […] We are not in their presence. They are in our presence.'
3 Susan Stewart, 'On the Art of the Future,' in *The Open Studio: Essays on Art and Aesthetics* (Chicago: University of Chicago Press, 2005): 15, 22, 26.
4 Daniel Heller-Roazen, *The Inner Touch: Archaeology of a Sensation* (New York: Zone Books, 2007): 93–5.
5 Jacques Rancière, *Aisthesis: Scenes from the Aesthetic Regime of Art*, trans. Zakir Paul (London and New York: Verso, 2013): x. I am grateful to Theron Schmidt for the nudge to look again at Rancière's work.
6 Ibid., x.
7 See Jacques Rancière, *The Politics of Aesthetics: The Distribution of the Sensible*, trans. Gabriel Rockhill (London and New York: Continuum, 2004), 23.
8 Rancière, *Aisthesis*, 111–12.

9 Rancière, *Aisthesis*, xiv–xvi, 113.
10 Jacques Rancière, *The Future of the Image*, trans. Gregory Elliott (London and New York: Verso, 2007): 11–12.
11 Ibid., 42.
12 Ibid., 46.
13 H.-T. Lehmann, *Post Dramatic Theatre*, trans. Karen Jürs-Munby (London: Routledge, 2006): 86.
14 Ibid., 45, 43.
15 Giulia Palladini, Marco Pustianaz and Annalisa Sacchi, 'Affective archiving: a manifesto,' in *Archivi affetivi/Affective Archives. Un catologo/A catalogue* (Vercelli: Edizioni Mercurio, 2013): 16–17. The conference took place in Vercelli, November 2010, as an Italian regional cluster of Performance Studies international. For earlier work on the term see Ann Cvetkovich, *An Archive of Feelings: Trauma, Sexuality, and Lesbian Public Cultures* (Durham: Duke University Press, 2003).
16 Others included writing, film and video, collective rule-based game-playing, broadcasting and listening, as well as mastication and the contractual ownership of remains.
17 Stewart, 'Art of the Future,' 26.
18 *Iran: New Voices* symposium, Barbican, London, November 2008.
19 The landscape was in large part that of New York Lower East Side performance venues where, as Nicole Eschen recalls in her essay on the show, Split Britches and other queer artists have performed in the past. Nicole Eschen, 'Pressing Back: Split Britches' *Lost Lounge* and the Retro Performativity of Lesbian Performance,' *Journal of Lesbian Studies* 17 (2013): 56–71.
20 Eschen, 'Pressing Back,' 68, 69, 70.
21 Forced Entertainment, *The Thrill of it All*, 2010. http://www.forcedentertainment.com/page/144/The-Thrill-of-It-All/69 (last accessed 17 August 2014).
22 I am grateful to Maria O'Connor for an ongoing conversation that is echoed in some of the phrases here and throughout the chapter.
23 Fredric Jameson, *Brecht and Method* (London and New York: Verso, 2000): 177–8.
24 Ibid., 83.
25 Ibid., 91.
26 Heller-Roazen cites a passage in Giorgio Agamben's reading of Aristotle's *Nicomachean Ethics*, which draws attention to how Aristotle places aisthesis at the basis of 'the theory of friendship as a whole.' Heller-Roazen, *The Inner Touch*, 298. See Giorgio Agamben, 'The Friend' in *What is an Apparatus? And Other Essays*, trans. David Kishik and Stefan Pedatella (Stanford: Stanford University Press, 2009): 31–3. The Aristotle passage appears at the start of Book 9 of the *Nichomachean Ethics*.
27 See Boyan Manchev, 'The Unimaginable and the Theory of the Image' (2004) http://theater.kein.org/node/50 (last accessed 9 June 2014).
28 Much of what follows in this section was first rehearsed in a performance dialogue 'Promises' with Silvia Bottiroli and Giulia Palladini, commissioned for the public programme of *Performing Idea* (2010), part of the Arts and Humanities Research Council-funded research project *Performance Matters*. The project was curated and directed by Adrian Heathfield, Gavin Butt and Lois Keidan of the Live Arts Development Agency. See http://www.thisisperformancematters.co.uk/performing-idea/home.html (last accessed 25 August 2014).

29 Paul Ricoeur, *Memory, History, Forgetting* (Chicago and London: University of Chicago Press, 2006): 131.
30 Ibid., 427–35.
31 Ricoeur, *Memory, History, Forgetting*, 39.
32 See ibid., 190–91.
33 Friedrich Nietzsche, *The Birth of Tragedy and The Genealogy of Morals*, trans. Francis Golffing (New York: Doubleday Anchor Books, 1956): 191. See Hannah Arendt, *The Human Condition* (Chicago and London: University of Chicago Press, 1998): 243–7.
34 Arendt, *The Human Condition*, 245.
35 Ibid., 244.
36 Paul Ricoeur, *The Course of Recognition* (Cambridge, Mass. and London: Harvard University Press, 2005). See Simone Weil, 'Friendship,' in *The Simone Weil Reader*, ed. George A. Panichas (New York: David McKay, 1977): 366–72.
37 Weil, 'Friendship,' 370.
38 Maurice Blanchot, 'Friendship,' in *Friendship*, trans. Elizabeth Rottenberg (Stanford: Stanford University Press, 1997): 289–92.
39 Wendy Houstoun, *Pact with Pointlessness*, Purcell Room at Queen Elizabeth Hall, London, June 2014.
40 See Judith Mackrell, 'Wendy Houstoun: the death that made me question everything,' *The Guardian*, 26 May 2014. For a pertinent essay on friendships between men and women from a queer studies perspective see Jennifer Doyle, 'Between Friends,' in George E. Haggerty and Molly McGarry, eds., *A Companion to Lesbian, Gay, Bisexual, Transgender, and Queer Studies* (Oxford: Blackwell, 2007): 325–40.
41 An online search will deliver these and many more sources.
42 'Nigel Charnock,' obituary, *The Independent*, 15 September 2012. The article is signed 'Wendy Houston.' For Charnock on art and entertainment see the filmed interview *Nigel Charnock: Choreographing Life*, http://vimeo.com/ 31969397 (last accessed 9 June 2014).

7 The writing on the wall (on images and acts)

Romeo Castellucci, *Four Seasons Restaurant / Giudizio, Possibilità, Essere* (2012–2014); *On the Concept of the Face Regarding the Son of God* (2010); *Orfeo ed Euridici / Orphée et Eurydice* (2014); Gillian Rose, *Mourning Becomes the Law* (1996); T.J. Clark, *The Sight of Death* (2006)

We are supposed to arrive on time for the theatre. There is a designated hour on our tickets and, in the more well-appointed places, a five minute and maybe even before that a ten minute hurry-up bell, and there is sometimes a notice on our tickets or signs on the theatre foyer wall (Latecomers Will Not Be Admitted, or at least not until a suitable break in the performance) reminding us of the consequences of tardiness. Perhaps, though, as we have been suggesting throughout the previous chapters, for all our best efforts there is no way not to be late for the theatre – and also no way to get a jump on what Rebecca Schneider, for one, has referred to as theatre's 'always already anachronistic, always almost but not quite obsolescence' – and we know this is the case, and so does the theatre.[1] So it is, on the outskirts of the northern Italian city of Bologna in early 2014, that a number of us turn up for a show called *Giudizio, Possibilità, Essere* [*Judgment, Possibility, Being*] that is being staged at an old-fashioned public gymnasium – the floor marked out for basketball and other games, nets at either end, wooden climbing frames along the walls, a few of the polystyrene tiles in the ceiling displaced I presume by basketball attack. The first thing that happens when the show eventually starts (it starts a little late, there is a wait for latecomers) is a sort of prelude. This involves a short text – I think of silent cinema caption boxes – projected onto a small self-assembly screen from a whirring, blinking home-movie film projector, operated by a young woman whose dun-coloured long skirt and shawl suggest the dress styles

of the nineteenth century. The captions tell us about the sound that is starting to fill the gymnasium space, a slow-rushing roar like that of a massive wind blowing from another world. Which is indeed what it is: as the text on the screen explains, what we are hearing is X-ray activity converted into signals discernible to the human ear and collected by a NASA outer space telescope from the vicinity of a Black Hole in a star cluster in the Milky Way, 250 million light years from earth. We are listening to something that sounded – if *sounded* is what it ever did – a long time ago. It is a reconstructed phenomenon, technologically reconstructed but also a thing of the imagination, that puts everything else, as the saying goes, 'in perspective': the young woman's quaint costume, the rather arcane film projection apparatus (later on in the evening, on the side of the main action, we will be treated to what look like super-saturated, early colourfilm slides: fields, flowers, verdant hills and bright chalets), and not least the schooldays-evoking community gym. Compared to that stellar wind, given such inconceivable distances in space and time, these other elements are only the latest breaths of human history, mixed together in the same mouth. Maybe lateness at the theatre is only one way, and a minor way at that, of being unpunctual for the images, of finding ourselves shaken loose into the gaps between other historical bits and pieces that have their own sense of assurance as to where they stand in relation to each other. Anyway I retain the feeling – even at the end when the actors will make their individual final exits amongst us, walking between us, so close, like ghosts that have put on actual flesh and warmth – that we are still late enough.

Or so I remember it. As it is, those walking-amongst-the-audience exits did not happen in Bologna so it must have been at another performance, another gymnasium where the doors are arranged differently; perhaps the previous year's showing in the nearby town of Cesena – the home town of the company Sòcietas Raffaello Sanzio and director Romeo Castellucci, whose work this is. Or perhaps that memory of the actors exiting amongst the audience is a composite (mis-)remembering from several performances. When I attended the performance in Bologna I had already seen the work three or four times, including a longer version with a different title (*Four Seasons Restaurant*), where the explanatory textual prelude about sound from a Black Hole was projected onto a video screen or onto the stage curtain before any actor had appeared, and which included a final sequence set inside a volcano that is not possible to realize outside of a professional theatre building, or anyway not in a sports-hall gym.[2] Even in the 'theatrical' versions however, where the gymnasium setting was clearly a piece of scenographic fiction revealed on the opening of a curtain, I was struck by something which

complicated even further the experience of this particular latecomer spectator. This was the sense, simply, that the space, once revealed, is waiting for something to happen; or rather, something that *will* happen. A waiting room, we might call it, if the phrase didn't evoke spaces set aside at the doctor's surgery or the lawyer's office or the railway station, foyer and threshold places where we await a departure or an arrival, a consultation, a visit or an operation, something that will happen to us or to people we know. That meaning may become appropriate enough as this chapter develops, but for now I am thinking not of a room for waiting in, but a particular frequent and uncanny effect of theatrical scenography: the appearance of a room that waits – waiting for what will only ever have happened right here. Waiting, that is to say, for some significant action – indeed let us go the whole yard and say some significant *human* action, even if the work we are talking about opens, as already noted, with an invocation of pre-ancestral existence, before there were any human beings to wait or be waited for. I am thinking also of the sense of indifferent anticipation (or unremarked recent departure: people are about to arrive here, or else they just left) we might take from an architectural perspective drawing, not least if such a drawing, such a represented space, is marked up with indicative lines of direction and measurement, orthogonals and perpendiculars and the like: not altogether unlike the floor of a sports-hall gymnasium.[3] When perspective is sufficiently and explicitly articulated in the theatre, as it still tends to be, it can appear to be a place where we ourselves, the beholders of the action, have also been awaited, for who knows how long. Then again, if those are only lines that happen to be on the floor, set out like that for people's games, perhaps it matters not who comes or when, or what they choose to notice. Would-be beholders shuffle for a spot, as we do in Bologna, amongst the few benches, some places on the floor and standing room to the sides.

As for the action itself, it starts we might say with the nausea of decision. A group of young women, a dozen or so, enter the gymnasium. They are dressed in the same fashion as her who operated the film projector earlier, in clothes of another time, maybe Civil War America (there are confederate flags draped on some of the climbing-frames) although nothing is so definite. Also their time and place – wherever, whenever it is – is not altogether, not yet, removed from the present occasion in which we see them arrive. Their time is our time too, potentially. But then they perform the cut. Each of the women, one by one, cuts out her tongue with a pair of scissors. It is a fiction, of course, but done with some representational fidelity. None of the women refuse to go through with the self-mutilation but there are signs of understandable nervousness – some

hesitation, some weeping – that register their awareness of an irrevoc-
able act. An act which, in the larger scheme of the drama, may even be a
small event, a sort of threshold action, but a threshold from which there
is no going back. It is the sort of action that can be decided upon and
planned out but cannot be rehearsed; the sort of decision that can be
discussed and considered but can only be enacted with a cut.[4] As if to
confirm the irrevocability of what has happened (and with it the forget-
ability, the dissipation in historical time of the individual trauma) a dog
comes on and licks up the small pieces of flesh that spot the floor.

What follows, then, we can characterize as an embodied reflection on
the poetry and philosophy of the decisive, creative act. Or, we might
remark that for the rest of the evening the women rehearse a play. For
the next thirty or forty minutes, with renewed, recovered, redeemed or
straightforwardly borrowed voices (at times the actors' live voices are
replaced by recordings, previously 'cut' from themselves) the women
rehearse fragments from a play that is itself a series of unfinished, frag-
mented versions. The play is the late eighteenth-century poet Friedrich
Hölderlin's drama *The Death of Empedocles*, about the doctor and poet-
philosopher of ancient times whose own irrevocable act (unless it was a
punishment of sorts for setting himself up over nature) was to commit
suicide by throwing himself into the volcano of Mount Etna on the
island of Sicily. It is a play of mourning. Indeed, Hölderlin's poetic tra-
gedy might be considered a late version of the sort of seventeenth-century
Trauerspiel (mourning plays) analyzed by Walter Benjamin in the book
on the emergence of German tragic drama that he was working on
during that period in 1924 on Capri with Bloch and others.[5] That said,
there is not too much really of allegorical melancholy in the women's
performances – a bright-eyed and obstinate enthusiasm morelike – and
although Hölderlin's play was unfinished, the women's actions imply
that for them there are in fact ways of living with loss (to anticipate a theme
that we will come to soon) on the other side of sorrow. Indeed, in their
hands the text serves less as a latterday *Trauerspiel* than a precursor to
another, modernist German dramatic form, the Brechtian *Lehrstück* or
learning-play, in which the 'actors' would work through a script for the
sake of what they (in the way of political training) can get from it.

Either way, the women appear to play for themselves, like students (I am
imagining now classically trained adepts of the humanistic training of
the modern enlightenment Gymnasium school system), accompanying
every speech with the sort of arcane and strictly coded rhetorical gestures
that derive from Renaissance paintings. They make themselves into an
image, a series of images – literally, like speaking figures in a painting –
as if in this way, somehow, the intelligence of pictures could be mined,

not by a beholder, but from the inside, by the actor-figures themselves. There is a peculiar sense that what we are seeing and hearing repeated – the gestures, the speeches from the play – is not the play's performance but its perpetual rehearsal. It seems as if the play itself were suspended, held in store by those same audible sentences and legible gestures and ready to precipitate, like rain, out of another sky than the one we are gathered under, in the form of poetry that is capable of soaking us to the skin – not just the actors but ourselves also – or else washing straight off us, however the case may be.

Perhaps this sense of a suspension of the drama has to do with the ways that the decisive, creative act – if that indeed is the quarry here – is difficult to conceive, let alone enact, not least as regards its timing, its punctuality let's say. In a passage from the first version of his play (I don't recall if these words were recited by the actors in Castellucci's production) Hölderlin has Empedocles express something like a resigned frustration with the limitations of his own act, which will always have missed its proper (i.e. historical) moment, happening too late, or appearing to happen too late. 'What was I waiting for, and for so long, / Till fortune, spirit, and my gentle youth had passed / and nothing but absurdity remained, and misery.'[6] But then, too late is always too soon also, as there is never time to rehearse enough. Empedocles' speech continues: 'O silent ones! you good gods! the mortals' too / Impatient word goes rushing out ahead / And will not let the hour of accomplishment / Mature unhurried.' In a short prose fragment of 1795 known as *Being Judgment Possibility*, from which Castellucci's work borrows its title, Hölderlin rehearses the conditions for this limitation in phenomenological (and ultimately political) terms, whereby the unity of being that the poet dreams of is prevented by the divisions, the distances, the separations that are intrinsic to self-consciousness – i.e. to those acts of intellectual intuition and perception by which the dream as such is realized.[7] The same sorts of distances and separations, we might say, that institute the theatre. Which perhaps has something to do with why Hölderlin never completed his Empedocles drama, leaving his hero perpetually at the lip of the volcano, although the mourning for his act had already long begun, from the first lines of the first version ('This is his garden! There in the veiled / penumbra, near the bubbling spring, he stood / not long ago, as I passed by – you / have never seen him?'). As if the 'love' that would hope to overcome such separations – the love that grounds a collective imagining perhaps, of a social unity of equality and freedom – were itself unrealizable, impossible; or possible only as 'an apparent solution a temporary solution' (Hölderlin again, from an essay on Empedocles), though one cover the earth in its pursuit.[8]

We come back to the women in the gymnasium, whether they are engaged in an improvisatory re-birthing ritual as they will be at the end of the performance, each adding their infinitesimal soul's weight to the wind that blows through the enormity of the galaxies; or alternatively, as some of them do, strapping on the rifles and the partisans' bandanas of political radicals in this sublunary world. Shall we say that they, in their immediacy and collective anonymity, succeed in their commitment to the decisive act in a way that Hölderlin's hero does not? Shall we say for instance that they succeed in leaving behind the scene of sacrifice in which – in Hölderlin's phrase – 'the whole human being becomes actual and visible,' and where again for a moment the strife of the times appears to be dissolved, but dissolved in the form of an image – nothing more than an image after all – whereby 'the individual goes down in an idealized deed'?[9] Shall we say that they succeed where Hölderlin, with his unfinished play does not, or cannot, by completing their mourning? If they do so, they do so after all in – or rather *as* – the theatre, where their actions are subject to the separations and distances of witnessing (even to witness what passes us by so closely, just a breath, just a whisper away), and also to the contortions of judgement. Certain consequences follow from that. To suggest just two: Any act performed for the sake of a transformation of the present situation, for the sake of an imagined future, will, under such conditions – the conditions of there being a spectator – risk being judged as ridiculous, to the extent that the future is nothing that the act itself, however decisive, can guarantee. We give ourselves up to the decision, we cut ourselves away, and the wind blows anyway. Second, any speech, any poetry, any reasoning that follows on such an act may be apt to sound pretty much like that wind, blowing in from elsewhere like a speech borrowed from the past, or from abroad. We open our mouths, we raise our arms, and it is another's voice that speaks through us, or so it will seem *to others*, even if the voice is – was, once – our own. Of course, such actions, such language, we can shake them off, we can leave *them* behind also with the arcane pictorial gestures that accompany them, like last year's lesson, like old clothes. Although it may be we choose to wear our ridiculousness – even that, precisely that – a little longer, and not least in the sight of others. It may be still there is something possible – in the theatre or wherever – to be realized in that.

This has been a rather long preamble to this final chapter, but I needed to arrive at that note as a point for stepping off into what is to come. We will return to the work of Romeo Castellucci. We will also, more immediately, return to this question of the intelligence embedded in forms of figurative picture-making, not unlike the sort of picture-making that

takes place in the theatre. In particular I want to focus on two modern essays on seventeenth-century painting, where the image of the act – the act that illuminates the image even as it suffers its own imaging – is considered in relation (or so I argue) to questions of punctuality and perspective that borrow something from (or lend themselves to) a theatrical bent of thought. My hope is that through discussion of these words, actions, performances and images I can also draw together some of the main themes I have sought to develop in this book, and lead things towards a way of concluding. As I say, I will be getting back to the theatre eventually – we will finish up at the opera in fact – and we will get there by setting out from where the previous chapter ended, in situations of mourning. This – our punctuality, let us say, through anticipation and acknowledgement and attachment to the fact of human fragility, but also of human resilience – will be an aspect of everything that follows, of everything left to say. As for when we arrive again at the theatre – not *too* late hopefully – I won't claim that the questions we aim to address will all have been resolved, but we will at least find the theatre taking a hard look at its own act of thought, at the heart of which is the only one able to hold up the represented world, in thought or deed: the actor herself, whom we will meet where we are able to find and acknowledge her, to her face.

Punctuality and the passerby

Something is going on in the open space framed by the large oak trees under the bright blue sky. It is a sunny day. The few clouds that there are, are high or distant. We can see clearly all the way towards the pillared temples and porticoed buildings of a 'classical,' pre-modern Western city disposed around a towering rock, some few hundred yards away across a level plain. In the middle ground, on this plain between the city itself and a low outer wall just beyond which we are located, people – in small groups most of them, citizens of that place – are going about their daytime activities in the sunshine, fully visibile to each other. In the foreground, in the centre, beside a road that passes through the outer city wall, there are two more prominent figures – two women – whose actions appear more circumspect. Their postures, their alertness to where they are and the significance of what they are doing, communicate something of the risk, the vulnerability of being exposed to view like this and the urgency of their business. That said, it is not clear what exactly it is that they are doing. The older of the two women is the one engaged in an action. She bends forwards, on her knees, her hands dealing with something on the ground, something greyish; there are

sticks nearby, maybe ashes from a fire. The younger woman, her back to us – it is not *our* witnessing she is concerned with – twists around at the shoulders, startled it would appear by what looks like a male figure concealed among the trees to the right. It is not easy to notice this figure. You have to look quite hard. But maybe he does not matter, he is just somebody who happens to be there. It is anyway the women who are important. We will be coming back to them shortly. They aren't going away.

It should be apparent that I am describing a picture: a medium, as Hans Belting would say, in which images appear, images that may then (they might have already done so) take us over, 'colonise our bodies' as Belting puts it, ourselves being media for the society of images just as much as pictures are.[10] This particular picture is Nicolas Poussin's 1648 canvas *Landscape with the Ashes of Phocion*, which hangs in the Walker Art Gallery in Liverpool, and which is discussed by the philosopher Gillian Rose who has, in one way or another, been with me throughout this project and some of whose ideas I touched on briefly in an earlier chapter. Poussin's painting of an otherwise seldom (if ever) depicted episode from Plutarch's biography of the ancient Athenian general Phocion is a point of focus for a lecture by Rose entitled 'Athens and Jerusalem: a tale of three cities' which is printed as an essay in her 1996 collection *Mourning Becomes the Law*.[11] The story, in brief, is as follows. In the city of Athens power has been usurped by tyrants, and Phocion – the epitome for his time of the just man, the good statesman, the honourable citizen – has fallen foul of his enemies, been executed, and his body discarded, without funeral rites, outside the city boundaries.[12] The painting shows an episode late in the tale, after Phocion's body has been taken some distance from Athens and burned, and where the wife of Phocion – she is not named by Plutarch, she remains anonymous – takes the risk of collecting her husband's ashes and bones to carry home, to be protected by the family hearth, until such time – according to Plutarch's account – as they can be restored to a proper sepulchre. For the viewer of the picture, however, as I was suggesting above, none of this is necessarily immediately available. Our point of view is from just outside the city walls, with the two women placed in the foreground and further off the city itself filling the skyline, as if the viewer were a citizen of the city returning from an excursion perhaps, or a stranger to the city arriving for the first time – or a passerby in fact. Making sense of the scene will not be a simple business of being in the know, or reading the signs.

As she admits, Rose came across Poussin's painting as a sort of passerby herself, although not as a visitor to the Walker Gallery in Liverpool. She tells us she accidentally recorded television art historian and

nun Sister Wendy Beckett's discussion of the picture, while trying to make a video recording of a film on another channel.[13] A subsequent correspondence – and Rose's polite but considered disagreement with Sister Wendy's reading – contributes to the argument of her lecture, which is about a great deal more than an interpretation of Poussin's image. In short, Rose, writing in the early 1990s, challenges what she takes as a 'postmodern' predilection towards a particular ethical–political attitude, which she characterizes here in civic – or more particularly – architectural terms. The postmodern attitude, in Rose's view, involves a rejection of the sort of critical rationality that is represented in the picture by the harmoniously ordered built structures of Athens. For the postmoderns, such apparent rationality is tainted by the notion that the European enlightenment finds its dialectical *telos* in the anti-rationality of the Holocaust. The reaction is to favour a contrasting ideal, the 'immediate ethics' of New Jerusalem, associated in Rose's essay with a sort of anti-architecture that represent ways of living and thinking together in boundless 'community.' For Rose, this kind of ethical idealism is expressive of an endless, inexhaustible philosophical melancholy, brought about by postmodernism's separation of ethical considerations from any and all 'metaphysical' principles – the refusal, for instance, to countenance concepts such as 'truth' or 'reason' or indeed 'freedom' or 'justice,' to the extent that such concepts 'are deemed to depend on the "metaphysics" of truth.'[14]

Rose draws attention to the blind-spots of such a vision, the way for instance abusive conjunctions of knowledge and power in the city may *also* be at work – but less acknowledged – in more spontaneous, ethically constituted community structures, even friendship groups for example; or ways in which this imagined passage from Athens to New Jerusalem may carry with it, again unacknowledged, the baggage of capitalist individualism that obscures any politics worth the name.[15] And we are in danger, Rose argues, of overlooking the value of those semi-autonomous institutions that mediate between the individual and the collective and which sometimes at least alleviate some of the pressure that life puts upon people (she proposes architecture and law, but we might mention some others – a certain promise of theatre for instance?), if we assume such institutions to be inevitably compromised by totalizing structures of power.

In distinction to this, then, the scene depicted in Poussin's painting is for her exemplary of a counter-politics, or indeed of politics as such. Rose sees the ritual funerary action of Phocion's wife *not* as a gesture of infinite love set against the grimly bounded metropolis and all it stands for (such is Wendy Beckett's reading), but rather, in Rose's phrase, as a

'finite political act' performed in the face of usurping tyranny that happens to have taken root, at this particular moment, in these peoples' lifetime, in *this* city. For Rose, the women's act here is political in that it recognizes and sets about to renegotiate the contingent boundaries of both the soul (which one inhabits, as it were, as an individual) and what is analogous to the soul at a social level, the city which we all have to share. It is an act that makes visible – makes intelligible if you will – the risk and vulnerability inherent in the current, local situation: here and now. And makes apparent also how even an ordinary or symbolic action such as this can contribute to changing a situation, can be part of the constitution of power and law, for good as for ill (not that these are always simply distinguishable from each other). Speaking of the Athenian architecture in the background of Poussin's painting, Rose argues that if anything the image it presents of abstract, classical rationality – a certain measure, we might take it, of 'just' organization, given that 'transcendent' justice can still be 'representable justice'[16] – sets the specificity of the act performed before it into relief. Justice, like anything else, if it is lost, forgotten, or abused, is to be mourned. But mourning, for Rose – we suggested something similar for the young women reciting Hölderlin's *Death of Empedocles* – is completable. As Rose says of personal bereavement: 'To acknowledge and to re-experience the justice and injustice of the partner's life and death is to accept the law, it is not to transgress it – mourning becomes the law.' Which is to say that mourning is not 'unbecoming' to jurisprudence, in the sense that it suits it well. For sure it befits the law of the civic life to which the living partner returns, 'renewed and reinvigorated for participation, ready to take on the difficulties and injustices of the existing city.'[17] Not, though, that this is the whole story. In the latter part of her essay, she will take the argument further, bringing into discussion another resonant place name, Auschwitz, proposing that what we postmoderns may be most concerned to countenance are the continuities between the 'third city' (after classical Athens and New Jerusalem) that most of us actually inhabit and are familiar with (places of reason and muddle, of utopianism and violence, built out of the struggle between 'politics and anti-politics,' where the just man and the just woman live and act humanely, in freedom and justice, as best they can) and the fourth city, Auschwitz: an imaginable continuity that becomes all the more apparent when one hears of the architectural plans that were drawn up but never realized for that place's post-war new town expansion.

As for Poussin, we have come to the seventeenth-century French painter in part because for us his work on this occasion happens to be the stage of Rose's philosophical performance. Not, though, that the

paintings do not lend themselves to such. Indeed the theatricality of Poussin's compositions – and particularly of the landscape paintings of the late 1640s such as *Landscape with the Ashes of Phocion* – has been much remarked upon. It is, however, not just the theatricality that interests me but the provocation to certain sorts of speech and writing that this pictorial theatricality provokes. T.J. Clark (to whom we will return shortly) cites Denis Mahon's comment that much of the power of these paintings has to do with the way that the zone in which their 'drama' unfolds is 'sharply defined, like a stage setting,' where – in Clark's words, paraphrasing Mahon – 'landscape conspires to articulate a human message, centred on one (or two or three) figure's life and death.'[18] Louis Marin, meanwhile, writing about a number of descriptions, from Poussin's time to our own, of another painting by the French artist from the same year as *Landscape with the Ashes*, notes how 'the descriptive discourses read the painting as a theatrical performance through which a drama is represented in a place whose entire function is to offer it to view, in the diachrony of its moments: nature is henceforth defined functionally as the decor for human action, and man as the actor in a drama that puts him on stage.' We will come back to diachrony shortly also, but pause to note here for the moment both the construction of nature *as* theatrical environment, and also the framing of the theatricalized landscape or environment as at once the ground and support for dramatic representation and at the same time indifferent to the life that the representation evokes. Marin: 'Nature will thus take two forms: in one, it is the ground, the *locus standi et representandi* for human action, while in the other it is pure decor, the environment from which man is excluded.'[19] And while we are in these environs we might also include the following, an entry on the Phocion paintings from a fairly recent (2008) exhibition catalogue, which sounds that same note in the context of the sort of neo-Stoic world-view that belonged to Poussin's time: 'it is precisely in the deliberately marked opposition between nature's calm and the hero's last rites and the gathering of his ashes amid general indifference that the bitter message of the two compositions resides: exemplary illustrations of the insignificance of life and the derisory human condition.'[20]

It goes without saying, there is not much sense of the insignificance of life or the derisory human condition in Rose's *political* reading of the *Ashes of Phocion* picture (or in Sister Wendy's more romantic reading either, for that matter), where the suffering of the image – by which I mean here Rose's sufferance of the painted image that presents itself to her fascination – is of a more dynamic stamp. More *theatrically* dynamic, I want to say, in that her reading takes in not just the 'drama'

of the represented action, but also the theatricality of the looking, its histories and contexts, its insights and blind-spots. And takes in too the act of representation – in the sense both of the depiction or presentation that proposes to 'speak' in the place of another, and also the decisive act that speaks for justice, out of the relative silence of the image. Just to highlight a couple of aspects or approaches. First, there is an aspect to Rose's thought that conceives the beholder of the painting – or the witness to the scene – as a 'third' party whose capacity to *see* what goes on between two other positions, or two other discussants or combatants as it might be, goes along with a capacity to *move* in-between, or towards or indeed away from those positions. Even, we might say, to exit the scene, the representation, the dialogue – the theatre of it all, in short – towards the world of lived experience and lived politics that the representation draws upon. To enact – for herself – the movement of return, as we were considering in an earlier chapter, to the 'difficulties and injustices of the existing city' that the dramatic fiction looks forward to in its own suffering of the image of the suspended (political) act. As Rose writes in the introduction to *Mourning Becomes the Law*, 'it takes three to make a relationship between two: the devastation between [...] power and exclusion from power, implies the universal, the third partner, which allows us to recognise that devastation': that is, to 'witness' but also to experience in one's own person the 'irruption' of 'the brokenness in the middle.'[21] This also is part of what I understand the 'third city' to mean: it is a place we go to – or carry around with us as a way of focusing and attending, a sort of mobile technology of feeling and thought – so as to see those other cities and their inhabitants 'in action,' and to imagine our place – or placelessness – amongst them.

The other approach, however, is given in the painting itself, in how it is composed so as to be seen, both in what it offers to simple seeing and to sustained, discriminate attention.[22] The composition of Poussin's painting involves a classic (i.e. early modern) perspectival arrangement which situates its vanishing point somewhere at the heart of that distant city and its viewing point at a place on the road bisecting the outer wall, where someone – it could be anyone but it happens to be someone; everyone will have to shift for themselves[23] – has arrived at this particular moment, punctual to what is going on, but responsible to their own thought for how they read the signs and how they make this scene intelligible. That someone may be the returning citizen; or the stranger at the gate or the disinterested passerby; or indeed the interested spectator. For Rose – and this may be our last comment upon her reading of the painting – the intelligibility of the women's act, even as they perform what is essentially a sacred rite (the honouring of the ashes) involves a

critical consideration of the 'sacred' as such, both 'the reality of the sacred' as it is acknowledged here in the urgency of the forbidden action, but also the danger of 'its ubiquitous reinsinuation' through dogma of whatever sort.[24] This too requires a certain perspective.

Then again, ways of seeing have their sacrality also. John Berger summarizes the theory of perspective, which in its various forms came to dominate Western models of visual representation in the early modern period, thus: 'Perspective makes the single eye the centre of the visible world. Everything converges onto the eye as to the vanishing point of infinity. The visible world is arrayed for the spectator as the universe was once thought to be arranged for God.'[25] As Berger notes, the *point* of perspectival conventions was that the appearances so produced could persuasively be 'called [...] reality.' For Alberti, who elaborated the *techne* and effectively codified the understanding of perspective drawing in his fifteenth-century treatise *On Painting*, the point of perspective in painting was to serve the representation of '*historia*' – scenes of significant human action drawn largely from textual sources, intended to move and impress a viewer, such that 'the men painted in the picture outwardly demonstrate their own feelings as clearly as possible,' provoking us to 'mourn with the mourners, laugh with those who laugh, and grieve with the grief-stricken.'[26] Put otherwise, the *historia* present themselves to a 'prior viewer,' one who 'looks through' the picture plane at 'a second or substitute world.'[27] This viewer would be punctual to all eventualities, just as they – the spectators – might be expected to be familiar with whatever scene is being depicted, finding a ready resonance in the collective memory, the point being I suppose not so much to see the scene (one has it in mind already) as to see the scene come back to life, right there in the picture I have made for myself, right here where I feel the picture working on me, at such an intimate distance as that.[28] Except, this doesn't seem to be quite what is going on in the seventeenth-century example (nor the late twentieth-century reading) we have been discussing.

Nearer our own time than Alberti or Poussin, art historian Rosalind Krauss, with the support of the philosopher Jacques Derrida – as it happens one of the main figures of the sort of 'postmodern,' anti-foundational philosophy that Gillian Rose had in her sights in the early 1990s – performs a direct take-down of the perspective painting's blink-of-the-eye illusion of a 'perpetual now,' while exploring ways in which the Renaissance idea of pictorial punctuality was adopted – and adapted – by modernist painters and thinkers. Thinkers, that is to say, such as the phenomenologist Husserl who theorizes this punctuality as an immediacy of self-presence that makes no requirement of self-consciousness,

i.e. a consciousness that would tell about itself, through the reading and further circulation of signs. Derrida's deconstruction of this position proceeds by observing that such punctuality could only function in the absence of signs, but then draws out how Husserl's conception of the 'now' in fact admits a continuity between lived experience and memory and expectation (or 'retention' and 'protention' as Husserl names them). There is, as Krauss puts it, 'a duration to the blink and it closes the eye.'[29] Where Krauss goes next with this is to consider, amongst other things, how a series of erotic mythological drawings by Picasso might be responding to another sort of punctual *techne* of the visual, the personalized proto-cinematic technology of the flip-book, as modernists such as Picasso experience a 'voluptuous succumbing to the productivity of the device.'[30] Where we will go ourselves, however, one last time with a view to closing this section of the chapter, is back to Poussin – and to proto-theatrical (or should that be post-theatrical?) writing from our own times *about* Poussin's paintings – and to remind ourselves that a dispersal – so to speak temporal and spatial – of dramatic and pictorial punctuality was already at work long before we arrived at the paintings.

This sort of dispersal is apparent in another painting by Poussin from 1648, *Landscape with a Man Killed by a Snake*, in the National Gallery in London. Here is how Denis Diderot described the work when he saw it in Paris a hundred or so years after it was made. It may be that Diderot was already writing from memory – a group of fishermen who might have been mentioned are missed out, he has the snake killing a woman rather than a man, and one of the figures he mentions (the 'crouching man') is hard to locate – but his account gives a fair sense of things. Not least, of how the painting works on – and arrives at – its viewer, while gathering up a few viewers and listeners within the picture itself:

> The background of his canvas is filled by a noble, majestic, immense landscape; no more than rocks and trees, but very imposing ones. Your eye wanders through many different levels of depth, from the closest to the most distant points. On one of those levels, at left, some distance off, in the background, a group of travellers who are resting and conversing, some seated, some reclining, all perfectly safe. On another level of depth, further forward, in the centre of the canvas, a woman washing her laundry in a river; she listens. On a third level of depth, further left, quite far forward, a crouching man, but he's begun to rise and casts his gaze, a mixture of anxiety and curiosity, towards the left of the scene; he has heard. In the extreme right foreground is a standing man, transfixed by terror, ready to

flee; he has seen. But what is the source of his terror? What is it he's seen? He has seen, in the far left foreground, a woman lying on the ground, encircled by an enormous snake that devours her and drags her into the depths of the water, where her arms, head, and hair are already hanging. From the tranquil travellers in the background to this last terrifying spectacle, what an immense distance is covered, and within it what a sequence of different passions is laid before you – you, the limit point of the composition.[31]

Or another way of telling it. Something has happened to someone, someone we don't know, but something terrible – and, for anyone there, terrible to behold. Something that has not happened to us, or has not happened yet, but the sort of thing one might feel bound to speak about with others, or at least retain in mind for private reflection. Except the speaking, the thinking about and the beholding does not happen at once, nor does it happen in the same place. A man on a path above the pond where some poor soul has been enwound by a giant snake – the only person who sees this death happen – is still looking directly at it as he breaks into a run. His arm is extended, his mouth is open. Perhaps he is crying out, but what is there to say, and who is there – as yet – to say it to? The woman who is washing clothes does not see the death although she sees the running man coming towards her. Maybe she has heard his cry. She raises her arms. She sees that something terrible has happened but she does not know what. She can imagine an accident, even a death: but a death like this? Of the group of travellers reclining by the lakeside further away, one turns round, his head on his elbows, having heard something or other that may provoke a query, a remark or two, between himself and his companions. For the fishermen across the lake, the resonances presumably are even weaker. A dot or two of paint indicate a face turned in this direction, while the men's daily work of gathering in nets and piloting a skiff goes on as it would. The sun-illumined city sketched out in the far distance is impassive, oblivious.[32]

In 2006 T.J. Clark published *The Sight of Death*, a book-long 'experiment in art writing' made up of a series of diary entries in which, over four months, Clark returns daily to Poussin's *Snake* painting, a work that Clark knows well from London and which he happens to encounter on loan at the Getty Institute in Los Angeles where he was conducting research at the time. His book becomes a finely detailed – we might say exhaustive – account not only of the painting itself (there is another Poussin picture in the Los Angeles gallery, *Landscape with a Calm*, and Clark starts off considering both, but *Snake* eventually colonizes his attention) but of this process of returning to look again at

something already seen, and of speaking about it, to himself and others. Clark's writing style here seems to be deliberately invoking the extemporizing liveliness of speech, written out of the immediacy of encounter, as if speaking what he has seen to an ear ready to listen. As with Rose's lecture, Clark's text has been a sustaining provocation to me throughout the writing of the present volume.[33] That both Clark and Rose focus on 1648 paintings by Nicolas Poussin would appear to be one of those persuasive coincidences of which 'something' ought to be made, and to which these pages do attempt to answer, although what it is that these texts together give me to think about lies, I think, outside that sort of contingent association. To an extent it isn't really 'about' Poussin. It has more to do with contingency, with the unforeseen experience of 'coming across' something and recognizing at that point that there is work to do: the work of recognition as such and acknowledgement of sorts (in sight and hearing as well as in speech). That said – and to put acknowledgement to work right away – it is Poussin's script (a pictorial script of course) that is being staged here, adapted, performed upon. Maybe after all the play is the thing.

If I were to elaborate some generalized observations upon T.J. Clark's performance they would concern the following: the attention his text gives to what emerges – details of the painting's surface, insights to meaning and intention, historical and other allusions and resonances – as if unforeseen, and as if indiscriminately, although everything that appears is credited to the composition and its painterly rendering, to something made, imagined, put together by someone *in this way* and at that moment in history. We are never far from the 'means of production' nor from the decisions that were made when that means was put to use. Nor are we far from the contingencies of remainingness: what time and use (and abuse) does to a painting, what history does to a picture, and what desire and remembrance and everything else does to the image therein (and without). I would want to say something too about these scenes that Clark works on – and Rose too – being populated images, and populated by people in human situations (situations in which someone does something, or situations in which things happen to people). But populated also by 'things' as such, rendered materialities that participate in whatever drama is going on, and not just as background or 'decor.' Rose, as we heard, had much to say about architectural things (as well as more intangible materialities that take their place in the picture: belief systems, ways of seeing and knowing, situations of risk, rituals and intentional acts and so on). Clark speaks of the 'mute things,'[34] of buildings, dwellings, workplaces, cityscapes and such, and of the painting of trees and shadows and foliage, of spots of land, of

sky and clouds, of blotches of space and the rendered surfaces and implied depths of patches of water, all of which – along with Clark himself – are part-players in a politics of the image,[35] a sort of cosmo-politics of picturing and of talking about pictures that seeks ways for its 'explicitness' to be 'overtaken again by the thing-ness, the muteness, of what it started from.'[36] I would want also to say more about this on-the-spot *ekphrasis* that Clark engages in (we will speak of ekphrasis before the end), this movement between words freshly minted and images-being-encountered-right-now, for readers who will come along later, as I come along myself (although I have done so, like Clark himself, on sev-eral occasions since), this intimacy at a distance that chooses after all – in the end it is a decision, no mere contingency – to speak about the sight of death. To speak and also let it be heard, let it be seen how that sight and this seeing and saying extends into a much wider landscape, into distant places and times where people will be concerning themselves with other matters than this. But of which this death and its dispersed acknowledgement is now part of the burden, part of what they – the ones who are already tasked with re-building the world that we bequeath – will have to carry with them, in the future of us all.

Rather, though, than attempting to cover all of these bases in turn, I will instead focus on some comments Clark makes about the most pro-minent figure in the painting: not the victim of the snake attack but the anonymous running man who is nearest to the incident. He is in every sense the punctual witness to the event. He is the only one with a per-spective on the matter (although a perspective from within the scene), this passerby who still has his head turned over his shoulder to see what is going on but who is already on the move, as if running away from what terrifies him, although he has nowhere to run other than deeper into the picture. Clark cites another viewer, Louis Marin, whose words about the 'theatricality' of Poussin's 1648 paintings we encountered ear-lier. According to Marin, the running man in the *Snake* painting is the very 'form of an enunciation,' 'a body gathering itself to say something.' You could say – says Clark – that the figure itself amounts to something being said, that his expressive, rhetorically postured body 'is already a sign.' Clark proposes an inflection on this view, suggesting that the run-ning man rather 'is on his way back into the world of signs, from somewhere – some occurrence or experience – slightly outside it. And even as he raises his hand to *make* a sign, he looks over his shoulder, just to be sure, or because he has not quite escaped from the dark fore-ground – the place of the visible – into the realm of speech.' He is, says Clark – in reference to a myth that we will come back to at the end of this chapter – 'like Orpheus looking back at Eurydice. The snake (which

is wordlessness concentrated into a form, a hiss) still fixes him with its beady eye.'[37]

The running man is caught, immobilized, in the moment of crossing over, of passing through, escaping from the visual into the world of speech, suffering in this moment the image – the sight of death – even while becoming (having already become) an image himself for others, coming into range at some velocity without in fact moving at all.[38] And not just as an image either. He is, we might say, the passerby who became a spectator who is about to become an actor. He is caught in the moment of moving from the more or less arbitrary space of 'something happened' into the potential arena of critical – or – as Rose would have it – political risk and responsibility. From which – as an image at least, an image of someone who knows something of what has happened and what is still to come, which is what the actor as *figure* amounts to here – there would be no turning back. Although ... that is still what he does: he turns back, to look, to witness, to prove, one last time, what drives him to turn away. We the beholders on this side of the picture see what he sees, and we see him seeing it, and we see too something of the world that suffers and absorbs the shock, as far as it goes. An impression that leaves barely a bruise on existence, although we are right there with him, any time any one of us chooses to return.

The actor's act

I have been talking about the supposed 'theatricality' of seventeenth-century paintings, and the essayistic 'performances' of late twentieth-century and early twenty-first-century philosophical and critical writers in response to those pictured dramas. It is time to turn back to the theatre again, and to recall a moment where the sort of instance that Clark is focused on – this movement of one who suffers *in* or *as* the image, towards becoming an actor, a figure of signs – happens on the contemporary stage. I have in mind a moment from another piece directed by the Italian theatre maker Romeo Castellucci, his 2010 *Sul concetto del volto nel Figlio di Dio* (*On the Concept of the Face Regarding the Son of God*). It sounds, I know, more like the title of an academic or scientific treatise than a theatrical performance, but we will get to that.[39] The implied formality is soon unsettled anyway if we consider the work as addressing again a certain nausea, this time a nausea of repetition and of ending; and of shame, of shame-facedness. But we will get to that too. To start with, the stage presents a picture, literally; although this time we are in portrait rather than landscape format. Dominating the back wall of the theatre is a massive reproduction of

Renaissance artist Antonello da Messina's late fifteenth-century painting
Christ Blessing or *Salvator Mundi*. The picture, which like Poussin's
Snake can be seen in the original at the National Gallery in London, is
here cropped to exclude the hands that were making the gesture of ben-
ediction and just show the face of Jesus – or at least, this particular
imagining of that face. It is one of those portraits that appear to look at
us looking. It 'does' this throughout the show. As if it sees what we the
spectators see, sees us, sees everything, overseeing it all (which is not to
presume that those painted eyes *notice* anything) with an expression, it
has been said, of unspeakable gentleness.[40]

In front of the painting is a more conventional stage picture, a con-
temporary domestic scene rendered naturalistically amidst white leather
and chrome furnishings, a functional bourgeois setting for the muttering
of everyday exchanges and the undemonstrative performance of habitual
household activities, as if unheard, unseen by us. A bearded, white-
haired, white dressing-gowned old man is taking a meal as he watches
TV. A younger man, his son, wearing a suit and tie, having served the
meal is about to go out, to work (it may be morning) or on a date (it
might be evening, really it is hard to tell what time of day it is supposed
to be – soon enough it will not matter overmuch). Anyway, he has things
to do in the world, although it turns out he will never get back there, not
in this life, not out of this picture. The older man is incontinent; he shits
himself. We see it happen. That is, we see the brown liquid leak around
him on the white sofa. We smell something too, or imagine that we do,
when a sour ammoniac odour is piped into the auditorium later in the
performance. The son fetches the towels (white), the bucket, the plastic
gloves, and cleans his father up. The father apologizes. The son cracks a
joke. It is no big deal, they know the routine, this is the ordinary where
they both live and they have accommodated themselves to its strains,
with whatever good spirits or weariness we can only imagine. This time,
though, the routine is endless. Each time the father is cleaned by his son,
he shits again. This goes on for twenty, thirty, maybe forty minutes, by
which point both men are exasperated, weeping, exhausted. And
ashamed. Or that is what they communicate. The son ashamed of his
inability to cope. The father ashamed of the scene. His shame, we might
say, is disproportionate, but it arises from disproportion as such: of
producing too much shit for those who care for us to be able to deal
with, of taking too much space and time in the world, of being too slight
to merit the care. And of shrinking from view, becoming less than oneself,
in all this disproportion.

But we also saw the following happen. It was a small moment indeed,
you would not necessarily notice it and if you did you might take it for a

flick of detail, a grace note, a bit of business added late in rehearsal or even during the run.[41] But it happens. As matters approach catastrophe, as the brown liquid comes to dominate the scenography, at some point Gianni Plazzi, the actor playing the older man, performs an act. Or is it the father himself who does so? On the bedside table there is a screw-top plastic container. Sitting on the edge of the bed Plazzi pours more brown liquid from the container onto the sheets beside him and onto the floor around his feet. He knows what he is doing. He looks out at us, Lear-like, with the face of one who knows his action is irrevocable, or that it will have become so. As it is, the plastic container and the pouring of the liquid may remind us of the most indelible demonstration, a sacrifice akin to Empedocles' act: a petrol can and the prelude to an immolation. (The son's actions throughout the play, of course, have been all about denying the indelible, wiping the marks, cleaning up the mess – in these circumstances the most decent sort of daily commitment and endeavour. Except the task proves impossible, there is simply too much mess, the helplessness is endless: even though this is exactly what the theatre does do, after every performance, clearing up the mess before the next show arrives – it is called the 'get out.' And it is only representation after all. Except, then, we also know that performances and performative actions have all sorts of ways of remaining, insistently, insidiously and other-wise, messing up the what happened with the what might happen next.) But the gesture also seems to say something about the irrevocability of an image, which is where a certain suffering really begins. That involves at once someone's sense of inhabiting the image – as actor and beholder, sufferer and sympathizer both – and also everything involved in 'regard-ing the pain of others' (to recall Susan Sontag's phrase) on the part of others such as ourselves: compassion for instance, but also nausea, and also the taking of offence.[42] Offence, say, at the fact of suffering, borne here on our behalf by these two men who are not only nameless, they only have the faces that the actors – Plazzi and, in the role of the younger man, Sergio Scarlatella – lend them. Nor is this to imply that the actors' identities are lent for remembrance sake. What that gesture with the plastic con-tainer – which, after all, involves a quantity of pigmented liquid poured onto a white surface for the sake of an appearance: it is *paint*, basically – also seems to be saying is something of the order of 'forget me': I am not the one that matters, I am here as a maker of signs, here where an image is put into play between us, between the actors and the spectators. The image of an actor who pours the liquid that makes the stain, the contingent and indelible stain of our inexhaustibly terminal condition.

Because the actors are no fools. Whoever said they were? Well, Kant for one, in a phrase cited by Hannah Arendt – one of Gillian Rose's

exemplary precursors – in the course of Arendt's discussion of thinking as a sort of self-removal from active life and the world of appearances, something like the withdrawal into solitude of the spectator at the theatre, so as to cultivate understanding of such appearances and the spectacle that is revealed there. A spectacle which, according to Kant, 'may be moving for a while; but the curtain must eventually descend. For in the long run it becomes a farce. It becomes ridiculous. And even if the actors do not tire of it – *for they are fools* – the spectator does, for any single action will be enough for him if he can reasonably conclude from it that the never-ending play will be of eternal sameness.'[43] To which Arendt appends the comment that if we subscribe to the notion of the course of human history being merely a natural progress, or evidencing the inevitable march of 'reason' taking place 'behind the backs of acting men,' then the spectacle of our actions may as well be performed by fools. She also, though, goes on to remark that 'even if the spectacle were always the same and therefore tiresome, the audiences would change from generation to generation; nor would a fresh audience be likely to arrive at the conclusions handed down by tradition as to what an unchanging play has to tell it.'[44] In relation to which I am reminded of Clark's comments as he approaches the conclusion of his book about the ways that the image-world in our own times has become 'the very *instrumentation* of the market,' so that the 'spectacle' has become 'internalized, privatized, "personalized" – with the image doses more and more self-administered by interactive subjects, each convinced that the screen was the realm of freedom.'[45] The sorts of freedoms aspired to and mourned for in the Castellucci works we have discussed so far would appear to be in reaction to this particular entrapment, and I reiterate the observation from earlier that, however it may be for these individuals we see represented on the stage, when Plazzi pours the liquid from the container he knows what he is doing. He is, at the very least, taking care of the business of representation. This is the work that the actors, the stage technicians and everyone else involved in the production – director, producers and theatre management, as well as the spectators – are bound to do. That is, taking care in each moment of the work itself, so that things will be illuminated and amplified, so that they will stay within budget, so that they will start and finish on time, and, as required, be repeatable. So that they will *happen*. Because, if the theatre is a representational means of bringing the interminable 'to term' (a phrase that implies, of course, a birth as well as an ending) it is also in the business of returning its representations to the world of affairs, just as the lost soul aspires to return to the city, as it were under the actor's care.

So it is that the son aspires to return to the world of his affairs – although in this play he never gets to do that. Instead he appeals to the face of Jesus, pictured at the back of the stage. That is, he goes over to the foot of the picture, raises an arm and hides his own face. The face in the portrait does not answer. Rather, it appears that the picture itself begins to leak its material substance (Alan Read writes of the Christ 'shitting *through his face*'[46]). Dark liquid, like the juice of the image, or the ink of all the commentaries, the paint expended over the centuries as far back as the first icon painters in every attempt to give a face to the son of God, whose face we do not know at all, oozes over the picture surface, which breaks up – is torn to pieces from inside – and replaced momentarily by a phrase in English that shines out from the surface of the picture's support. Or it does for a while, before the now indestructible image that the picture supported (in this era of digital reproduction it is unlikely that any such image as this could be lost or destroyed, although it is conceivable that the painting itself might be) is returned, in the exact same format, as a video projection. A line from the psalms, with an extra word inserted, fading against the more familiar words in the phrase, intermittently visible, slightly less legible: 'you are (not) my shepherd.' A sort of *mene tekel peres*, like the writing on the wall at Belshazzar's feast as recounted in the *Book of Daniel*: the mysterious formula inscribed by a ghostly hand of supposedly familiar Aramaic words designating measurement, which interrupts the thoughtless pleasures of the King and his cronies, but which none of them are able to make sense of. Until, that is, Daniel is called, who reads, interprets and delivers the warning: you are weighed in the balance and found wanting, the days of your kingdom are numbered, your future is written, it is already finished. What the message in the Old Testament legend says – and shows – is something that the receivers of the message should, it is implied, already know, something manifest, something apparent to all, but not taken in by all. It can be like that in the theatre too, where everything is visible but not everything is noticed, or not all at once. A place where what is not supposed to be shown or spoken of comes obscenely into view, more relentless than any attempts to disavow or hide it away. The mechanics of theatrical representation for instance; or the unbearable understanding on the imagined face of the son of God; or the physical collapse we will have to live with and suffer and care for, our own and others; or indeed thinking itself. And where, if there is a message, carried by one who is running towards us at velocity but without speed, what the message might have to say is: look to yourself, your kingdom is divided, remember what you are, you are comprehending flesh, this is how you go, this is how you smell, this is how it will

end for you, and in this you are no more nor less than those you thought, as a thinking speaking being, to distinguish yourself from. In the ear of the King that can sound like a curse, although we don't have to hear like a king does. In the words of the theatre maker: 'The Mene Tekel Peres is what renders me human, it is what brings my soul close to the animal. It is everything that reduces me that renders me human and frees me.'[47]

And the writing on the wall that appears for us this evening? What, for instance, of that small, parenthesized '(not),' like a trace of voice in the writing, but a voice that is quieter, less substantial than what supports and surrounds it, and which exists or survives in a different way from that in which icons or writings exist or survive? Well, maybe we can understand this after all as a gesture of disengagement, or an attempt at such a gesture, encapsulated in a message, a return transmission to those out there, out here – on the stage or in the audience – who suffer and participate in the spectacle of thoughtless living, an antiphrastic gesture, cruel to be kind. You are not my shepherd. You have been measured and found wanting. I, we abandon you to what you are, your creaturely being. Or else: You are not my shepherd, nor am I yours. I am abandoned. I, we abandon ourselves in your thoughtless sight. Something of that sort, nothing too demanding, some writing on the wall, a graffito is what it amounts to. In T.J. Clark's words, from another context: 'It is, needless to say, a *weak* politics [of the image], a reactive and defensive one; but at least it recognizes [...] the ethos of deception it is reacting against.'[48] That is, it recognizes its own deception, its own failures of acknowledgement and recognition. Whatever else is to be made of it, the intruder word 'not' strikes me as the minimal renewal of the act, embedded in the over-familiar phrase. Like a whisper, like a voice in the writing, a still small voice amidst the noise and ignorance and confusion that is going on around it, a voice of doubt in the face of illusion, of insistence in the face of what is indifferent even to being addressed, of uncertainty and refusal in the face of the inefficacy or efficacy of our performed actions, and of perplexity in the face of all our sufferings. An articulate silence that is categorical enough, but which remains on the side of provisionality and aporia. An ambivalent negation that halts along the way to bring wandering thought back to where the performances, the texts, the images and everything else have stopped in front of us, and stop us in our places. As such, the sort of thinking that belongs to the theatre.

Out of the ekphrastic academy

Let us suggest this, then, as we approach our conclusion: that it starts with performance – with presentation and direct address, with the

interpreters ready to speak and to act, with the making of propositions and an induction into duration as such, an induction into the passing time through which we might learn to respond to those propositions, dialogically. But say also that it concludes in theatre, where a third looks over, listens in maybe, on a dialogue between the two (or three or four or however many) and where the time we have left doesn't matter so much anymore, not least because the scene that they – or we – are playing out is one we can already imagine being repeated. I mean, it is being repeated here in the theatre, already, like a sort of déjà vu. But also we can already imagine reproducing the images somehow for ourselves, and for others, even as *they* – the actors – will be completing their parts. They may be reproduced, for instance, as an ekphrasis: another sort of speech or writing with regard to the picture, the screen, the scene, the wall, and which arguably has been an aspect of my own practice throughout this book. *Ekphrasis* is an old Greek word that has survived un-translated in languages other than its own and which refers, in its modern meaning, to the verbal description of a work of visual art. The *locus classicus* was Homer's elaborate description in *The Iliad* of the images adorning the shield of the warrior Achilles but the term has also had a wider application, including descriptions of persons, places and things, as well as historical events: triumphs and catastrophes and battles for instance.[49] In rhetorical theory and practice an ekphrasis was composed so as to have an effect on its audience, so that they would 'see' the subject matter being spoken of – to make an audience of listeners into viewers; or as Simon Goldhill has suggested, to make an audience 'almost become viewers' (Goldhill is quick to deploy that 'almost' to make a connection with classical Greek theatre).[50] Crucial to ekphrasis is the concept of *enargeia*, a vividness of speech produced by an orator sufficiently able to conjure a scene in his own mind so as to convince his listeners to do the same, to make them feel as if they could be there: at the event or the performance as it unfolds in time in the telescoped brevity of the description, or feel themselves to be there in front of the picture as not only are its marvelous details elaborated but something of the emotion of the encounter is transmitted also: an imagined encounter with a picture which, in actuality, may not exist.

I was first encouraged to think about ekphrasis by the artist Claudia Castellucci – the sister of Romeo, the theatre-maker whose work we have been considering in this chapter and one of the co-founders of Socìetas Raffaello Sanzio – when she introduced the topic to the symposium on affective archives that was mentioned in the previous chapter. Claudia referred us to two notable pieces of classical ekphrastic writing from the second and third centuries AD: Lucian's *The Hall* – a short

virtuoso improvisation in which the orator praises his host's mansion and the paintings displayed there – and the book *Images*, in which Philostratus the Elder lectures on a collection of paintings in a house in Naples for an audience of students – local young people with a curiosity to hear – but addresses his speech directly to the ten-year-old son of his host, who sits in front of the other listeners. Castellucci made the point that the ekphrastic performance has a 'public' and that the pedagogical work of Philostratus drew attention – not least through this demonstrable address to the ten-year-old boy – to the heterogeneity of that public and the potential diversity of points of view, any of which are represented by someone who is as capable as anyone else of seeing through, as it were, to what is being said. This diversity of perspectives is pedagogically generative as well as bearing witness to the pleasures of the ekphrastic performance (this comes across especially in the text by Lucian), which is always an entertainment and a living testimony to a desire to prolong, in words shared amongst others, the pleasures of encounter with the artwork, and of learning for oneself. Claudia Castellucci – whose own art practice over twenty-five years has been substantially built around the devising of experimental schools in art, philosophy and performance, often for very young people – developed in her talk the theme of the school (or as we might imagine it the ekphrastic academy) as a complex and provisional gathering of human relationships, where the participants are strangers to each other, where there is an element of chance, of accident as to how any particular provocation might be taken up by any participant, and where the role of the passerby – who disturbs the assumption of community by promising a multiplication of stranger-participants, of foreign faces and names and points of view – is ever to be valued.

One reason I go back to Claudia's recalling of the scene of learning – which is, after all in a sense, where this chapter started out, and institutionally where most of my own professional labours are focused – is to recall for my own argument a sense of difference. I have been coming round to the notion that *theatrical* thinking, with its repetition and reproduction, its body-to-body transmission of what 'remains' in the passing by and passing on of performance (as Rebecca Schneider has written of it), and its incorporation of the punctual passerby spectator who 'later might reperform the work, or talk about it' (Schneider again), does indeed touch on immortality. And it does so by staging its own interminable scene of learning. However, it does this in a somewhat different way than school does.[51] Or at least the theatre that I have in mind right now seems to do. Let us try and get there by going back to the 'talk[ing] about it.' Back, that is, to ekphrasis.

Ekphrasis, like any rhetorical practice, is riddled with all sorts of problematics and aporia. As Peter Wagner has noted, 'as a form of mimesis, it stages a paradoxical performance, promising to give voice to the allegedly silent image even while attempting to overcome the power of the image by transforming and inscribing it.'[52] It is, as Adrian Rifkin has suggested, a way of calling an image into being so that a subject can speak in place of the image by calling upon *its* subjecthood, like an invocation of the dead, a putting on of their masks to make them speak, 'and this too is an anxious confusion.'[53] A device anyway that brings a metaphysics along with it, a metaphysics of the other, of all sorts of 'others,' so that in pointing to meanings elsewhere ekphrasis threatens to undermine its own action, even when at its most fluent.[54] Or it points to nothing unforeseen at all. For example, in seeking to persuade us to entertain, in our imaginations, what we have not seen with our eyes, it may be that ekphrasis calls on what we already have in store, stock images and themes and established ways of seeing. For Goldhill, in his understanding of classical ekphrasis, this had to do with the repertoires of civilized sociality, with behaviours of cultivated exchange amongst Roman Empire citizens who knew how to perform, how to 'play the game of competitive self-scrutiny as a performer in culture.'[55] Goldhill, though, with his focus on ekphrasis as social practice, is also one of many who draws attention to structures of privilege and exclusion, in particular the privileging of a would-be universalizing male perspective and the tendency to feminize the ekphrastic image. It was a point made with some force by W.J.T. Mitchell in a notable essay in the early 1990s and has been developed since by scholars such as Page duBois in investigations of a range of exclusionary social hierarchies, along with – and this was a theme of Mitchell's essay also – the ambivalence, paralysis and sometimes productive critical irony around such structures, as words and pictures, viewer and viewed, narrator and listener threaten to collapse, again, into each other's supposed territories.[56]

Then again, Rifkin, whom we mentioned a moment ago, finds the inauguration of the ekphrastic operation somewhere further back than 'any gendering or sexual specificity,' in a more fundamental imbalance between mourning and melancholy – which brings the discussion around again towards some of the particular concerns of this chapter. The problem has to do with some very basic and practical – but at the same time 'undecidable and arbitrary' – decisions: where to start with the image, which 'bit' of the image does one start with?[57] Where, in other words, does the image itself begin? The approach to that one, which is to say the ekphrastic approach, has to do for Rifkin with 'being able both to separate from possibly inexistent things and to fetishize them in the same

gesture,' which sounds, said like that, the very formula for a melancholy mourning. As for where the ekphrasis ends up, or more specifically how it regards its own future, it will not be the long-term future as far as Rifkin is concerned – 'the time of global warming and desertification, or war, exploitation and apocalypse' – but that of 'the very next thing, the next breath.' As Rifkin goes on to say, the moment of the future is no longer future but only 'that space of the envisageable, where it might now appear that a decision has been made, or that an event either has or has not taken place.'[58] Spaces of act and happenstance where, amongst all, a face will have appeared. What we might call here the ekphrastic envisageable – the very face of things, as said if not shown – certainly covers a considerable range, including, as Rifkin himself suggests, everything that the 'angel of history' is forced to see in that dread wind blowing from paradise, ripping through all of history's constellations, in Walter Benjamin's famous fantasia on Paul Klee's painting.[59] Everything, that is to say, from a somewhat 'poisonous nostalgia for the next,' a sort of displaced curiosity for what we see coming even before we can tell ourselves about it, to what we can hardly bear to look at, the 'almost' irregardable: which yet 'remains to be seen.'[60] And remains to be spoken of too, be it the sight of death we close our eyes for, or the sound of life happening ('the very next thing, the next breath') that enters our ears, however it can. As if we were back with a certain punctuality after all, the punctuality in which we regard the envisageable indeed: as a face, the face of *someone*, an uplifted face, where past and future are at once gathered together and lost, utterly, or lost until we learn to see better.

But then, as Davide Stimilli has proposed, 'we do not reach any knowledge through physiognomy, we can only acknowledge faces, or recognize them.' And such recognition 'is also the dawn of under-standing as such.' An understanding that is perennially troubled by shame, by shame-facedness – ultimately our shame in the face of our own mortality. But sustained, Stimilli goes on to argue, by a critical practice, a scholarly practice of sorts (although it is not just about scholarship), of 'transliteration.' Not an ekphrastic practice exactly, but a way of acknowledging the very particular faces of things in the form of what does remain to history: letters, words, names, the materials of speech and writing. For example, the names of ideas or myths or parti-cular ways of seeing and understanding that have remained untranslated over centuries (*ekphrasis* is an example, although not one that Stimilli mentions; 'idea' is one that he does). These are ideas that have kept their names (while adapting their purpose) as adopted 'foreign words' in a range of different languages, if only to remind us 'of the unity of all languages, for every word was once a foreign word, before acquiring a

familiar physiognomy.' Ideas, Stimilli asserts, are 'irrepressible, or, said otherwise, untranslatable, they keep returning out of oblivion in their transliterated form.' Or they do so as long as we remain able to recognize our faces as our own, which only shame can prevent, and only hope – for all its deceiving cruelties – can hope to guarantee: 'For only hope can lend us our true, shameless face.'[61] At which point we return, at last, to the theatre.

At the beginning of his discourse on the paintings supposedly gathered in the house in Naples, Philostratus instructs his young listener to close his eyes, to look away momentarily. 'Turn your eyes away from the painting itself,' he says, 'so as to look only at the events on which it is based.'[62] And now, he says, look back at the painting, and see – or rather hear, this is after all an ekphrastic demonstration – how those events, these stories from Homer, are here represented in the picture. Romeo Castellucci's theatre has at times deployed an analogous gesture, screens and curtains and periods of pitch darkness that obscure the view, extremely bright lights which temporarily dazzle the spectator, even at times the instruction not to look – 'Don't look at me' – spoken or transmitted from the stage.[63] At times we might be inclined to take this in the sort of spirit that some of Stimilli's thinking would chime with, as the acknowledgement – and often paradoxical disavowal – of a certain shame-facedness on the part of some of the stage figures, or even of the stage itself. At other times it is harder to say how to take it, although I wonder if what is at stake may have been analogous to Philostratus' purpose, an injunction to turn away from the *image*, focus instead on the *action* that the representation is made of: that is, the appearing of the actor, without whom the work does not happen at all. An injunction, of course, that once demanded, is hard to obey (we say 'don't look' when we are preparing something, a gift, a showing, a surprise, so as not to reveal ahead of time the preparations themselves; and even so, we draw attention to them). The injunction not to look also, famously, structures the Orpheus and Eurydice myth, certainly in the story's most notable classical re-tellings, in Virgil's epic *The Aeneid* and a generation later in Ovid's *Metamorphoses*. We are back with that collection of tales. Here is how this one goes. Eurydice is bitten by a snake and dies, shortly after her marriage to the musician and poet Orpheus, who is unable – or unwilling – to abide the situation. Nor does he have to, at least not at first. His music, which, it has been said, not even the deaf are immune to,[64] enables him to force himself upon the hospitality of the underworld, the land of shades, where Eurydice's shade now resides. However, wherever love is mourning, love lays down the law, and here the law takes the form of an ekphrastic paradox. Orpheus may bring his

love back to the world – back, we note, to a world of mortality and anxiety, the living out of an allotted time – but he must not look back at her as he does so. As if, in theory, there is a future to be had in company with the lost love, as Rose would put it beyond sorrow in the acceptance of mourning, but not if Orpheus insists on seeing Eurydice return. An impossible, aporetic demand: or so it is for Orpheus who is incapable of not looking at the one who is following him into the world of company and ordinary light. At which point she is lost to the world a second time and forever. Love's law, if that is how we are making sense of it, carries the day.[65]

Or that is how we might make sense of it in Christoph Willibald Gluck's opera *Orpheus and Eurydice*, where the figure of Amor (Love) is personified as a third character in the drama, and where there is a further and rather fantastical and wish-fulfilling development – a suspension of mourning altogether – as Orpheus and Eurydice are restored to each other after what is revealed to have been Amor's little test, although only after the core of the familiar myth has been fully played through, including Orpheus' inconsolable despair at the second irrevocable loss. (As to how Eurydice feels about it all, some of the more complex and ambivalent sentiments in the opera are accorded her character as she departs Death's realm, unregarded, discountenanced by her husband, unsure just what it is she is returning to).[66] Gluck's opera was first performed in 1762 Vienna in Italian as *Orfeo ed Euridici*, the Orpheus part written for a male castrato. It was revised a decade later by Gluck in a French version, which was subsequently re-orchestrated in the mid-nineteenth century, again in Paris, by Berlioz, to feature a female contralto singer – and, as it happens, with a set design based upon Poussin's painting *Et in Arcadia Ego*.[67] The work is notable in operatic history as a 'reform' opera, one in which principles of 'simplicity and fluidity' of musical form were put to the fore over the 'ridiculous' and 'tedious' effects of vocal virtuosity that had dominated the form to date. And where – according to a text attributed to Gluck – he sought 'to restrict music to its true purpose of serving the poetry, as regards the expression, and the situation of the fable, without interrupting the action or chilling it with useless and superfluous ornaments, and I have believed it should do the same thing [for the poetry] as vivacity of colour and a well-varied contrast of light and shade do for a correct and well-ordered drawing, serving to animate the figures without altering their contours.'[68] Which may lead us to expect something musically rather staid. It is not.

The 1762 Italian version and the 1859 French re-orchestration were performed in 2014 at the Vienna Festwochen and at the Brussels opera house La Monnaie/De Munt respectively, in twin productions directed

by Romeo Castellucci. A male singer performed in Vienna and there was a female Orpheus in Brussels, with different musical resources and production in each city, but with the same basic staging – and according to the same theatrical principle. The production starts as follows. Orpheus, in nondescript contemporary clothes, sits in a simple chair set at the back centre of the stage, in front of a screen that fills the space of the proscenium. While the orchestra – barely visible in either theatre – plays the overture, a woman's name is projected onto the screen in simple, legible, sans serif script. In Vienna, Karin Anna Giselbrecht; in Brussels, Els (only the first name of the Belgian woman is given). They are, I realize, the first protagonists, in any of the works discussed in this chapter ('wife of Phocion' excepted), to have their names announced as part of the performance text. As the production begins, however, there is as yet no face to put to the name. Further text tells us that this performance of the opera is, at this moment, being transmitted to the named woman in her room at the Neurology Department of a nearby hospital, in Vienna or Brussels. A large microphone has been brought on stage, some few yards in front of where the Orpheus singer is seated. We realize it is not for amplification but to facilitate this transmission. To the side of the stage – and the only other object that we can see – there is what looks like a stack of black technical boxes with sliders and small, flickering coloured lights, the sort that might monitor sound levels in a theatre or recording studio, or heart rate, neurological response, chemical levels and such in a human body at a hospital. This object is more or less human scale and its lights blink through most of the performance, part executor and part witness,[69] drawing attention in its mute way to the putting together of a representation: devices – sliders – for operating the representational means, those little flickering lights for measuring the actuality that the representation touches and how this actuality responds.

The singer comes forward and begins to sing, the dramatic fiction proceeds and the text on the screen tells us, in a clear and direct continuous present tense, the life story of the woman who is hearing the music somewhere across the city, Karin or Els. The life stories are detailed, as any life is. Of Karin's, for instance, we hear of parents and a younger brother, of favourite childhood activities, of an early love for music and ballet, of professional dance training and qualification, of the family's move from Linz to Vienna, of foreign trips and ambitions, and then of a sudden cardiac arrest, a diagnosis that reveals a potentially life-threatening heart condition, and her fall into a coma, three years previous to the present performance. Orpheus meanwhile sings of Eurydice. Amor enters, sung by a boy or a young woman, singing not to Orpheus, not to his face, but to where he is standing, where his role is being played, in

front of the microphone. The deal is made, Amor sets the terms, Orpheus commits to the journey. The text on the screen tells us about the condition that Karin or Els is in, about pseudo-coma and locked-in syndrome, about a person's capacities to communicate with others from that situation by opening and closing their eyes, about how a person with locked-in syndrome retains the ability to see, to hear, to touch and remember, about sleep patterns and therapy regimes and daily routines in the hospital, and family visits.

Orpheus begins his journey to the land of shades, although of course he goes nowhere: there is nowhere for him to go other than the few steps between the microphone and his seat, to which he returns while offstage choirs are singing the roles of Ghosts and Furies. Behind him, meanwhile, the view from a video camera fills the vast screen, a blurred view that is drained of colour and affect, from inside a car that has also started up, inside a city-scape somewhere, junctions and traffic lights arrived at and left behind – in this same city where the opera is being performed and Karin or Els is listening in. We realize, I think, quite soon that the camera is going to the hospital just as Orpheus is heading to find Eurydice. I also realize that both journeys are a narrative fiction of sorts. Not that the journey is not happening, not that the video is not being transmitted back to the theatre as it appears to be, live, in the same way the performance is being broadcast to a room in the hospital; but that there is an act being performed, or shortly to be performed, by the young woman in the Neurological ward that is no less of a decisive gesture than the action of the opera's fictional hero. A hero whose music, even as it sings of the most grievous isolation, is also the most intense of pleasures, a thing of the most cutting sweetness, as isolation can be also. It is, after all, the music not him that is able to reach, if anything is, into the dull wreckage of a world where young people like Karin and Els can fall out of their lives in this way, just as it is the remote video camera not the spectators in the theatre that is able to realize the promise of visual perspective and to journey through the urban forest into the picture, all the way to the one who is waiting upon her cue to appear. The camera comes into focus as a building is approached, a sign, the name of a hospital, returning to the previous blurred view as the hospital grounds are surveyed. In the theatre, Orpheus arrives at the Elysian fields. We watch as the camera patrols the hospital corridors. Orpheus is seeking out Eurydice. This, I realize, is not the perspective of a passerby, there is another sort of punctuality than that involved: a designated time for departure, a moment when arrival has to happen, in sync with the narrative. It needs to have been prepared. It is after all the narrative that brings us to the image, on this occasion at least. A room is arrived at;

there is a figure on the bed. The camera takes the measure of personal photographs – in Els's room family groups and children's drawings – before focusing, finally, on the face of the person who occupies the bed. The image fills the screen. It becomes a picture. When the Eurydice singer appears, visible behind the screen some yards away, raised from the floor as if in perspective, she and Orpheus are tiny figures against the scale of the young woman's face, Eurydice herself appearing like a figure from a perspective drawing that has been scissored from its background and pasted onto this other surface, seemingly floating in some sort of nowhere at the bottom corner of the picture. Orpheus and Eurydice sing their dialogue, the face of Karin or Els between them, listening in from another world. And then the Orpheus singer turns around to look and the screen whites out, almost immediately. Eurydice and the young woman's face both disappear.

All systems shut down to darkness – even the technical stack at the side of the stage stops flickering – as Orpheus sings of his despair. I imagine the woman in the hospital not hearing this, I imagine silence there, as if all contact were broken temporarily, but the darkness is all on this side. Our side. Everything, after all, is for the spectators. Amor enters with an electric candle which he – or she – wipes against the darkness with a simple movement, revealing a restored Eurydice (or rather a Eurydice body-double) cavorting naked, like a new Eve – new for a twenty-first-century production of an eighteenth-century musical rendition of a first-century telling of an ageless myth – in what looks like a 3D enlargement of a seventeenth-century neoclassical landscape,

Figure 7.1 Romeo Castellucci, *Orfeo ed Euridice*, 2014. (Photo: Luca del Pia)

something by Claude perhaps, or (if it were not otherwise unpopulated) by Poussin even. This is the happy ending that the times demanded. It is given its due. There is more than one face of hope, just as there is more than one way of projecting one's sense of what 'justice' might mean upon a myth that makes no accommodation to any of our needs, and never will. For a while, the image of the young woman in the hospital bed is returned to the screen while the opera finishes in silence. Hands from off-screen remove the headphones from her ears. In Brussels I remember someone gently stroking Els's forehead. Her eyes are open, seeing. And this is our last look at the actor before the camera shuts off and the theatre goes dark.

Notes

1 Rebecca Schneider, *Performing Remains, Art and War in Times of Theatrical Reenactment* (London and New York: Routledge, 2011): 165.
2 I saw *Four Seasons Restaurant* at the Avignon Festival in 2012 and at the Malta Festival, Poznań in 2013. The title refers to the paintings that Mark Rothko made for the Seagram Building in New York, and which the artist withdrew when he found out they were to decorate an exclusive restaurant.
3 For a fascinating and extensive discussion of the scenographic potential of the 'unpopulated' architectural drawing see Hubert Damisch, *The Origin of Perspective* (Cambridge, Mass. and London: MIT Press, 1994). For the foundational demonstration of orthogonal lines and such see Leon Battista Alberti's 1435 *On Painting*, trans. Cecil Grayson (London: Penguin, 1972). For an extensive discussion on visual perspective in the theatre see Maaike Bleeker's *Visuality in the Theatre* (London: Palgrave Macmillan, 2008), passim. There are also valuable comments in Dominic Johnson's *Theatre & Visuality* (London: Palgrave Macmillan, 2012): 25–31.
4 For more on decision and cut (etymology: *decidere*, to 'cut off') see discussions in Paolo Virno, *Multitude: Between Innovation and Negation*; Samuel Weber, *Benjamin's -abilities*; and Jacques Derrida, *Politics of Friendship* (London and New York: Verso, 1997). All of these contemporary discussions of the philosophy of decision are at base engaging with Carl Schmitt's *Political Theology* of 1922.
5 See Walter Benjamin, *The Origin of German Tragic Drama*, trans. John Osborne (London and New York: Verso, 1996).
6 Friedrich Hölderlin, *The Death of Empedocles. A Mourning-Play*, trans. David Farrell Krell (New York: SUNY Press, 2008): 67.
7 Friedrich Hölderlin, 'Being Judgment Possibility,' in J.M. Bernstein, ed. *Classical Romantic German Aesthetics* (Cambridge: Cambridge University Press, 2002): 191–2.
8 Hölderlin, 'Being Judgment Possibility,' 38. See 'The Basis of Empedocles' in Hölderlin, *The Death of Empedocles*: 144–52, 148. For more, much more, on love, collective imagining and the theatre see Nicholas Ridout, *Passionate Amateurs: Theatre, Communism, and Love* (Ann Arbor: University of Michigan Press, 2013).

9 Ibid., 147.

10 Hans Belting, *An Anthropology of Images: Picture, Medium, Body* (Princeton and Oxford: Princeton University Press, 2011): 10f.

11 The other depiction of the Phocion story is by Poussin himself, *The Funeral of Phocion* (1648) in the Louvre.

12 In fact the city is Megara, where Phocion's body was taken, but Rose treats it as if it were Athens. Gillian Rose, 'Athens and Jerusalem: a tale of three cities,' in *Mourning Becomes the Law: Philosophy and Representation* (Cambridge: Cambridge University Press, 1996): 15–40.

13 *Sister Wendy's Odyssey* was a series of ten-minute programmes, each looking at an individual painting, first broadcast by the BBC in 1992.

14 Rose, 'Introduction,' *Mourning*, 2, 5.

15 For a more recent critical take on the complicities between contemporary capitalism and much community-based discourse, and which also takes issue with mourning-inflected performance studies perspectives, see Miranda Joseph, *Against the Romance of Community* (Minneapolis: University of Minnesota Press, 2002).

16 Rose, *Mourning*, 36. For a clear account of Rose's thinking on law and justice I recommend the opening chapter of Vincent Lloyd's *Law and Transcendence: On the Unfinished Project of Gillian Rose* (London: Palgrave Macmillan, 2008).

17 Rose, *Mourning*, 36.

18 T.J. Clark, *The Sight of Death: An Experiment in Art Writing* (New Haven and London: Yale University Press, 2006): 110–11. See Denis Mahon, 'Réflexions sur les paysages de Poussin,' *Art de France*, 1 (1961): 119–32.

19 Louis Marin, *Sublime Poussin*, trans. Catherine Porter (Stanford: Stanford University Press, 1999): 37.

20 Pierre Rosenberg and Keith Christiansen, *Poussin and Nature: Arcadian Visions* (New York: Metropolitan Museum of Art, 2008): 229.

21 Rose, *Mourning*, 10.

22 The theoretical distinction here is Poussin's own between 'aspect' (simple seeing) and 'prospect' (looking attentively), which Svetlana Alpers notes involves the 'discriminating eye, the visual ray, and the distance from the eye to the object.' Prospect, Alpers adds, has to do with picturing according to perspective theory. Svetlana Alpers, *The Art of Describing: Dutch Art in the Seventeenth Century* (London: Penguin, 1983): 48–9.

23 Hubert Damisch: 'In theatre as in painting, then, it's up to the "subject," even if the prince himself, to get its bearings within the configuration of the scene, as within that of the painting.' *The Origin of Perspective* (Cambridge, Mass. and London: MIT Press, 1994): 399.

24 Rose, *Mourning*, 10.

25 John Berger, *Ways of Seeing* (Harmondsworth: Penguin, 1972): 16. Cited in Martin Jay, *Downcast Eyes:The Denigration of Vision in Twentieth-Century Thought* (Berkeley: University of California Press, 1994): 54. It should also be noted that the perspectival representation of visualization is not universal, but a Western model and tradition. For a thorough setting out of the matter (not just on perspective but on picturing more generally) see Hans Belting's *Florence & Baghdad: Renaissance Art and Arab Science* (Cambridge, Mass. and London: Belknap Press, 2011).

26 Alberti, *On Painting*, 76.

27 Alpers, *The Art of Describing*, 43, xix.

28 Panofsky, whose 1927 essay is foundational to late modern reconsiderations of perspective, offers this on the implied punctuality of the viewer of Dürer's *Saint Jerome* in his study: that the representation is determined not by the architecture but the 'subjective standpoint of a beholder who has just now appeared.' Erwin Panofsky, *Perspective as Symbolic Form* (New York: Zone Books, 1997): 69.

29 Rosalind E. Krauss, *The Optical Unconscious* (Cambridge, Mass. and London: MIT Press, 1994): 213–15. Derrida's reading of Husserl appears in *Speech and Phenomena* (Evanston: Northwestern University Press, 1973). For a more recent and different sort of take on how the 'undivided "now" of sensation' in fact 'must rest upon a duration with which it does not coincide,' see Daniel Heller-Roazen, *The Inner Touch: Archaeology of a Sensation* (New York: Zone Books, 2007): 51–4.

30 Krauss, *The Optical Unconscious*, 229.

31 Denis Diderot, *Diderot on Art, Volume II: The Salon of 1767*, trans. John Goodman (New Haven: Yale University Press, 1995): 242.

32 We might also think of Bruegel's painting *Landscape with the Fall of Icarus* and W.H. Auden's ekphrasis on the painting in his poem 'Musée des Beaux-Arts.' Auden, *Collected Shorter Poems 1927–1957* (London: Faber, 1966): 123–4.

33 I am grateful also to Eirini Kartsaki for sharing her thoughts with me on Clark's text, on Kierkegaard's *Repetition* (see Chapter 2) and indeed all things repetitious.

34 The phrase echoes a comment from one of Poussin's letters: 'I who make a profession of mute things.'

35 Clark, *The Sight of Death*, 185.

36 Ibid., 216.

37 Ibid., 106.

38 I have a note of a comment of Romeo Castellucci's on how to 'enter as an image.' I paraphrase: indifferent to the gaze, but without evading it; into the gaze, but without inviting it; at velocity, but without moving fast; like an animal, but without imitating one. Unfortunately I no longer have the source.

39 Someone who got to it recently in a particularly rich reading of the implications of the show in terms of the face, the public secret and political demonstration (amongst other things) is Alan Read in *Theatre in the Expanded Field: Seven Approaches to Performance* (London: Bloomsbury, 2013): 58–64.

40 The phrase 'dolcezza indicibile' is Castellucci's. See, for example, Sabrina Cottone, 'Il viso di Cristo tra gli escrementi', *Il Giornale* (Milan), 19 January 2012.

41 I remember Castellucci himself coming on as a stage hand to perform the gesture at a performance in Essen.

42 Offence was also taken by Christian groups who invaded the stage in Paris and organized threats against the show – and those producing it – in Italy. For some documents on the controversy including texts in English see http://www.teatroecritica.net/2012/01/lo-spettacolo-di-castellucci-deve-andare-in-scena-un-appello (last accessed 7 August 2014).

43 Arendt's emphasis. See Hannah Arendt, *The Life of The Mind. One/Thinking* (New York: Harcourt, 1978): 95.

44 Ibid., 96.

45 Clark, *The Sight of Death*, 185.
46 Read, *Theatre in the Expanded Field*, 61.
47 Romeo Castellucci and Joe Kelleher, 'Les homes marchent sans fin ... ' *Alternatives théâtrales* 113–114 (2012): 16–19.
48 Clark, *The Sight of Death*, 185.
49 Ruth Webb's article '*Ekphrasis* ancient and modern: the invention of a genre,' *Word & Image* 15.1 (January–March 1999): 7–18 informs my opening comments. See also her book *Ekphrasis, Imagination and Persuasion in Ancient Rhetorical Theory and Practice* (London: Ashgate, 2009). Key sources on ekphrasis include Murray Krieger, *Ekphrasis: The Illusion of the Natural Sign* (Baltimore: Johns Hopkins University Press, 1992), J.A.W. Heffernan, *Museum of Words: The Poetics of Ekphrasis from Homer to Ashbery* (Chicago: Chicago University Press, 1993), and W.J.T. Mitchell's essay 'Ekphrasis and the Other' in *Picture Theory*. I have found particularly useful the essays gathered in a special image of *Classical Philology*, vol. 102, no. 1, 2007, edited by Shadi Bartsch and Jaś Elsner. Leonard Barkan in *Mute Poetry, Speaking Pictures* (Princeton and Oxford: Princeton University Press, 2013), considers the emergence of the early modern theatre out of the theatre's 'essential understanding of itself [in terms of] the analogy to painting,' 133. For some fascinating reflections on ekphrasis and enargeia as historiographical practice see Carlo Ginzburg, 'Description and Citation,' in *Threads and Traces: True False Fictive*, trans. Anne C. Tedeschi and John Tedeschi (Berkeley and London: University of California Press, 2012): 7–24.
50 Simon Goldhill, 'What is Ekphrasis For?' in Shadi Bartsch and Jaś Elsner, eds., *Classical Philology*, vol. 102, no. 1, 1–19; 3.
51 See Schneider, *Performing Remains*, 134–8 and also her chapter 'Still Living,' on liveness, performance and photographic stills in the same book.
52 Peter Wagner, ed. *Icons, Texts, Iconotexts: Essays on Ekphrasis and Intermediality* (New York: de Guyter, 1996): 13.
53 Adrian Rifkin, 'Addressing Ekphrasis: A Prolegomenon to the Next,' in Bartsch and Elsner, *Classical Philology*: 72–82, 73.
54 Shadi Bartsch and Jaś Elsner, 'Eight Ways of Looking at Ekphrasis,' in Bartsch and Elsner, *Classical Philology*: i–vi, vi.
55 Goldhill, 'What is Ekphrasis For?' 19.
56 Page duBois, 'Reading the Writing on the Wall,' in Bartsch and Elsner, *Classical Philology*: 45–56.
57 Rifkin, 'Addressing Ekphrasis,' 74.
58 Ibid., 75.
59 Walter Benjamin, *Illuminations*, 259–60.
60 Rifkin, 'Addressing Ekphrasis,' 81.
61 Davide Stimilli, *The Face of Immortality: Physiognomy and Criticism* (New York: SUNY Press, 2005): 5, 8, 9, 119. For a detailed discussion of physiognomy and shame-facedness in performance and theatrical contexts see also Simon Bayly, *A Pathognomy of Performance* (London: Palgrave Macmillan, 2011). Related matters are discussed in Nicholas Ridout's *Stage Fright: Animals and Other Theatrical Problems* (Cambridge: Cambridge University Press, 2006). For the cruelties of hope see Lauren Berlant, *Cruel Optimism* (Durham: Duke University Press, 2011).
62 Philostratus, *Elder Philostratus, Younger Philostratus, Callistratus*, trans. Arthur Fairbanks (Loeb Classical Library Volume 256. London: William Heinemann,

1931). See http://www.theoi.com/Text/PhilostratusElder1A.html (last accessed 7 August 2014).

63 The phrase 'non guardami' (don't look at me) was heard at the appearance of the figure of Mussolini in the Rome episode of Romeo Castellucci's *Tragedia Endogonidia* (2003).

64 See Jalal Toufic, *Undying Love, or Love Dies* (Sausalito: The Post-Apollo Press, 2002). 'The deaf can hear Orpheus' music, without this implying that it had preliminarily healed their organic deafness. Contrariwise, the deaf would not have heard the music of the Sirens, and would thus have been spared the fatal allure of their song,' 45.

65 The Orpheus and Eurydice myth has also been read as an allegory of the aporias of artistic and creative process. See in particular Maurice Blanchot's essay 'The Gaze of Orpheus' in *The Station Hill Blanchot Reader: Fiction and Literary Essays* (Barrytown: Station Hill Press, 1999).

66 Some of the more interesting readings have approached the myth from Eurydice's point of view. See for example Kathy Acker, *Eurydice in the Underworld* (London: Arcadia Books, 1997) and Hélène Cixous, *Three Steps in the Ladder of Writing*, trans. Sarah Cornell and Susan Sellers (New York: Columbia University Press, 1993).

67 Barbara Kendall-Davies, *The Life and Work of Pauline Viardot Garcia: The years of fame, 1836–1863* (Cambridge: Cambridge Scholars Press, 2003): 410.

68 *New Grove Dictionary of Music and Musicians*, 2nd edition, vol. 10 (Oxford: Oxford University Press, 2001): 48.

69 I am grateful to Kasia Tórz for this observation.

Bibliography

Acca, Fabio 2008 'Per farla finita con Antonin Artaud: *I Cenci/Spettacolo*' in Kinkaleri, *Kinkaleri 2001–2008 La scena esausta*, Milan: Ubulibri, 95–106.

Acker, Kathy 1997 *Eurydice in the Underworld*, London: Arcadia Books.

Adorno, Theodor 2005 *Minima Moralia: Reflections on a Damaged Life*, trans. E.F.N. Jephcott, London and New York: Verso.

Agamben, Giorgio 2005 *The Time that Remains: A Commentary on the Letter to the Romans*, trans. Patricia Dailey, Stanford: Stanford University Press.

——2009 *What is an Apparatus? And Other Essays*, trans. David Kishik and Stefan Pedatella, Stanford: Stanford University Press.

Alberti, Leon Battista 1972 *On Painting*, trans. Cecil Grayson, London: Penguin.

Allsopp, Ric and Emilyn Claid, eds. 2013 *On Falling*, Issue 18.4 of *Performance Research*.

Alpers, Svetlana 1983 *The Art of Describing: Dutch Art in the Seventeenth Century*, London: Penguin.

Althusser, Louis 1971 *Lenin and Philosophy*, trans. Ben Brewster, New York: Monthly Review Press.

Anderson, Perry 1992 *A Zone of Engagement*, London: Verso.

Arendt, Hannah 1978 *The Life of The Mind. One/Thinking*, New York: Harcourt.

——1998 *The Human Condition*, Chicago and London: University of Chicago Press.

Aristotle 1987 *De Anima (On the Soul)*, trans. Hugh Lawson-Tancred, London: Penguin.

Artaud 2010 *The Theatre and its Double*, trans. Victor Corti, London: Oneworld Classics.

Auden, W.H. 1966 *Collected Shorter Poems 1927–1957*, London: Faber.

Azoulay, Ariella 2001 *Death's Showcase: The Power of Image in Contemporary Democracy*, Cambridge Mass. and London: MIT Press.

——2008 *The Civil Contract of Photography*, New York: Zone Books.

Barkan, Leonard 2013 *Mute Poetry, Speaking Pictures*, Princeton and Oxford: Princeton University Press.

Barthes, Roland 2002 *A Lover's Discourse: Fragments*, trans. Richard Howard, London: Vintage.

Bartsch, Shadi and Jaś Elsner 2007 'Eight Ways of Looking at Ekphrasis,' in Shadi Bartsch and Jaś Elsner, eds., *Classical Philology*, vol. 102, no. 1, i–vi.

Bayly, Simon 2011 *A Pathognomy of Performance*, London: Palgrave Macmillan.

Beckett, Samuel 1984 *Collected Shorter Plays of Samuel Beckett*, London: Faber.

Beech, Amanda and Robin Mackay 2010 'Body Count', *Parallax* 16.2, 119–29.

Belting, Hans 2011 *An Anthropology of Images: Picture, Medium, Body*, trans. Thomas Dunlap, Princeton and Oxford: Princeton University Press.

——2011 *Florence & Baghdad: Renaissance Art and Arab Science*, Cambridge, Mass. and London: Belknap Press.

Benjamin, Walter 1977 *Illuminations*, trans. Harry Zohn, Glasgow: Fontana/ Collins.

——1996 *The Origin of German Tragic Drama*, trans. John Osborne, London and New York: Verso.

——2005 *Selected Writings*, vol. 2, Harvard: Harvard University Press.

Berger, John 1972 *Ways of Seeing*, Harmondsworth: Penguin.

Bergson, Henri 2007 *Mind-Energy*, ed. and trans. Keith Ansell-Pearson and Michael Kolkman, London: Palgrave Macmillan.

Berlant, Lauren 2011 *Cruel Optimism*, Durham: Duke University Press.

Bernstein, J.M. 2008 'In Praise of Pure Violence (Matisses's War)' in Diarmuid Costello and Dominic Willsdon, eds., *The Life and Death of Images: Ethics and Aesthetics*, London: Tate, 37–55.

Bernstein, J.M. ed. 2002 *Classical Romantic German Aesthetics*, Cambridge: Cambridge University Press.

Blanchot, Maurice 1954 *The Space of Literature*, trans. Ann Smock, Lincoln, Nebraska and London: University of Nebraska Press, 1982.

——1992 *The Writing of the Disaster*, trans. Ann Smock, Lincoln and London: University of Nebraska Press.

——1997 *Friendship*, trans. Elizabeth Rottenberg, Stanford: Stanford University Press.

——1999 *The Station Hill Blanchot Reader: Fiction and Literary Essays*, Barrytown: Station Hill Press.

Bleeker, Maaike 2008 *Visuality in the Theatre*, London: Palgrave Macmillan.

Bloch, Ernst 1998 'Images of déjà vu,' in *Literary Essays*, trans. Andrew Joron and others, Stanford: Stanford University Press, 200–208.

Bock & Vincenzi 2004 *invisible dances ... from afar: a show that will never be shown*, London: Artsadmin.

——2006 *Here, As If They Hadn't Been, As If They Are Not*, London: Artsadmin.

Bordini, Silvia, Donata Presenti Campagnoni and Paolo Tortonese 2001 *Les arts de l'hallucination*, Turin and Paris: Museo Naxionale del Cinema and Presses de la Sorbonne Nouvelle.

Borja-Villel, Manuel J., Bernard Blistène and Yann Chateigné, eds. 2007 *A Theater Without Theater*, Barcelona: Actar.

Boyce, Richard 2013 'Postscript,' *Dickie Beau: LOST in TRANS*, Purcell Room at Queen Elizabeth Hall.

Brough, John B. 1996 'Presence and Absence in Husserl's Phenomenology of Time-Consciousness' in Lenore Langsdorf, Stephen H. Watson and E. Marya Bowe, eds., *Phenomenology, Interpretation, and Community*, vol. 19, New York: SUNY Press, 3–15.

Butler, Judith 2008 'Response to J.M. Bernstein' in Diarmuid Costello and Dominic Willsdon, eds., *The Life and Death of Images: Ethics and Aesthetics*, London: Tate, 56–62.

Butt, Gavin and Ben Walters 2014 *This Is Not a Dream* [film].

Camp, Pannill 2007 'Theatre Optics: Enlightenment Theatre Architecture and the Architecture of Husserl's Phenomenology,' *Theatre Journal* 59.4: 615–33.

Castellucci, Romeo and Joe Kelleher 2012 'Les homes marchent sans fin ... ' *Alternatives théâtrales*, nos. 113–114, 16–19.

Cave, Terence 1988 *Recognitions: A Study in Poetics*, Oxford: Clarendon Press.

Cavell, Stanley 2002 *Must We Mean What We Say? A Book of Essays*, Cambridge: Cambridge University Press.

Cixous, Hélène 1993 *Three Steps in the Ladder of Writing*, trans. Sarah Cornell and Susan Sellers, New York: Columbia University Press.

Clark, T.J. 2006 *The Sight of Death: An Experiment in Art Writing*, New Haven and London: Yale University Press.

Costello, Diarmuid and Dominic Willsdon, eds. 2008 *The Life and Death of Images: Ethics and Aesthetics*, London: Tate.

Cottone, Sabrina 2012 'Il viso di Cristo tra gli escrementi.' *Il Giornale* (Milan), 19 January.

Crary, Jonathan 2001 *Suspensions of Perception: Attention, Spectacle, and Modern Culture*, Cambridge, Mass. and London: MIT Press.

Cvetkovich, Ann 2003 *An Archive of Feelings: Trauma, Sexuality, and Lesbian Public Culture*, Durham: Duke University Press.

Dalton, Stuart 2001 'Kierkegaard's *Repetition* as a Comedy in Two Acts.' *Janus Head* 4.2. http://www.janushead.org/4–2/dalton.cfm (last accessed 24 October 2014).

Damisch, Hubert 1994 *The Origin of Perspective*, Cambridge, Mass. and London: MIT Press.

Deleuze, Gilles 2004 *Difference and Repetition*, trans. Paul Patton, London: Continuum.

Dennett, Daniel 1993 *Consciousness Explained*, London: Penguin.

Derrida, Jacques 1973 *Speech and Phenomena*, trans. D.B. Allison, Evanston: Northwestern University Press.

——1997 *Politics of Friendship*, trans. George Collins, London and New York: Verso.

Diamond, Elin 1997 *Unmaking Mimesis: Essays on Feminism and Theatre*, London and New York: Routledge.

Diderot, Denis 1995 *Diderot on Art, Volume II: The Salon of 1767*, trans. John Goodman, New Haven: Yale University Press.

Didi-Huberman, Georges 2005 *Confronting Images: Questioning the Ends of a Certain History of Art*, trans. John Goodman, Pennsylvania: University of Pennsylvania Press.

Dolar, Mladen 2006 *A Voice and Nothing More*, London and Cambridge, Mass.: MIT Press.

Doyle, Jennifer 2007 'Between Friends,' in George E. Haggerty and Molly McGarry, eds., *A Companion to Lesbian, Gay, Bisexual, Transgender, and Queer Studies*, Oxford: Blackwell, 325–40.

duBois, Page 2007 'Reading the Writing on the Wall,' in Shadi Bartsch and Jaś Elsner, eds., *Classical Philology*, vol. 102, no. 1, 45–56.

Eagleton, Terry 1992 *Literary Theory: An Introduction*, Oxford: Blackwell.

Eiland, Howard and Michael W. Jennings 2013 *Walter Benjamin: A Critical Life*, Harvard: Belknap Press.

Eschen, Nicole 2013 'Pressing Back: Split Britches' *Lost Lounge* and the Retro Performativity of Lesbian Performance,' *Journal of Lesbian Studies* 17, 56–71.

Etchells, Tim 1999 *Certain Fragments: Contemporary Performance and Forced Entertainment*, London and New York: Routledge.

Fassbinder, Rainer Werner 1992 *The Anarchy of the Imagination: Interviews, Essays, Notes*, ed. Michael Töteberg and Leo A. Lensing, trans. Krishna Winston, Baltimore and London: Johns Hopkins University Press.

Fensham, Rachel 2009 *To Watch Theatre: Essays on Genre and Corporeality*, Brussels, Bern: Peter Lang.

Fleming, Martha 2000 'On Invisible Dances.' http://www.artsadmin.co.uk/artson line/69/a-text-on-invisible-dances (last accessed 24 October 2014).

Florensky, Pavel 2000 *Iconostasis*, trans. Donald Sheehan and Olga Andrejev, Crestwood, New York: St Vladimir's Seminary Press.

Flusser, Vilém 2000 *Towards a Philosophy of Photography*, trans. Anthony Mathews, London: Reaktion.

——2002 *Writings*, trans. Andreas Ströhl, Minneapolis and London: University of Minneapolis Press.

Foucault, Michel 1997 'Sex, Power, and the Politics of Identity,' in Paul Rabinow, ed., *Essential Works of Foucault 1954–1984*, vol. 1, *Ethics, Subjectivity and Truth*, New York: New Press, 163–73.

Freud, Sigmund 1979 *Case Histories 2*, Penguin Freud Library, vol. 9, ed. Angela Richards, Harmondsworth: Penguin.

——1985 *Civilization, Society and Religion* (Pelican Freud Library Volume 12), trans. James Strachey, Harmondsworth: Penguin.

Fukuyama, Francis 1992 *The End of History and the Last Man*, New York: Avon.

Ginzburg, Carlo 2012 *Threads and Traces: True False Fictive*, trans. Anne C. Tedeschi and John Tedeschi, Berkeley and London: University of California Press.

Goldhill, Simon 2007 'What is Ekphrasis For?' in Shadi Bartsch and Jaś Elsner, eds., *Classical Philology*, vol. 102, no. 1, 1–19; 3.

Grange, William 2006 *Historical Dictionary of German Theatre*, Lanham, Maryland, Toronto, Oxford: Scarecrow Press.

Gropius, Walter and Arthur S. Gropius, eds. 1961 *The Theater of the Bauhaus*, Baltimore and London: Johns Hopkins University Press.

Grüber, Gints 2014 *More than Life* [film].

Haas, Andrew 2003 'The Theatre of Phenomenology,' *Angelaki* 8.3: 73–84.

Harding, James 2000 *Contours of the Avant-garde: Performance and Textuality*, Ann Arbor: University of Michigan Press.

Hargreaves, Martin 2004 'invisible dances ... in a body of text,' in Bock & Vincenzi, *invisible dances ... from afar: a show that will never be shown*, London: Artsadmin, 125–34.

Heffernan, J.A.W. 1993 *Museum of Words: The Poetics of Ekphrasis from Homer to Ashbery*, Chicago: Chicago University Press.

Heller-Roazen, Daniel 2007 *The Inner Touch: Archaeology of a Sensation*, New York: Zone Books.

Herzog, Werner 2010 *Cave of Forgotten Dreams* [film].

Hölderlin, Friedrich 2008 *The Death of Empedocles. A Mourning-Play*, trans. David Farrell Krell, New York: SUNY Press.

Hughes, Jenny 2011 *Performance in a Time of Terror: Critical Mimesis and the Age of Uncertainty*, Manchester: Manchester University Press.

Husserl, Edmund 1991 *On the Phenomenology of the Consciousness of Internal Time (1893–1917)*, trans. John Barnett Brough, Dordrecht, Boston, London: Kluwer Academic Publishers.

Irigaray, Luce 1974 *Speculum of the Other Woman*, trans. Gillian C. Gill, Ithaca, New York: Cornell University Press.

Jacob, Pierre and Marc Jeannerod 2003 *Ways of Seeing: The Scope and Limits of Visual Cognition*, Oxford: Oxford University Press.

Jacobs, Peter 2012 'Blackouts: Twilight of the Idols – Contact Theatre, Manchester.' *The Public Reviews*, http://www.thepublicreviews.com/blackouts-twilight-of-the-idols-contact-theatre-manchester (last accessed 24 October 2014).

Jameson, Fredric 1998 *The Cultural Turn: Selected Writings on the Postmodern, 1983–1998*, London and New York: Verso.

——2000 *Brecht and Method*, London and New York: Verso.

Jay, Martin 1994 *Downcast Eyes:The Denigration of Vision in Twentieth-Century Thought*, Berkeley: University of California Press.

Johnson, Dominic 2012 *Theatre & Visuality*, London: Palgrave Macmillan.

Johnson, Jeff 2007 *The New Theatre of the Baltics: From Soviet to Western Influence in Estonia, Latvia and Lithuania*, Jefferson and London: McFarland.

Joseph, Miranda 2002 *Against the Romance of Community*, Minneapolis: University of Minnesota Press.

Kear, Adrian 2013 *Theatre and Event: Staging the European Century*, London: Palgrave Macmillan.

Kelleher, Joe 2006 'Human Stuff,' in Joe Kelleher and Nicholas Ridout, eds., *Contemporary Theatres in Europe: a Critical Companion*, London and New York: Routledge, 21–33.

Kendall-Davies, Barbara 2003 *The Life and Work of Pauline Viardot Garcia: The years of fame, 1836–1863*, Cambridge: Cambridge Scholars Press.

Kennedy, Dennis ed. 2003 *The Oxford Encyclopedia of Theatre and Performance*, Oxford: Oxford University Press.

Kierkegaard, Søren 1942 *Repetition: An Essay in Experimental Philosophy*, trans. J. Lowrie, London: Oxford University Press.

——2009 *Kierkegaard's Writings, XVII: Christian Discourses: The Crisis and a Crisis in the Life of an Actress*, ed. and trans. Howard V. Hong and Edna H. Hong, Princeton: Princeton University Press.

Kinkaleri, 2008 *Kinkaleri 2001–2008 La scena esausta*, Milan: Ubulibri.

——2011 *WEST (Paris) (Roma) (Amsterdam) (Athina) (Wien) (Berlin) (Bruxelles) (London) (Beijing) (Praha) (Tokyo) (New York)*, Prato: Centro per l'arte contemporanea Luigi Pecci.

Kojève, Alexandre 1980 *Introduction to the Reading of Hegel*, trans. James H. Nichols Jr., New York: Cornell University Press.

Krapp, Peter 2004 *Déjà Vu: Aberrations of Cultural Memory*, Minneapolis: University of Minnesota Press.

Krauss, Rosalind E. 1994 *The Optical Unconscious*, Cambridge, Mass. and London: MIT Press.

Krieger, Murray 1992 *Ekphrasis: The Illusion of the Natural Sign*, Baltimore: Johns Hopkins University Press.

Lehmann, Hans-Thies 2006 *Post Dramatic Theatre*, trans. Karen Jürs-Munby, London: Routledge.

Lepecki, André 2006 *Exhausting Dance: Performance and the Politics of Movement*, London and New York: Routledge.

Lloyd, Vincent 2008 *Law and Transcendence: On the Unfinished Project of Gillian Rose*, London: Palgrave Macmillan.

——2012 'Gillian Rose: Making Kierkegaard Difficult Again,' in Jon Stewart, ed., *Kierkegaard's Influence on Philosophy*, Tome 3, Farnham: Ashgate, 203–18.

Lury, Celia 1997 *Prosthetic Culture: Photography, Memory and Identity*, London and New York: Routledge.

Mackay, Robin ed. 2011 *The Medium of Contingency*, London: Urbanomic and Ridinghouse.

Mackrell, Judith 2014 'Wendy Houstoun: the death that made me question everything,' *The Guardian*, 26 May.

Mahon, Denis 1961 'Réflexions sur les paysages de Poussin,' *Art de France*, 1, 119–32.

Manchev, Boyan 2004 'The Unimaginable and the Theory of the Image' http://theater.kein.org/node/50 (last accessed 24 October 2014).

——2011 'The New Arachne: Biopolitics of Myth and Techniques of Life.' Version of a chapter in Manchev, *Miracolo*, Milan: Lanfranchi; and article in *Divan*, 1–2, 2013.

Marin, Louis 1999 *Sublime Poussin*, trans. Catherine Porter, Stanford: Stanford University Press.

Marion, Jean-Luc 2002 *Being Given: Toward a Phenomenology of Givenness*, trans. Jeffrey L. Kosky, Stanford: Stanford University Press.

——2004 *The Crossing of the Visible*, trans. James K. A. Smith, Stanford: Stanford University Press.

Marranca, Bonnie and Alvis Hermanis 2010 'The Poetry of Things Past.' *PAJ: A Journal of Performance and Art*, 94: 23–35.

Mauro, Margherita 2010 'Interview with Alvis Hermanis,' in Mauro, ed., *Le Signorine di Wilko, or how to make poetry visible: the diary of a production*, trans. Vena Cantoni, Rome: Ponte Sisto, 169–85.

Mauss, Marcel 2002 *The Gift*, trans. W.D. Halls, London and New York: Routledge.

Metzinger, Thomas 2004 *Being No One: The Self-Model Theory of Subjectivity*, Cambridge, Mass. and London: MIT Press.

Milne, Seamus 2013 *The Revenge of History: The Battle for the 21st Century*, London and New York: Verso.

Mitchell, W.J.T. 1995 *Picture Theory*, Chicago and London: University of Chicago Press.

——2005 *What Do Pictures Want? The Lives and Loves of Images*, Chicago and London: University of Chicago Press.

——2008 'Cloning Terror: The War of Images 2001–04' in Diarmuid Costello and Dominic Willsdon, eds., *The Life and Death of Images: Ethics and Aesthetics*, London: Tate, 179–207.

Molloy, Christine and Joe Lawlor 2009 *Helen* [film].

Mondzain, Marie-José 2005 *Image, Icon, Economy: The Byzantine Origins of the Contemporary Imaginary*, trans. Rico Franses, Stanford: Stanford University Press.

——2007 *Homo Spectator*, Paris: Bayard.

——2009 'What Is: Seeing an Image?' in Bernd Huppauf and Christoph Wulf, eds., *Dynamics and Performativity of Imagination: The Image between the Visible and the Invisible*, London and New York: Routledge, 81–92.

Monks, Aoife 2010 *The Actor in Costume*, Houndmills: Palgrave Macmillan.

Muñoz, José Esteban 1999 *Disidentifications: Queers of Color and the Performance of Politics*, Minneapolis: University of Minnesota Press.

Nancy, Jean-Luc 2000 *Being Singular Plural*, trans. Robert D. Richardson and Anne E. O'Byrne, Stanford: Stanford University Press.

——2005 *The Ground of the Image*, trans. Jeff Fort, New York: Fordham University Press.

Nietzsche, Friedrich 1956 *The Birth of Tragedy and The Genealogy of Morals*, trans. Francis Golffing, New York: Doubleday Anchor Books.

Ophir, Adi 2005 *The Order of Evils: Toward an Ontology of Morals*, trans. Rela Mazali and Havi Carel, New York: Zone Books.

Ovid 1955 *The Metamorphoses of Ovid*, trans. Mary M. Innes, London: Penguin Books.

Paget, Derek 1987 '"Verbatim Theatre": Oral History and Documentary Techniques,' *New Theatre Quarterly*, 3.12: 317–36.

Palladini, Giulia 2011 'Queer Kinship in the New York Underground: On the "Life and Legend" of Jackie Curtis,' *Contemporary Theatre Review*, 21.2: 126–53.

Palladini, Giulia, Marco Pustianaz and Annalisa Sacchi 2013 *Archivi affetivi/ Affective Archives. Un catologo/A catalogue*, Vercelli: Edizioni Mercurio.

Panofsky, Erwin 1997 *Perspective as Symbolic Form*, trans. Christopher S. Wood, New York: Zone Books.

Philostratus 1931 *Elder Philostratus, Younger Philostratus, Callistratus*, trans. Arthur Fairbanks, Loeb Classical Library, vol. 256, London: William Heinemann.

Plato 2007 *The Republic*, trans. Desmond Lee, London: Penguin.

Pollock, Griselda 2008 'Dying, Seeing, Feeling: Transforming the Ethical Space of Feminist Aesthetics' in Diarmuid Costello and Dominic Willsdon, eds., *The Life and Death of Images: Ethics and Aesthetics*, London: Tate, 213–35.

Rancière, Jacques 2004 *The Politics of Aesthetics: The Distribution of the Sensible*, trans. Gabriel Rockhill, London and New York: Continuum.

——2007 *The Future of the Image*, trans. Gregory Elliott, London and New York: Verso.

——2011 *The Emancipated Spectator*, trans. Gregory Elliott, London and New York: Verso.

——2013 *Aisthesis: Scenes from the Aesthetic Regime of Art*, trans. Zakir Paul, London and New York: Verso.

Read, Alan 2008 *Theatre, Intimacy & Engagement: The Last Human Venue*, London: Palgrave Macmillan.

——2013 *Theatre in the Expanded Field: Seven Approaches to Performance*, London: Bloomsbury.

——2014 'Hello Darkness My Old Friend. Alan Read in Conversation with Alvis Hermanis,' in Margherita Laera, ed., *Theatre and Adaptation: Return, Re-write, Repeat*, London: Bloomsbury, 181–195.

Rebellato, Dan 2009 'When We Talk of Horses, Or, what do we see when we see a play?,' *Performance Research*, 14.1: 17–28.

Ricoeur, Paul 2005 *The Course of Recognition*, trans. David Pellauer, Cambridge, Mass. and London: Harvard University Press.

——2006 *Memory, History, Forgetting*, trans. Kathleen Blamey and David Pellauer, Chicago and London: University of Chicago Press.

Ridout, Nicholas 2006 *Stage Fright: Animals and Other Theatrical Problems*, Cambridge: Cambridge University Press.

——2010 'The Ice. A Collective History of Our Collectivity in the Theater,' in Henry Bial and Scott Magelssen, eds., *Theatre Historiography: Critical Interventions*, Ann Arbor: University of Michigan Press, 186–96.

——2013 *Passionate Amateurs: Theatre, Communism, and Love*, Ann Arbor: University of Michigan Press.

Rifkin, Adrian 2007 'Addressing Ekphrasis: A Prolegomenon to the Next,' in Shadi Bartsch and Jaś Elsner, eds., *Classical Philology*, vol. 102, no. 1, 72–82.

Rose, Gillian 1992 *The Broken Middle: Out of our Ancient Society*, Oxford: Blackwell.

——1996 *Mourning Becomes the Law: Philosophy and Representation*, Cambridge: Cambridge University Press.

——1997 *Love's Work*, London: Vintage.

Rosenberg, Pierre and Keith Christiansen 2008 *Poussin and Nature: Arcadian Visions*, New York: Metropolitan Museum of Art.

Sacchettini, Rodolfo 2008 'Il limite dello sguardo – Lo sguardo del limite,' in Kinkaleri, *Kinkaleri 2001–2008 La scena esausta*, Milan: Ububri, 125–30.

Sacchi, Annalisa 2010 'False Recognition: Pseudo-history and collective memory in Alvis Hermanis' *The Sound of Silence*,' *Meno istorija ir kritika/Art History & Criticism*, 6 (Performing History from 1945 to the Present), 32–37.

Sandford, Mariellen 1995 *Happenings and Other Acts*, London and New York: Routledge.

Sartre, Jean-Paul 2004 *The Imaginary*, trans. Jonathan Webber, London and New York: Routledge.

Schneider, Rebecca 2011 *Performing Remains: Art and War in Times of Theatrical Reenactment*, London and New York: Routledge.

Shepard, Sam 2013 'Programme note,' *A Particle of Dread*, Derry: Field Day Theatre Company.

Skantze, P. A. 2013 *Itinerant Spectator / Itinerant Spectacle*, Brooklyn: Punctum Books.

Sontag, Susan 1977 *On Photography*, London: Penguin, 1977.

——2004 *Regarding the Pain of Others*, New York: Picador.

Sorokin, Vladimir 2007 *Ice*, trans. Jamey Gambrell, New York: New York Review of Books.

Stein, Gertrude 1995 *Last Operas and Plays*, Baltimore: Johns Hopkins University Press.

Stewart, Susan 1993 *On Longing: Narratives of the Miniature, the Gigantic, the Souvenir, the Collection*, Durham and London: Duke University Press, 1993.

——2005 *The Open Studio: Essays on Art and Aesthetics*, Chicago: University of Chicago Press.

Steyerl, Hito 2012 *The Wretched of the Screen*, Berlin: Sternberg Press.

Stimilli, Davide 2005 *The Face of Immortality: Physiognomy and Criticism*, New York: SUNY Press.

Storey, David 1971 *In Celebration*, Harmondsworth: Penguin.

Suetonius 1983 *The Twelve Caesars*, trans. Robert Graves, revised Michael Grant, Harmondsworth: Penguin.

Terada, Rei 2009 *Looking Away: Phenominality and Dissatisfaction, Kant to Adorno*, Cambridge, Mass. and London: Harvard University Press.

Toufic, Jalal 2002 *Undying Love, or Love Dies*, Sausalito: The Post-Apollo Press.

Vasiliu, Anca 1997 *Du Diaphane: Image, milieu, lumière dans la pensée antique et médiéval*, Vrin: Études de philosophie médiévale.

Virno, Paolo 1999 *Il ricordo del presente*, Turin: Bollati Boringhieri.

——2008 *Multitude: Between Innovation and Negation*, Los Angeles: Semiotext(e).

Wagner, Peter ed. 1996 *Icons, Texts, Iconotexts: Essays on Ekphrasis and Intermediary*, New York: de Guyter.

Wake, Caroline 2013 'The Accident and the Account: Towards a Taxonomy of Spectatorial Witness in Theatre and Performance Studies,' in Bryoni Trezise and Caroline Wake, eds., *Visions and Revisions: Performance, Memory, Trauma*, Copenhagen: Museum Tusculanum Press, 33–56.

Walker, Scott 2006 *The Drift*, 4AD. [music album]

Webb, Ruth 1999 '*Ekphrasis* ancient and modern: the invention of a genre.' *Word & Image* 15.1. January–March: 7–18.

——2009 *Ekphrasis, Imagination and Persuasion in Ancient Rhetorical Theory and Practice*, London: Ashgate.

Weber, Samuel 2004 *Theatricality as Medium*, New York: Fordham University Press.

——2010 *Benjamin's -abilities*, Harvard: Harvard University Press.

Weil, Simone 1977 *The Simone Weil Reader*, ed. George A. Panichas, New York: David McKay.

Wiesing, Lambert 2010 *Artificial Presence: Philosophical Studies in Image Theory*, trans. Nils F. Schott, Stanford: Stanford University Press.

Williams, Raymond 1973 *Drama from Ibsen to Brecht*, Harmondsworth: Penguin.

Woodward, Kathleen 1991 *Aging and its Discontents*, Bloomington, In.: Indiana University Press.

Žižek, Slavoj 2009 *The Parallax View*, Cambridge, Mass. and London: MIT Press.

Index

Printed in Great Britain
by Amazon